THE MOTORCYCLE

THE MOTORCYCLE

DESIGN CHARLES M FALCO
ART ULTAN GUILFOYLE
DESIRE

	6-9	**FOREWORD**
1	10-31	**PAST PRESENT FUTURE** CHARLES M FALCO
2	32-53	**DESIGN** ULTAN GUILFOYLE
3	54-75	**TECHNOLOGY** CHARLES M FALCO
4	76-91	**DESIRE** ULTAN GUILFOYLE
5	92-113	**ART** ULTAN GUILFOYLE
6	114-297	**MOTORCYCLES**
7	298-307	**BIBLIOGRAPHY**
	308-313	**INDEX**

FOREWORD

The motorcycle is a powerful symbol of the ideals and aspirations that have propelled humanity from the middle of the nineteenth century, through the accelerating arc of the twentieth and into the twenty-first. The subject of often radical evolutions in engineering, applied technology and design, the motorcycle of the modern era has become firmly entrenched in popular culture as a signifier of individualism and freedom. Costing much less to build and to buy than other forms of private transport, the motorcycle has brought mobility to an astonishing proportion of the world's population. *The Motorcycle: Design, Art, Desire* is the story of what makes the motorcycle what it is today, all across the world.

It is the story of a superbly refined design object that, at its most innovative and sophisticated, is both a compelling tribute to the skill of its designer and maker and evocative of the age and ideas that impelled its production. While design history is key to *The Motorcycle,* both the book and the exhibition look back to the earliest motorcycle principally in order to project forward to the latest, seen just over the horizon. Beyond satisfying the desire for cheap and efficient personal mobility, the motorcycle is implicated in some of the most significant social and cultural shifts of its time. A consistently disruptive technology, motorcycles will continue to influence the reshaping and evolution of our cities into the future.

Seen across the 150 years encompassed by *The Motorcycle,* the world's most recognized bikes have come to symbolize the advance of contemporary technology and the innovative application of new materials to solving design problems. In themselves, they can represent shifting modes of production – from hand-built to mass manufacturing – and the sheer craft of their making and fitness for purpose. At the same time, motorcycles echo the aesthetic characteristics of their age and the raw emotion they undoubtedly generate when ridden. Today, perhaps more than ever, the motorcycle stands at a crossroads in its evolution, at the very moment humanity makes a global shift towards sustainability and renewable energy. Now, just as the battery-powered bike begins its exponential overtaking of the internal combustion engine, the future of the motorcycle has arguably never seemed more assured.

At present, there are two million motorcycles, on-road and off, in Australia, and hundreds of millions around the world. In many ways, the story of the contemporary motorcycle means two entirely different things, depending

on where in the world its rider lives. For those in newly industrialized countries such as Thailand, Vietnam and Indonesia, where on average eighty-six per cent of households own at least one motorcycle, generally a scooter, they are affordable, easy to park and the ubiquitous mode of transport. In countries such as the United States, Australia and those in Europe, an average of ten per cent of households own a motorcycle, with a focus on recreation and off-roading over everyday commuting – utilitarianism taking a back seat to style and speed.

As an art museum that focuses largely on the contemporary visual arts of Australia and the Asia Pacific region, the Queensland Art Gallery | Gallery of Modern Art embraces a broad definition of what constitutes contemporary visual culture – from fashion to film, architecture to design. *The Motorcycle* focuses on one very specific and yet multifaceted design object, an icon of the twentieth century viewed through the prism of 150 years of social, cultural and technological change that followed its invention in the late 1800s. Like the many objects of industrial design represented in global museum collections such as New York's Museum of Modern Art, the motorcycle is emblematic of its time. In so many of the bikes this exhibition and book celebrate, form follows function in extraordinarily beautiful ways that see some transcend their functional purpose to become celebrated for their aesthetic qualities as much as their material and technical innovations.

Design, like art and technology, is at its most compelling when it is disruptive, and which other object of art, design and desire has been so consistently disruptive on so many levels? The motorcycle has become a barometer of our values, ambitions, affluence and identity. Irrespective of whether we actively engage with bikes as a rider or pillion passenger, it is easy to see something of ourselves – perhaps even roads never taken – as we survey their many functional and often surprisingly beautiful forms.

The Motorcycle is an all-new exhibition curated exclusively for Brisbane's Gallery of Modern Art by motorcycle experts and aficionados Professor Charles M Falco and Ultan Guilfoyle, who were also responsible for the 1998 survey *The Art of the Motorcycle* at the Solomon R Guggenheim Museum in New York. In revisiting their deep knowledge and love of the motorcycle, they expand and reframe their view to encompass the cultural, ecological and technological transformation of the two decades since that record-breaking exhibition.

Falco and Guilfoyle trace the aesthetic and technical evolution of the motorcycle from the only example of the steam-driven Perreaux velocipede – an innovation made almost immediately obsolete by the subsequent emergence of the combustion engine. Following early Bauhaus and Art Deco influences, the exhibition then tracks the inter-war acceleration of new designs from France, Germany and Italy, and the mass production that exploded in Asia following World War II. From the 1950s, new cultures were emerging around the customization of motorcycles. Riders and mechanics who didn't fit the mould created wild new machines that shattered it completely, while choppers and other custom machines affirmed their place in popular culture through films such as *The Wild One* (1953) and *Easy Rider* (1969).

The exhibition features the early creations of Australian designers who crafted their own frames around imported engines, and pays homage to the distinctly Australian off-road

racing of the speedway. *The Motorcycle* features a Brisbane-made bike by David Spencer, who crafted a dozen machines by hand from locally cast parts in the first decade of the twentieth century.

While the internal combustion engine-powered motorcycle has been reinvented multiple times through its history, advancements in compact electric storage technology have revolutionized the vehicle in almost every aspect, down to its characteristic sound. With electric power the latest phase in this evolution, the exhibition will explore the sleek, modern design of zero-emission alternatives. While the technology evolves, the prominent place of the motorcycle in the cultural imagination has never waned.

I thank the exhibition's co-curators Charles M Falco and Ultan Guilfoyle for their superb reinvention of an art museum-based approach to their subject. Their erudite insight and lifelong passion for the motorcycle have again built an experience that will captivate loyal followers of the machine, and give the rest of us an insight into its enduring power and fascination. Their commitment to this project has been unwavering from the outset. Their unmatched knowledge of the history of the motorcycle makes this exhibition and the publication accompanying it extraordinarily engaging for the expert and the interested observer alike.

An exhibition of this scale requires the dedicated assistance of staff across the building, with special acknowledgement of the project's curatorial coordinator, Design Manager Michael O'Sullivan. He too has approached his task with undaunted energy and a keen local knowledge of bike culture. Similarly, Deputy Director of Collection and Exhibitions Simon Elliott has made a formative contribution, bringing these bikes together in a way that does justice to them, their makers and this gallery. As the Australian Cinémathèque's Robert Hughes shows in an accompanying film programme, the motorcycle retains its hold as a symbolic and practical vehicle for rebellion and escape.

The Motorcycle has been made possible by the deep commitment of the Queensland Government, through additional special exhibition funding, and the great support of Strategic Partner Tourism and Events Queensland, to present a globally unique and alluring exhibition. In staging the exhibition here, the Gallery acknowledges the profound intertwining of design culture and art, and the form and function of objects that may be manufactured, but are nonetheless the product of human imagination, passion and artistry. Let's ride.

Chris Saines CNZM
Director, Queensland Art Gallery | Gallery of Modern Art

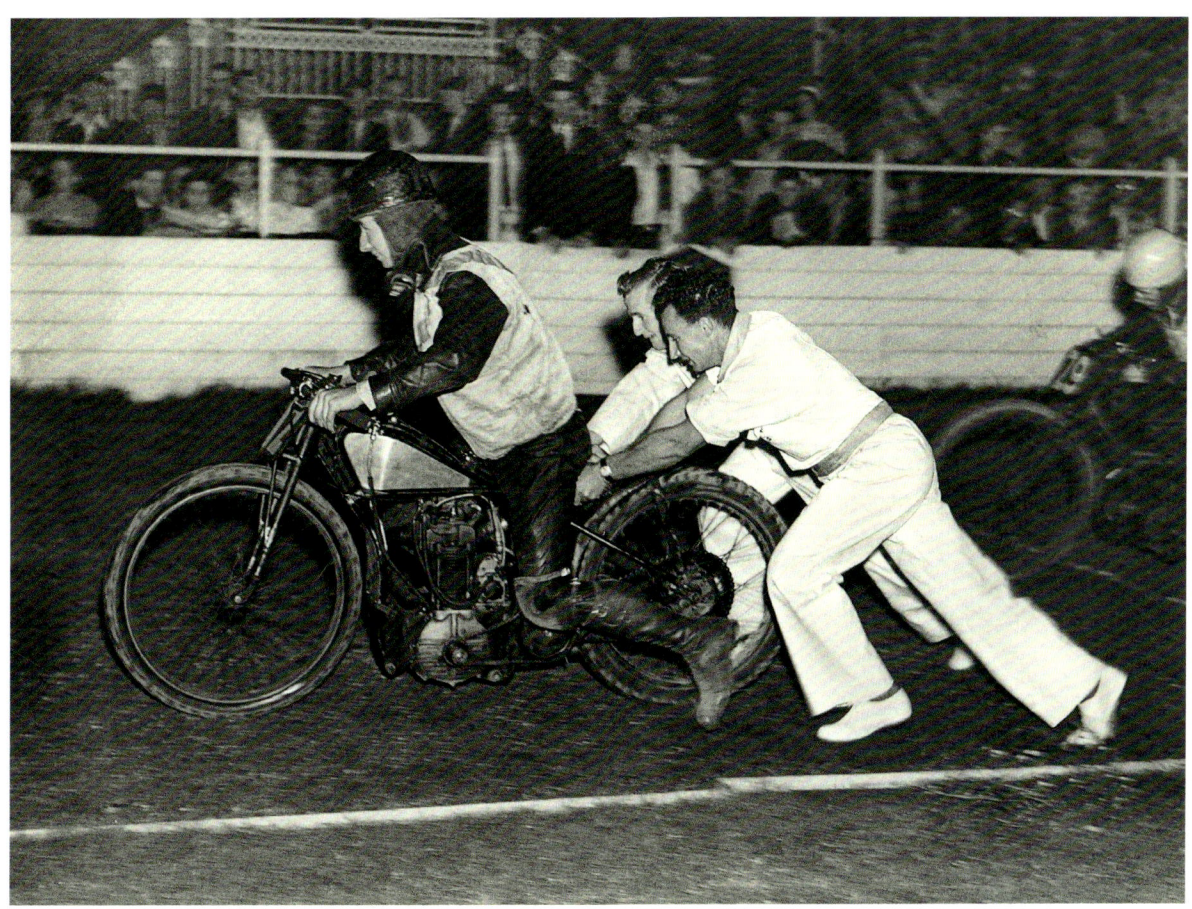

A racer gets a push start at a track in Brisbane, c.1954.

THE MOTORCYCLE

PAST PRESENT FUTURE

The history of powered transportation can be divided into three eras based on the principal mode of propulsion in use at the time: steam, internal combustion and electric. After centuries of development, the steam engine had been reduced in size to such an extent that in 1770 Nicolas-Joseph Cugnot demonstrated a large steam-powered car for the French military. By the 1830s, steam carriages and tractors were in use in England, with developments in their speed, carrying capacity and reliability continuing throughout the rest of the nineteenth century.

However, for motorcycles, the steam era ended almost as soon as it began. In 1871 Louis-Guillaume Perreaux of Paris patented a steam engine that was small enough to be used in a motorcycle and installed it in a frame similar to that of a Michaux pedal bicycle. Aside from the designs of Sylvester Roper, his near-contemporary in the United States, and a few slightly later experimenters, that point marked both the beginning and the end of the steam era for motorcycles; in 1862, even before the first steam motorcycle was made, Frenchman Alphonse Beau de Rochas had published the principle of the four-stroke internal combustion engine.

The first working internal combustion engine was made in 1876 by Nikolaus Otto in Cologne, Germany. In 1885, Otto's former assistant Gottlieb Daimler built a smaller engine near Stuttgart that he installed in a wooden bicycle-like frame with two outrigger wheels to create what he called a *Reitwagen mit Petroleum Motor* (riding car with petroleum engine). Although Daimler's can be called the first internal combustion–powered motorcycle, he turned his attention to producing motor cars, and only in 1894 did the first commercial production of motorcycles begin. Henrich and Wilhelm Hildebrand and Alois Wolfmüller set up in Munich to produce in quantity motorcycles using an engine and frame of their own design, which was also produced under licence in France as *La Pétrolette*. Unfortunately, an ignition system that relied on an open flame, along with the required high vapour-pressure fuel, resulted in serious accidents and complaints that caused the firm to go into liquidation by 1897.

RIGHT: The 1885 Daimler *Reitwagen* was the first internal combustion motorcyle.

BELOW: The 1894 Hildebrand und Wolfmüller was the first commercially produced motorcycle and was also made under licence in France as *La Pétrolette*.

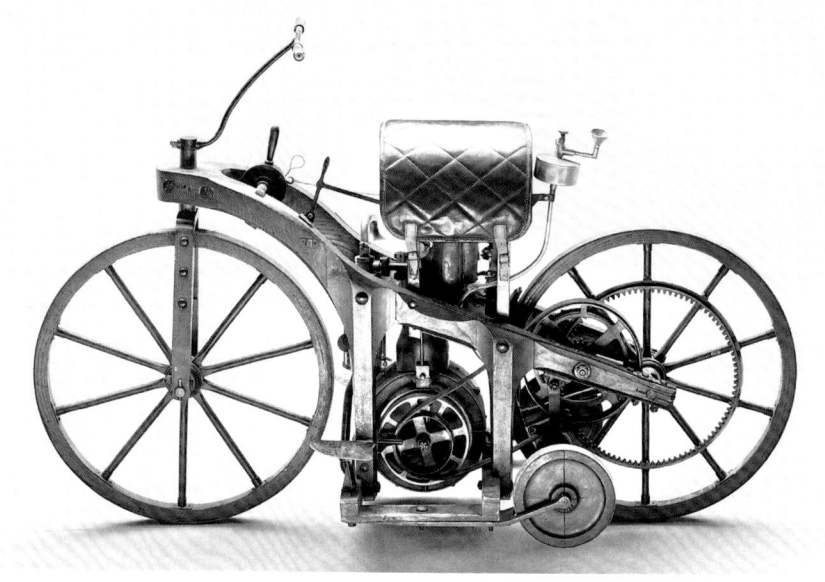

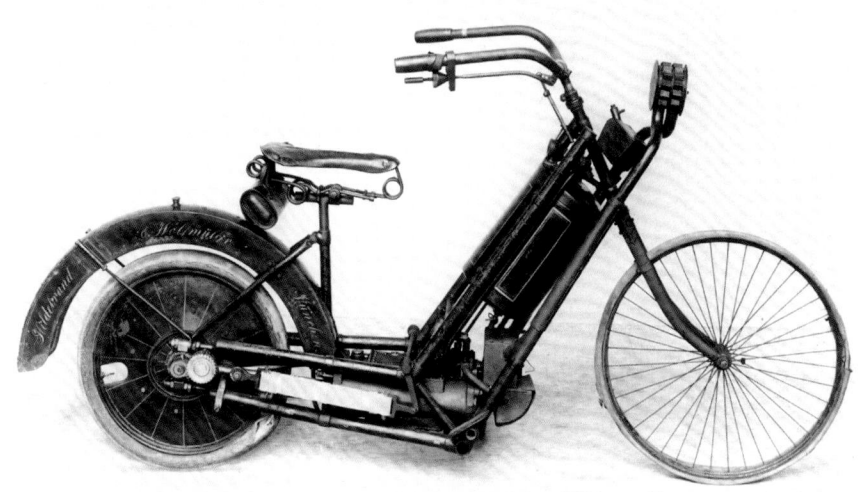

PAST, PRESENT, FUTURE

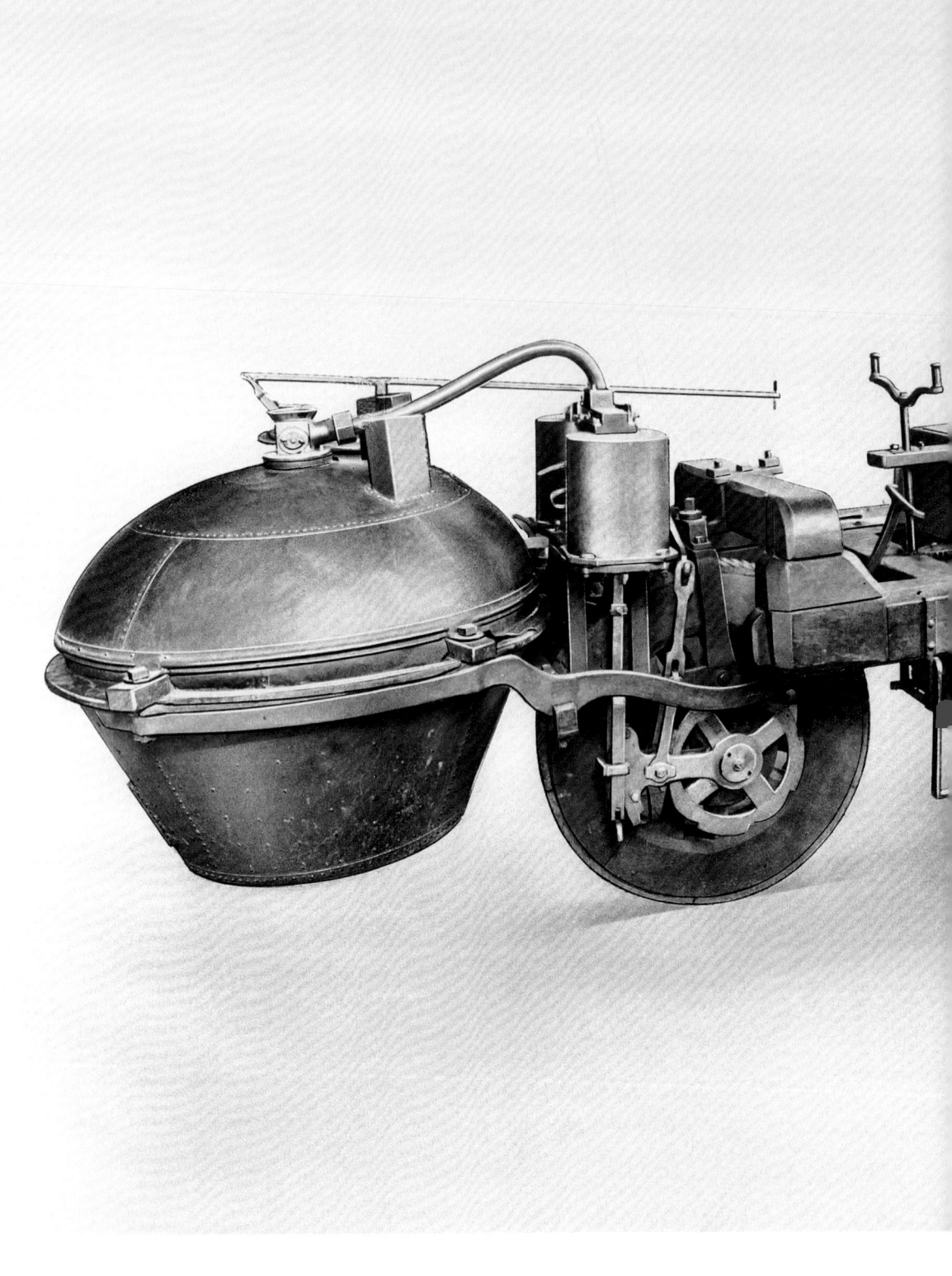

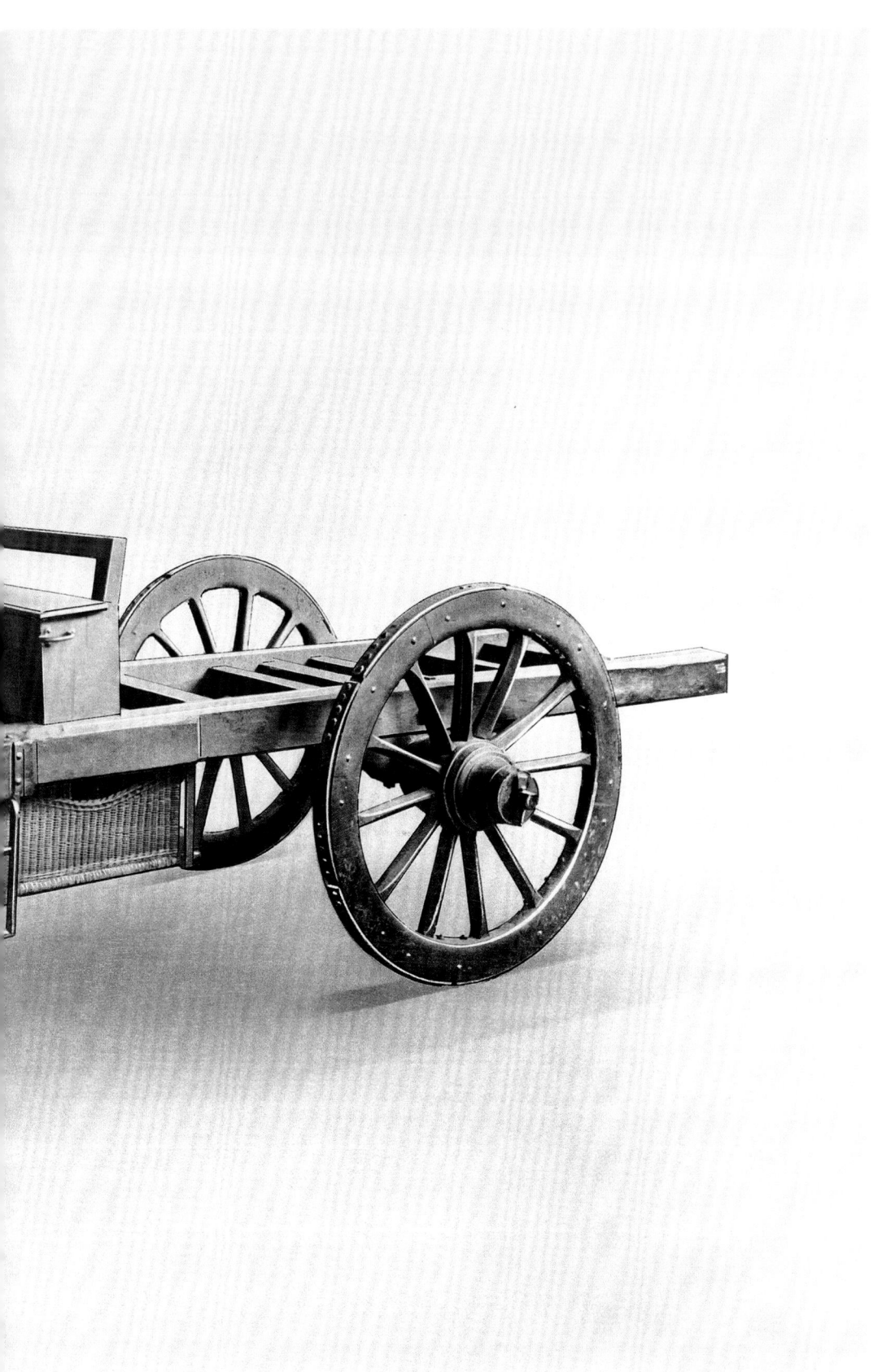

The first steam-powered car built in France in 1770 by Nicolas-Joseph Cugnot.

But, developments were gathering pace. In 1895, Count Jules-Albert de Dion and Georges Bouton produced a compact internal combustion engine in Paris that ran at the then-high speed of 1,500 rpm, and by 1896 they were selling improved versions of this engine in tricycle frames of their own design. This configuration was so successful that it was copied by a number of French, English and American manufacturers, including that of the 1898 Cleveland from the United States. The de Dion-Bouton engine itself was copied and improved upon by manufacturers, such as that of the American-made 1903 Indian.

As motorcycles increased in popularity interest also grew in the possibility of them carrying more than just the rider. As William Worby Beaumont wrote in his 1906 book *Motor Vehicles and Motors: Their Design, Construction and Working by Steam, Oil and Electricity*, there had arisen 'a demand for means of taking or carrying a second passenger [but] attempts to meet this demand have been only partly successful and require the use of a chair seat, spring mounted on two wheels and either used as a trailer ... or arranged at the front of the bicycle as a forecar.'

ABOVE: **Diagram of the 1895 single-cylinder de Dion-Bouton engine.**

BELOW: **The 1896 de Dion-Bouton tricycle was an important influence for almost a decade.**

OPPOSITE: **The 1898 Cleveland copied the layout and engine of the de Dion-Bouton tricycle.**

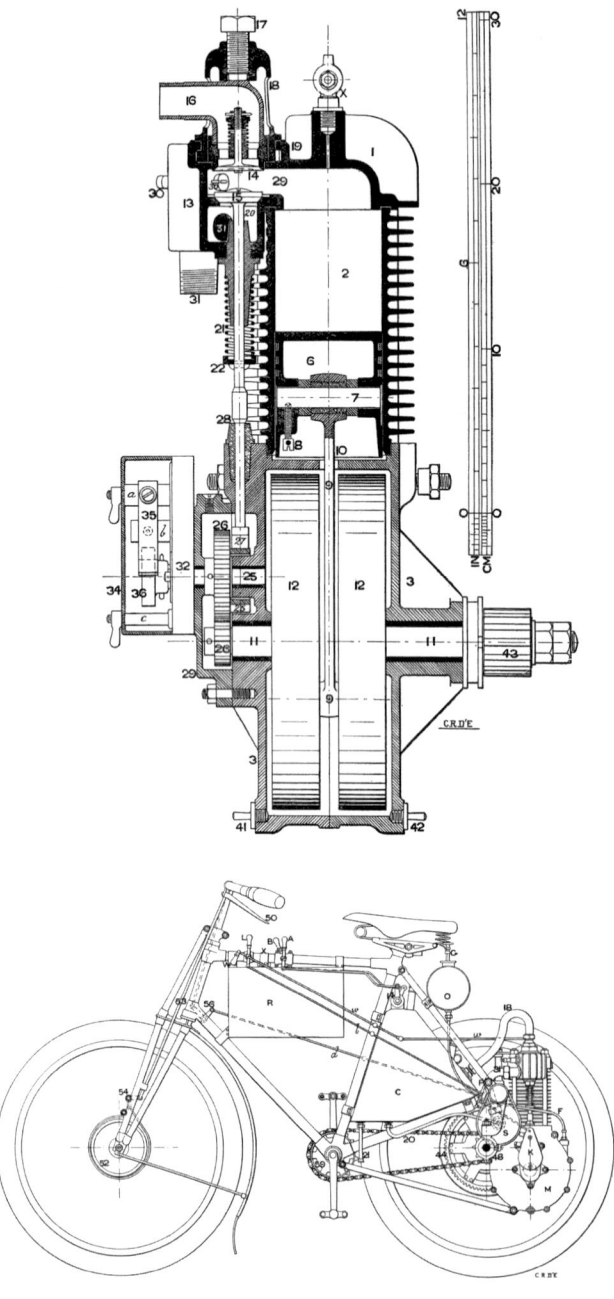

16　THE MOTORCYCLE

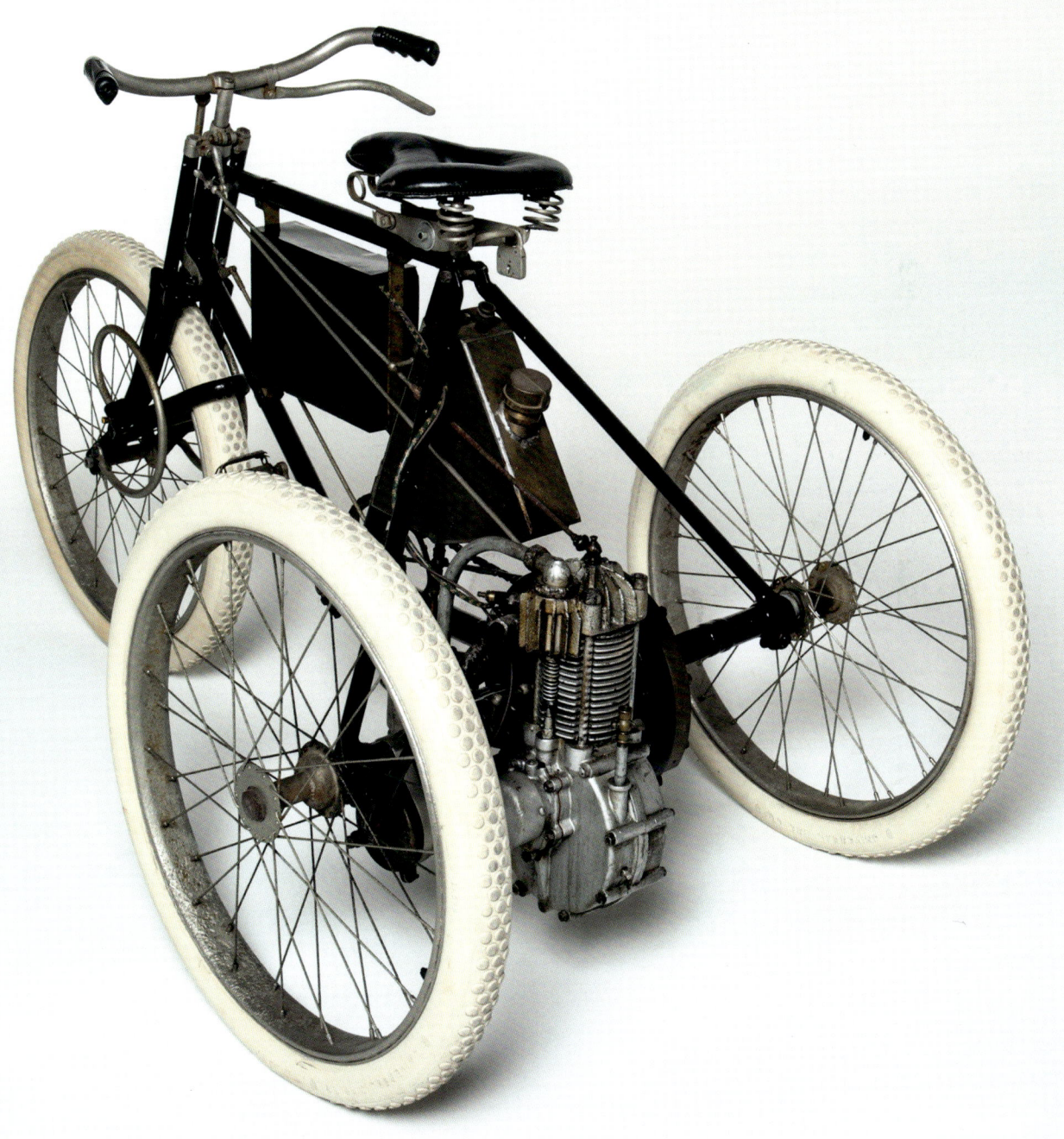

PAST, PRESENT, FUTURE

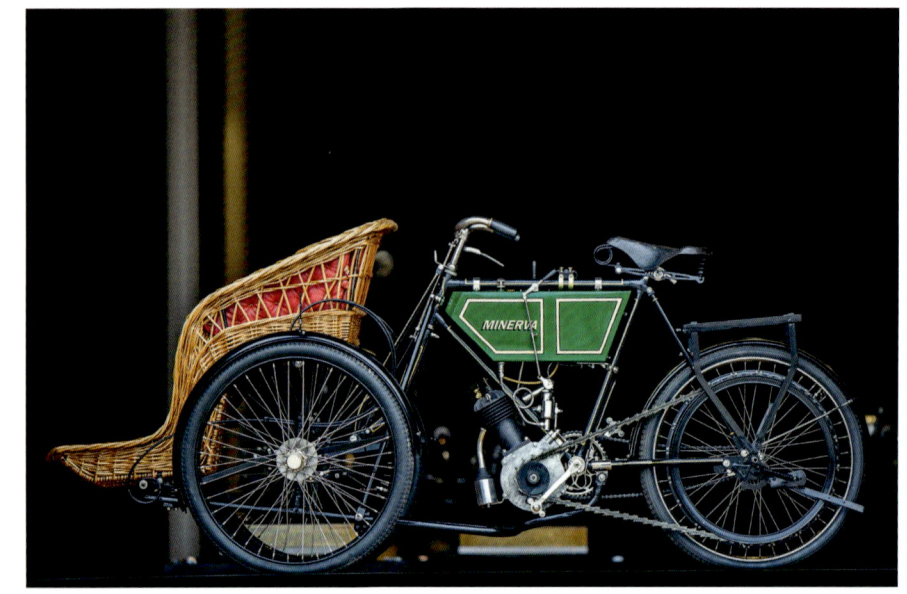

ABOVE: Advertisement for a Werner motocyclette, c.1900. Early designs had the engine mounted high but it was soon moved to the ideal location in the V between the frame tubes.

RIGHT: A 1903 Minerva with a Mills and Fulford forecar.

A 1908 Indian motorcycle with engine design based on the de Dion-Bouton.

A 1903 Minerva from Belgium shows one solution to this problem, although it was perhaps less than ideal from the passenger's perspective. Although the de Dion-Bouton tricycle had been a significant advance when it was introduced, the limitations of the relatively heavy tricycle frame, along with rapid innovation in the industry, soon made it obsolete.

With the French-made Werner of 1901, the engine had found its ideal location between the frame tubes: the spray carburettor and magneto had been developed to replace the unreliable surface carburettor and the hazardous open flame of hot-tube ignition. Everything was essentially in place, and the changes in internal combustion-powered motorcycles since then have mostly been gradual refinements. Though subtle, those refinements improved performance many times over.

Until repealed in 1896, the English Road Acts of 1861 and 1865 required someone on foot carrying a red flag to precede any motor vehicle by at least sixty yards to warn approaching horse riders as well as to warn the vehicle to stop until the horse passed. These Acts hobbled development of motor vehicles in England, giving continental Europe a significant head start. Meanwhile, in the United States, interest was primarily in motor cars.

In Australia, the pre–World War II history of motorcycles is largely one of importing major components, such as the engine or frame, and assembling them into complete machines. The 1906 Spencer is an exception, having been completely designed and manufactured at David Spencer's home in the Torwood suburb of Brisbane. He is known to have made at least eight engines of his own design, as well as many smaller components, and two complete motorcycles have survived.

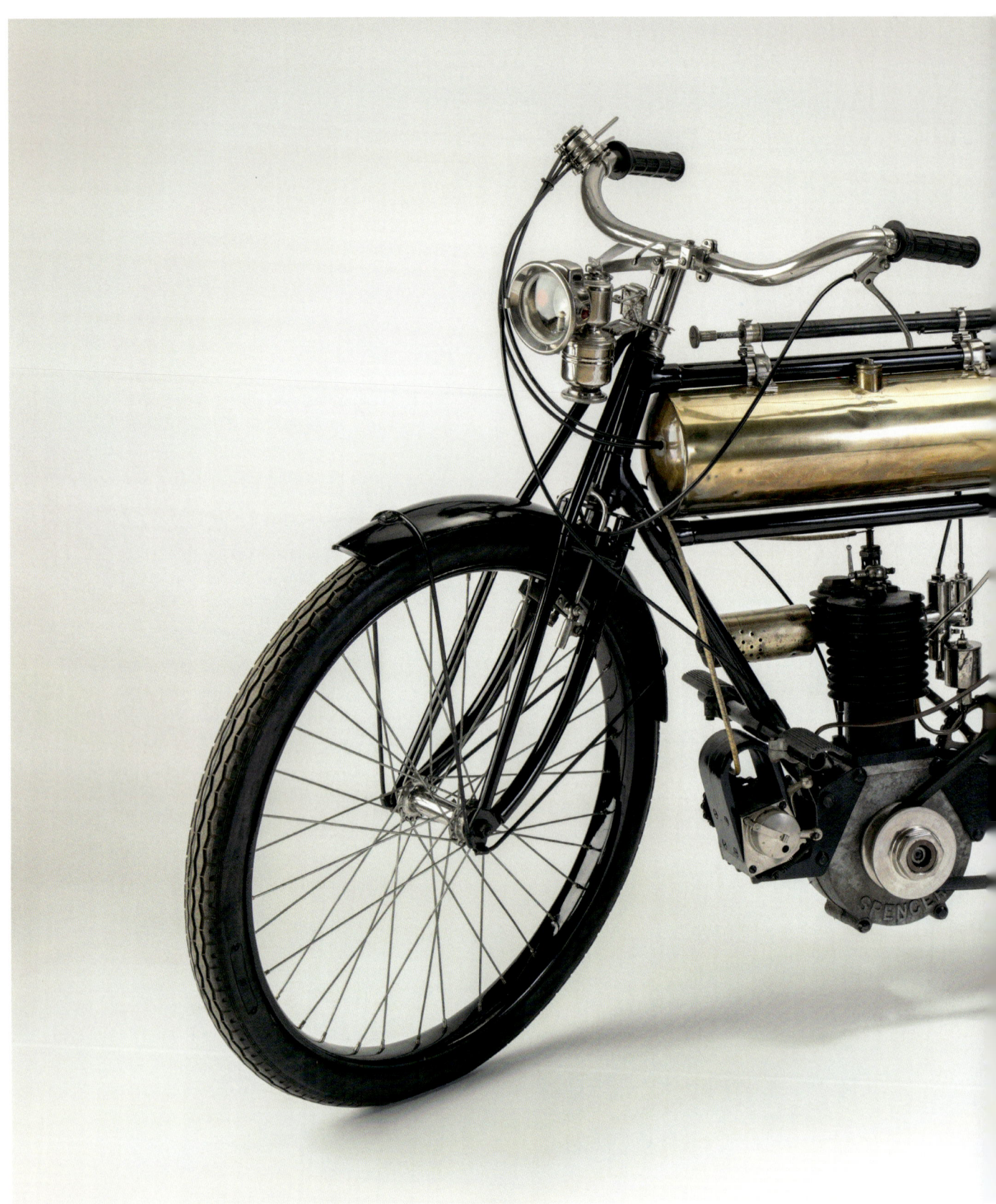

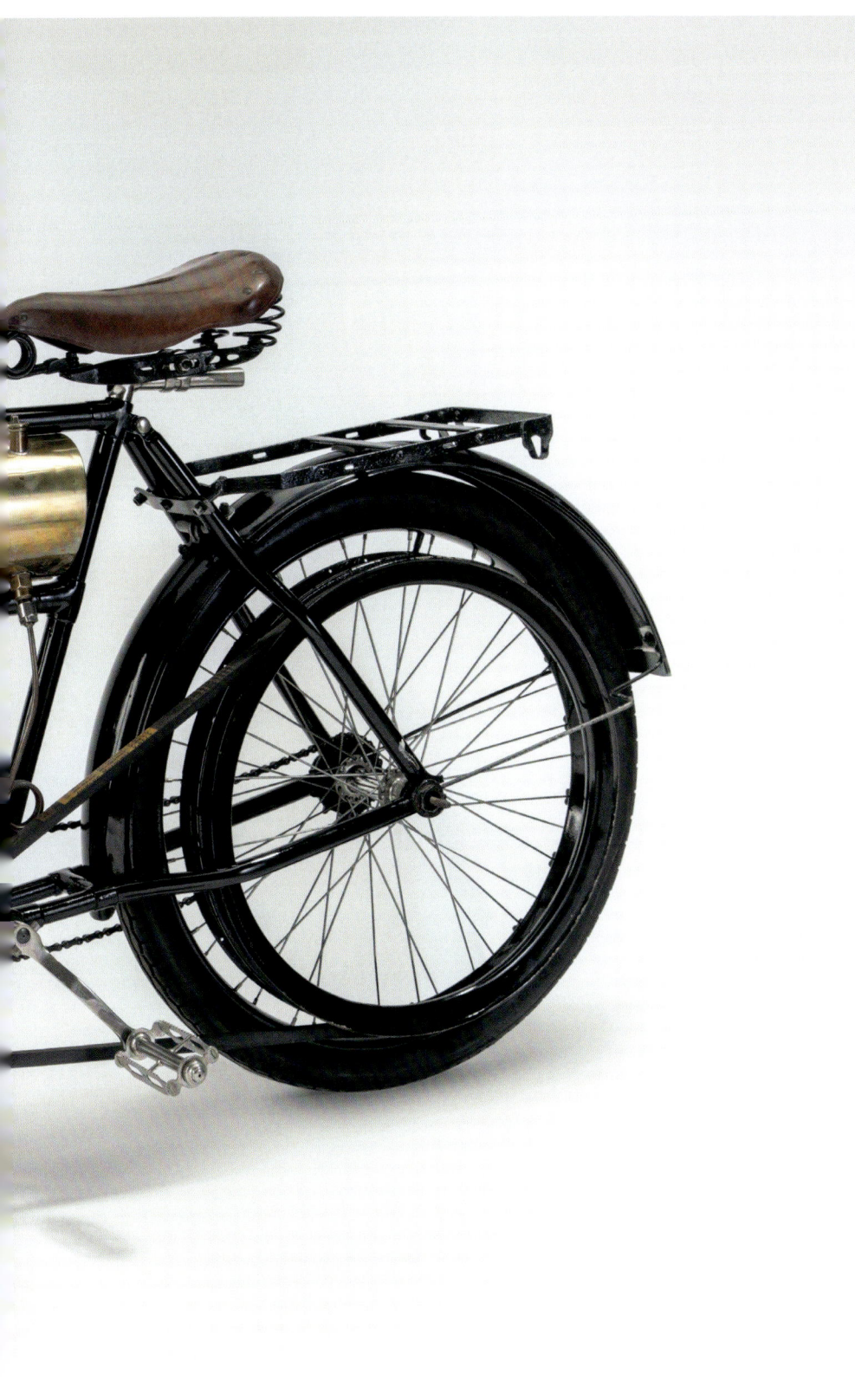

While most early Australian manufacturers assembled their motorcycles from overseas components, this 1906 Spencer was completely designed and manufactured by David Spencer in Brisbane.

PAST, PRESENT, FUTURE

The 1914 Whiting is another example of a motorcycle designed and manufactured in Australia. Saville Whiting of Melbourne designed an unusual frame with leaf springs at the front and rear as well as an air-cooled V-twin engine. He got as far as purchasing a factory in Victoria after World War I, but abandoned plans before production began.

In 1909 Narazo Shimazu fitted a 377 cc single-cylinder engine of his own design into a bicycle frame to create the first Japanese-manufactured motorcycle called the NS. Shimazu continued to play a role with several manufacturers for at least the next fifteen years. Although there were nearly thirty brands in pre-World War II Japan, total annual production was never more than 2,500.

The most powerful of the pre-World War II Japanese motorcycles was the 1200 cc Rikuo. However, rather than originating in Japan, it was actually a Harley-Davidson built under licence. Harley-Davidsons had been exported to Japan since 1923, but as a result of the devaluation of the yen in 1929, it became more profitable to build them in Japan rather than import them. In 1935, an agreement was signed with Rikuo to do so, but within two years American personnel were expelled from the country. However, Rikuo continued to produce around 18,000 of these exact copies before turning to other war production in 1942, without paying any royalties.

The post-World War II Japanese motorcycle story of the 'Big Four' – Honda, Yamaha, Kawasaki and Suzuki – is well known, but immediately after the cessation of hostilities it was the former aircraft manufacturers of Fuji (Kate torpedo bomber) and Mitsubishi (Zero fighter) that started to put Japan back on wheels. In the following twenty years, they produced more than a million Rabbit (Fuji) and Silver Pigeon (Mitsubishi) motor scooters.

The 1914 Whiting was designed and manufactured by Saville Whiting in Melbourne, Australia.

22 THE MOTORCYCLE

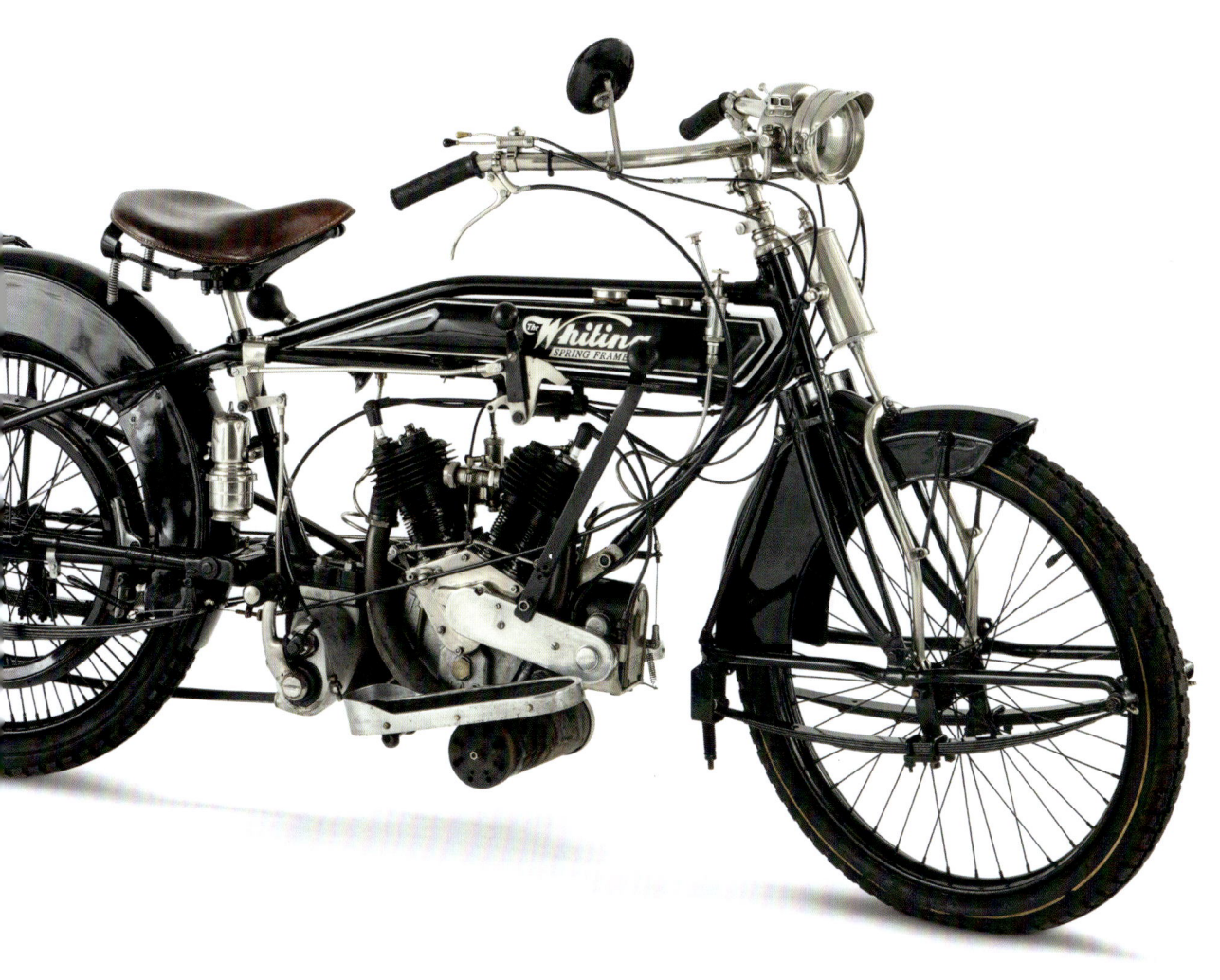

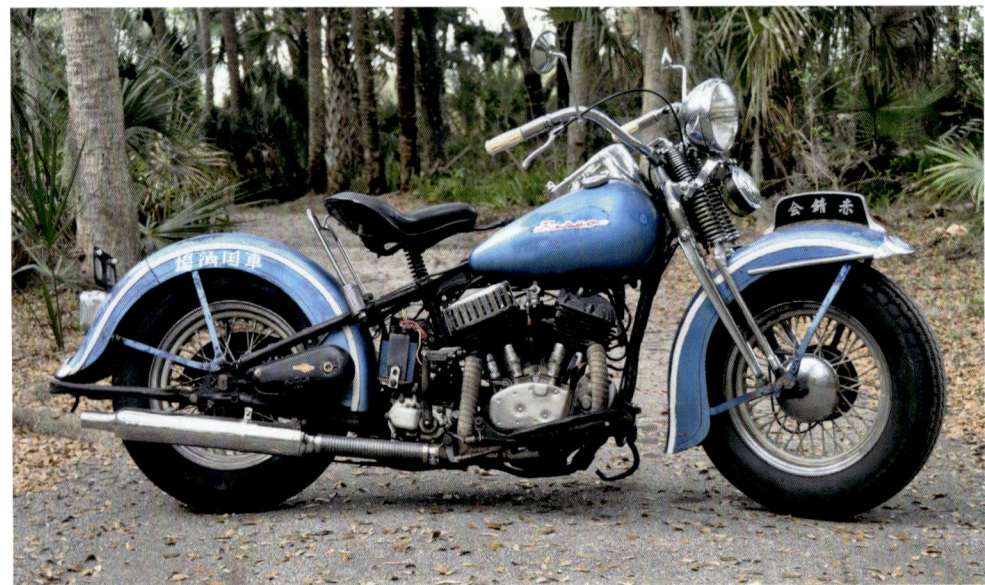

ABOVE: Promotional image for the Fuji Rabbit S-1, c.1946.

RIGHT: Harley-Davidson motorcycles were produced in Japan under licence by Rikuo from 1935 until 1942.

24 THE MOTORCYCLE

RIGHT: Advertisement for the Honda CB750, 1969. With its four-cylinder engine, electric starter, disc brake, and low cost, the bike was revolutionary when it was introduced.

BELOW: The 1969 Velocette Thruxton could not compete with the Honda CB750.

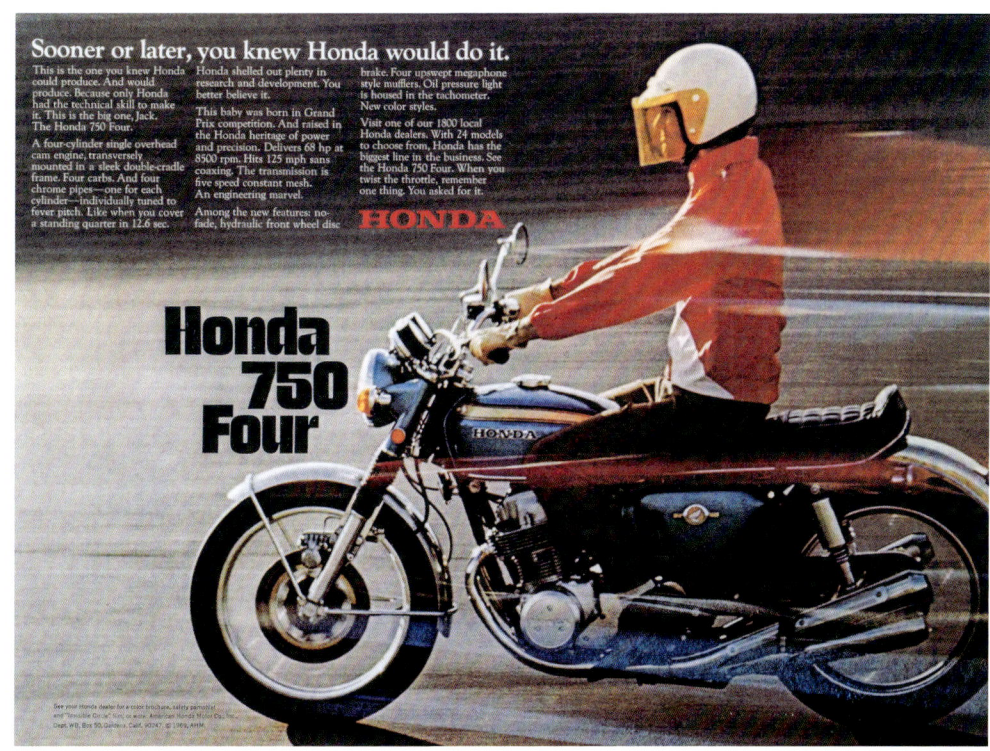

PAST, PRESENT, FUTURE

25

During the 1950s, the number of Japanese motorcycle manufacturers increased rapidly, from 42 in 1953 to 114 by 1959, with output increasing from less than 50,000 to nearly one million. However, sixty-five per cent of the production at the start of the 1960s was due to the Big Four, and by the end of that decade they were just about the only ones left.

The economies of scale and production achieved by the Big Four manufacturers did not just affect the smaller Japanese firms; they also effectively ended the British motorcycle industry. While at first Japan produced small motorcycles that were not direct competition for the bulk of British output, they slowly increased in capacity. In 1969, Honda released its revolutionary CB750 with a five-speed gearbox, disc front brake and electric starter. The same year BSA, until fairly recently the world's largest motorcycle manufacturer, produced its new Rocket 3. However, with its four-speed gearbox, conventional front brake and no electric starter, it was essentially a 1950s design. Worse, in the same year, the Velocette Thruxton was in shops trying to compete with the Honda with what was effectively a 1930s design. By 1974, the British motorcycle industry was no more, although it revived for a more niche market in 1991.

While Japanese manufacturers dominated production for many years, China and India have now become the dominant players. To put this in perspective, annual motorcycle sales in India are nearly forty times higher than in the United States. Unfortunately, India has twenty-two of the world's thirty most polluted cities, and motorcycles and scooters account for one-third of emissions. This has resulted in a governmental push to electric vehicles.

Riders on a BSA Rocket 3 at Brands Hatch Circuit in Kent, UK, 1969.

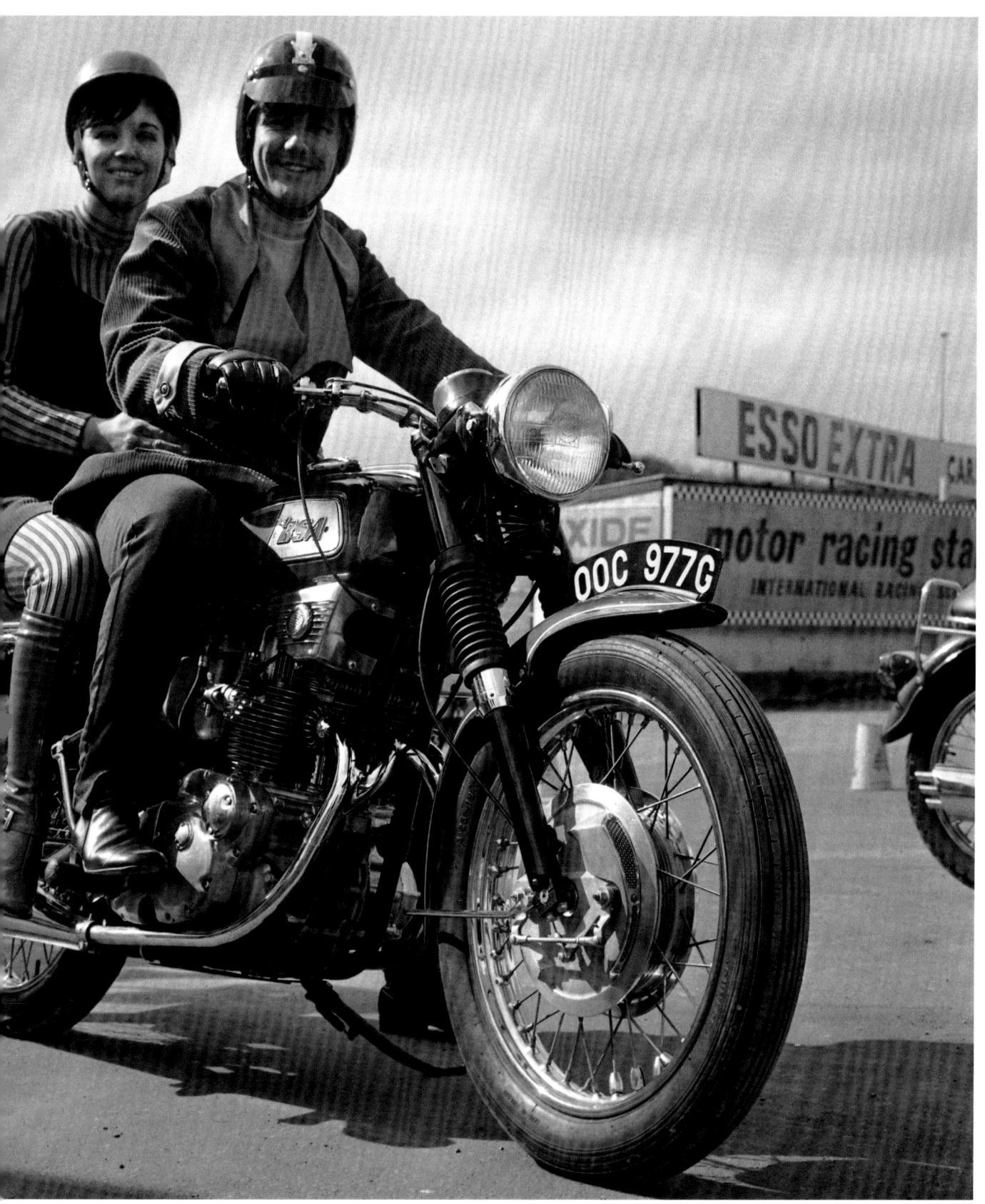

BELOW: The 2007 Bimota Tesi 3D uses a mass-produced Ducati engine to create a limited-production motorcycle.

OPPOSITE: Detail of the Bimota Tesi's exhaust system and rear shock absorber.

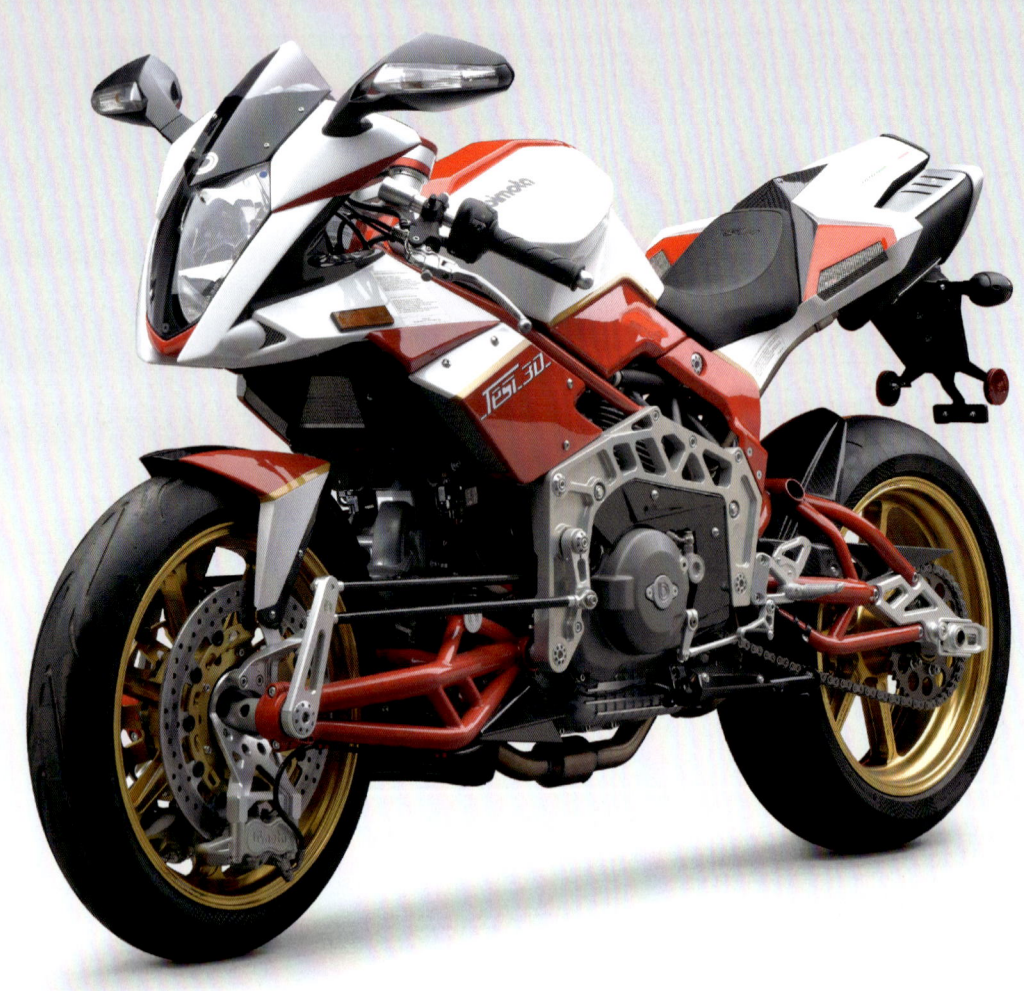

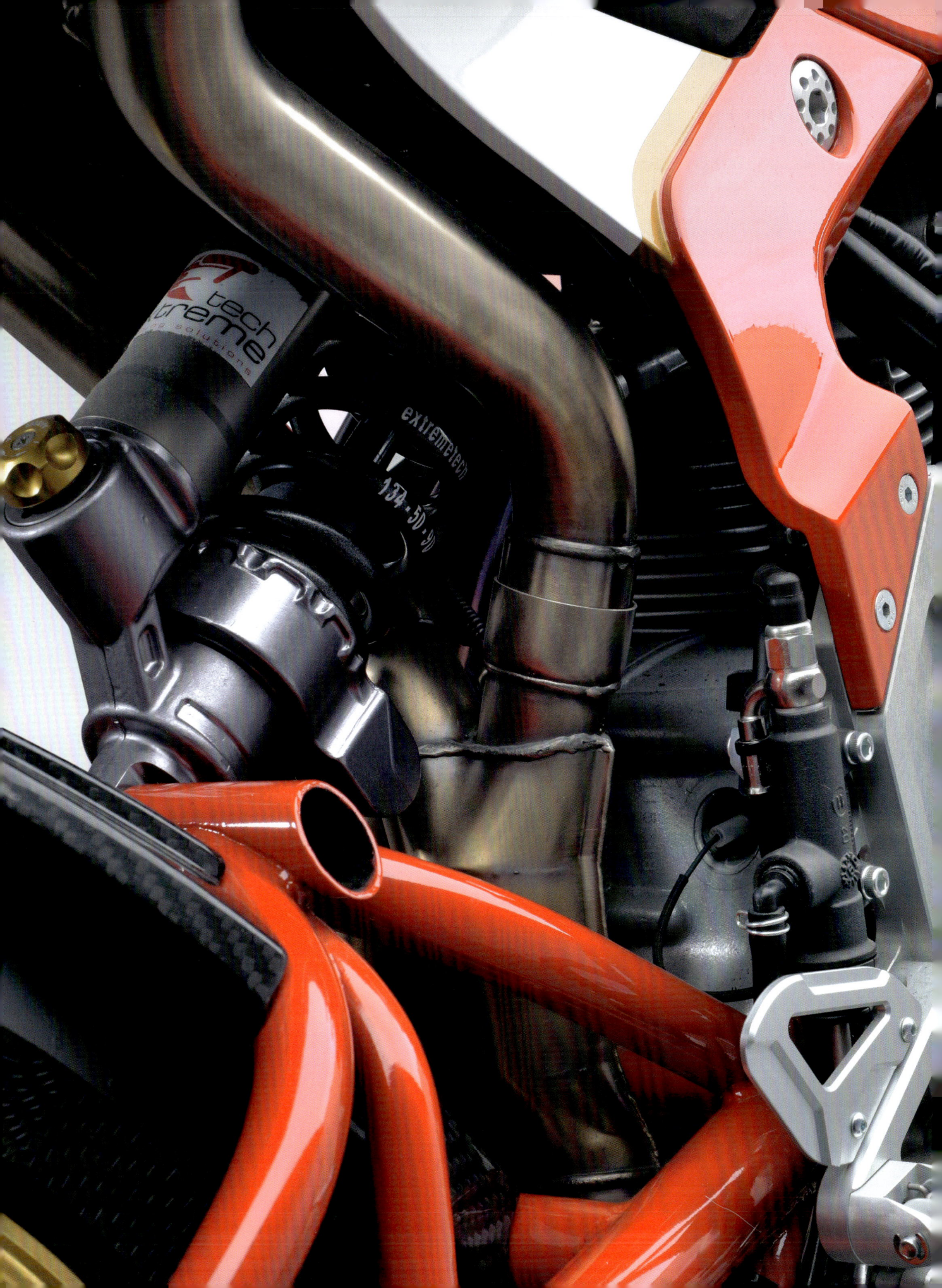

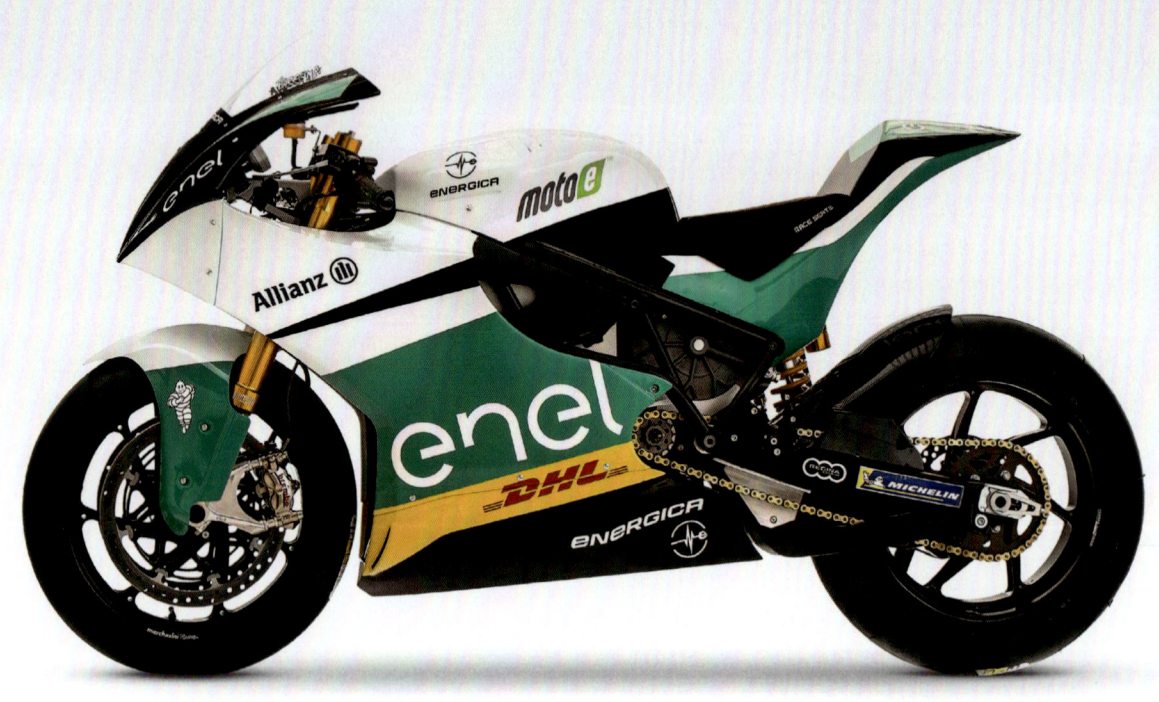

The 2019 Energica Ego Corsa is an electric motorcycle designed for the race tracks of the 21st century.

While mass production forced many smaller manufacturers out of the motorcycle business in the 1960s and 1970s, it later allowed speciality manufacturers to enter the market with machines that previously wouldn't have been possible. By purchasing mass produced engines that had already passed the expensive governmental testing requirements, and whose costs had been averaged over a large number of units, they were able to build relatively small numbers of their speciality machines at costs that, while high, are within the reach of enough enthusiasts to keep the companies in business. The 2007 Bimota Tesi 3D, with its Ducati engine, is an example of such a machine.

Thanks to more than a century of development, coupled with modern manufacturing methods and electronic technology, today's consumer has a wide choice of reliable motorcycles powered by internal combustion engines. The possibilities range from small, efficient machines that fill the streets of Mumbai, Hanoi and Jakarta, to large, powerful machines for the highways of Australia, Europe and the United States.

Looking to the future, after more than a century of development, batteries have reached a point where their use in motorcycles is becoming a realistic possibility. A machine like the 2019 Energica Ego Corsa is at one end of the spectrum, but neither high speed nor long range are factors for the transportation needs of millions of city dwellers. For the city, small electric scooters and bicycles provide personal transportation over distances of up to a few kilometres, while larger scooters and small motorcycles extend the reach into the suburbs. For urban dwellers as well as for sportbike riders, the future will be electric.

The 150 years since the steam-powered Perreaux have seen motorcycles undergo huge changes that have increased their speed, range and reliability tremendously. But their fundamental role of providing personal transportation remains the same today as it was then. With sustainable generation of electricity as a 'fuel' supply, motorcycles will continue to provide an environmentally friendly source of transportation in the future.

THE MOTORCYCLE

DESIGN

Miguel Angel Galluzzi was a student at the ArtCenter College of Design in Pasadena, California, in the mid-1980s when he noticed something unusual about the Hondas, Yamahas and Kawasakis that the kids of California were riding. He saw that they threw away the fairings, the bodywork that covered the handlebars and the engine, and stripped their bikes until they were almost naked. By this simple gesture, these kids eschewed the corporate automotive design trends of the day, and created their own style, a street style – one that would change the world.

After he graduated, Galluzzi went to work for Cagiva Design Group, Ducati's parent company. He didn't waste any time, soon persuading his boss, Massimo Bordi, that this idea of a bike without bodywork, a naked, muscular monster of a bike, would be a big hit. By stripping the bodywork from existing Ducati motorcycles, and raiding the factory for various bits and pieces from the production lines, Galluzzi created the Ducati M900 Monster, one of the most successful motorcycle designs of all time. It was a game changer of a motorcycle, and one with a deep and influential reach in the world of automotive design.

Lightning doesn't strike twice, so they say. Apparently only at Ducati. At the very same time Galluzzi was designing his Ducati Monster, the senior designer, Massimo Tamburini, was busy with his team designing the Ducati 916, a sleek and arrow-fast motorcycle for the street racer. The 916, in parallel with the Monster, made a huge impact on riders everywhere, and set Ducati on a decade's worth of commercial and critical success; success from great design, a formula that is all too-rarely applied to the production process.

The world does not change slowly; rather, it changes in great seismic shifts. The world of product design works in the same way, as the example of Ducati shows. Often the harbingers of these shifts are so subtle that, in that moment of transformation, most of us don't feel the ground moving underneath our feet. But when the shift happens, everything changes; nothing remains the same.

Such a momentous change happened in architecture in October 1997, when the Guggenheim Museum Bilbao, designed by Frank Gehry, opened. Although it wasn't fully understood at the time, the built world would never be the same again. The next twenty years of architecture and design would be radically different from everything that was built before. Without Frank Gehry, Zaha Hadid might not have flourished as she did.

RIGHT: The 1993 Ducati M900 Monster's minimal bodywork was a design phenomenon.

BELOW: The 1994 Ducati 916 by Massimo Tamburini was the most influential sport-bike of the late 20th century.

DESIGN

35

THE MOTORCYCLE

OPPOSITE: Louis-Guillaume Perreaux's steam velocipede of 1871 started a design and technological revolution.

LEFT: Early bicycle designs included velocipedes, 'ordinaries', also known as penny farthings, and hobbyhorses.

DESIGN

37

The basic layout of an early single-cylinder motorcycle (above) and a two-cylinder variation (below).

What about product design? Those seemingly innocuous objects that sneak up on us and change our world for ever. The first successful portable media player was the quickly forgotten Rio, produced in 1998 to play digital audio files (MP3s) of our favourite songs. Apple launched its own version, the iPod, in 2001, designed to coordinate with the iTunes digital music service. Before long, we had iPhones, so-called 'smart' phones that incorporated the best of the iPod's capabilities, and with iTunes built in (oh, and a camera). The design genius behind all of Apple's products in those days was the British designer Jonathan Ive who led a team of enormous creative talent. In under a decade, our world had changed again – changed by design.

But let's go back to motorcycles, and the beginning of motorcycle design. Elsewhere, Charles M Falco will describe the development of motorcycle technology (page 54), but what about the aesthetics of motorcycle design, from the very beginning? Well, the truth is, there wasn't much that was aesthetically pleasing about those early efforts. The Perreaux steam velocipede, generally regarded as the first motorcycle, has a confident, florid, Parisian style about it, which is natural when you consider that Paris in the second half of the nineteenth century was a confident, florid place: the centre of the known universe. Paris during the Second Empire, as this period is called, had the wealth, the architectural and design activity, the banking, the entrepreneurship, to lead the world.

Early bicycles were called velocipedes (from the Latin, via French, *velox* [swift] and *pes* [foot]) and Michaux (velocipedes) and Perreaux (small steam engines) combined easy-to-ride bicycles with a workable engine. Perreaux patented his own design for a velocipede in 1871, but the lines of Pierre Michaux's velocipedes were pleasing and the very centre of the frame seemed like a good place to stick an engine, even a steam engine.

Once the internal combustion engine became a reality, in the same way that smartphones became a twenty-first-century reality, everything changed. All types of contraptions with internal combustion engines were developed, large and small. With four wheels, the car became the vehicle of choice for getting people around in style and comfort. The motorcycle, with two or three wheels, found its niche, especially among young and adventurous types: the same sorts of people who, a century later, would gleefully buy the first MP3 player, the first iPod, the first iPhone.

Cars and motorcycles were, at first, just built. In other words, they were constructed in workshops and garages by talented mechanical and engineering innovators. With interest in these new, exciting machines at a frenzy, cars and motorcycles started to be designed, that is, drawn on paper, before being handed to the mechanics and engineers, the better to appeal to enthusiasts. Of course, an American wanted an American-style design, while someone in France wanted something that looked, well, French. The early world of motorcycle design had national characteristics that we can celebrate today.

The Brits designed slightly dull, workmanlike motorcycles, with names that flourish still: Triumph, Royal Enfield, Norton. They were solid, upright designs, with the rider in an upright position, as if riding a horse English-style, with a straight line running from north to south through the rider's shoulders, bottom and ankles. The young engineers who worked in those factories may not have arrived at their workshops on horseback, but they probably arrived in a horse and cart, and the style of horse riding was as familiar to them as the taste of roast beef and Yorkshire pudding. Very English.

DESIGN

Norton

REG^D TRADE MARK

OPPOSITE: Classic English graphic design of the 20th century.

RIGHT: The Triumph logo has a similar swooping design.

BELOW: A rider on an early Harley-Davidson V-twin racer.

DESIGN

Across the Atlantic, George M Hendee and Oscar Hedstrom, in Springfield, Massachusetts, and Messrs Harley and Davidson, in Milwaukee, Wisconsin, all arriving to work on horseback, rode in a different, 'cowboy' style: laid-back, feet-forward, neck-reining. That American style of riding a horse has come to define the American style of motorcycle design.

Thank goodness for the French, who of course went in their own direction, and created machines of timeless beauty. We have come to love nineteenth and early-twentieth-century French architecture as the embodiment of grace and beauty, with its Beaux Arts style radiating across the design world. French motorcycles, too, had a *leger-de-main* flourish that was in perfect harmony with the aesthetics of the time and French manufacturers including Terrot, Peugeot, Monet-Goyon and Gnome et Rhône thrived.

Conversely, sometimes a design can land with flourish and style, can be widely celebrated and become, at the same time, frozen in its moment, with no onward influence whatsoever. The Sydney Opera House, opened in 1973, is a building that came to define Sydney and Australia, but whose influence was negligible. Jørn Utzon, its brilliant architect, never changed the world, as Frank Gehry did. Frank Lloyd Wright's greatest building, the Guggenheim Museum on Fifth Avenue, New York, opened in 1959, a year after Mies van der Rohe's Seagram Building. While both were celebrated, the Seagram came to be seen as a very symbol of the International Style: taut, tight, perfect, an icon of its place and its time. The Guggenheim was admired, to be sure, but more as a symbol of its eccentric architect than for its own merits. As celebrated as Wright was, his influence was small, and never made headway against the prevailing winds of International Style Modernism, then howling at full strength.

The 1926 Peugeot P104 was a powerful, reliable and stylish machine.

DESIGN

Such is the history of French motorcycle design, and French motorcycles. They existed, and exist, for themselves. The greatest of them, perhaps, is the Majestic. It is a spectacular motorcycle, designed in 1930 by Georges Roy, but its impact on the world of motorcycle design was close to zero. We look at it today with a sense of wonder. We shake our heads and smile. We love it, we just can't imagine ourselves actually riding it.

Two timeless designs, both of which changed the world, emerged from the demands of war. Bayerische Motoren Werke (Bavarian Motor Works, or BMW) was an aircraft engine manufacturer of renown. BMW, however, was on the wrong side of World War I, and it struggled to gain a foothold as a manufacturer of engines and automobiles in the early 1920s. Aircraft engineer Max Friz, when asked to look at motorcycles as a way forward in those difficult years, created the R32, using a horizontally opposed air-cooled twin, the so-called boxer engine, that has been the hallmark of BMW motorcycles ever since. It was not just the engine that set the BMW apart, it was the way Friz integrated the engine into the rest of the design, how he married the engine seamlessly to its parts: the triangular frame, the tank, the pinstriped symmetrical mudguards, the low seat, the wide handlebars, and the headlight, perched high and leading the way forward, almost like a flag.

The Bauhaus, the German design academy that was founded by Walter Gropius in 1919 and which quickly became the dominant design and architectural philosophy in Germany and the rest of the world for the next century, was only in its infancy when BMW started producing motorcycles.

Georges Roy's 1930 Majestic is a beautiful example of French Art Deco styling.

THE MOTORCYCLE

DESIGN

OPPOSITE: **The 1923 BMW R32 exemplifies the beauty of form and function, played out between the frame triangles and wheel circles.**

ABOVE AND LEFT: **Two early designs of the so-called boxer engine, with horizontally opposed cylinders.**

DESIGN

48 THE MOTORCYCLE

ABOVE: Corradino d'Ascanio's timeless line drawing for the first Vespa.

BELOW: An early prototype c.1945.

But something of the zeitgeist, the spirit of the Bauhaus, the movement's idea of 'form follows function', courses through the veins of the BMW R32. There is a fluency and a verve that echo the French, but the sum of the parts is unmistakably German.

A little over twenty years later, Italy was dragging itself out of the poverty and dysfunction caused by another catastrophic conflict, World War II. Piaggio was the leading Italian aircraft manufacturer with a remarkably similar history to that of BMW and, like BMW, it had to kickstart its business model in the immediate aftermath of the war. Piaggio turned to Corradino d'Ascanio, a brilliant aircraft engineer, to see if he could come up with something that could address the desperate need for personal mobility in the aftermath of the war. The roads were in a terrible state, industrial infrastructure was destroyed, and people needed not only to work, but to be able to get to work, cheaply and easily. When d'Ascanio unveiled his scooter design, his boss exclaimed, *Sembra una vespa*! (It looks like a wasp!) – the name stuck. So did the design, which is still in production, most recently in electric form. The bodywork elegantly preserved the clothing of the rider as she traversed the muddy, pot-holed roads of postwar Italy. The arrangement of the engine, hidden under bodywork at the rear wheel, allowed the rider to step through the bike, and sit on, not over, the seat, making the design equally accessible for female riders in skirts. D'Ascanio's design was alive to the pressures of the time: poverty, the need for personal mobility, infrastructure devastated by war. And the Vespa, neither fast nor macho, changed the world, in its own gentle way.

So, what is changing the world today? Are we rewriting the twentieth century? In some ways we are, yet we are emphatically looking forward in other ways. Stefan Ytterborn is a Swedish designer and thinker who created the POC (Piece of Cake) line of safety gear for mountain bikers and skiers. As his company grew, Ytterborn's restless design energy saw that battery technology had reached a point that allowed Electric Vehicles (EVs) to be a reality. Combining his love of adventure and mountain-biking, Ytterborn designed the Cake, a small line of electrically powered bicycles for either adventure (the Kalk OR) or utility (the Ösa). Ytterborn's Cake bikes are not the only electric bikes on the roads today. But they are the most interesting.

Elsewhere, electric bikes of all sorts, whether on one, two or three wheels, seem to be emerging at a frantic pace. Everything from the bicycles, unicycles and monowheels of Segway-Ninebot, to sportbikes whose quotidian designs are virtually indistinguishable from their internal combustion counterparts, are beginning to flood the market.

Design and technology are finding each other in new ways. The world is changing again. Changing by design.

Stefan Ytterborn designed two versions of his Cake bike, the off-road model (Kalk OR) and this utilitarian, two-wheeled workhorse, called the Ösa.

DESIGN

51

> The 2018 Cake OR has the very large rear sprocket common to all electric motorcycles, which speaks to the uniquely 'torquey' characteristics of an electric engine.

3

THE MOTORCYCLE

TECHNOLOGY

Conceptually, the 1871 Perreaux and the 2018 Cake are both bicycles with engines. However, that the motorcycle has changed significantly in the 150 years between these two machines is obvious from the fact that the earliest motorcycle in this book is steam-powered and the latest are electric, but for most of the intervening years power was provided by internal combustion engines.

Since motorcycles are the result of several technologies coming together, a history of the complete machines could start at various earlier points in the developments of those technologies. This discussion starts with the Michaux bicycle, the first commercially successful pedal bicycle, produced in France from 1868. Within a few years, the Parisian engineer Louis-Guillaume Perreaux patented a design for a steam engine that he installed in a modified Michaux bicycle, and the motorcycle was born. As an aside, unfortunately for Perreaux, his steam-powered machine was a technological dead-end the moment it was created, since already in 1862 fellow Frenchman Alphonse Beau de Rochas had published a technical description of the four-stroke internal combustion process.

Although the motorcycle was born c.1870, turning it into a practical machine for personal transportation awaited development of a working internal combustion engine in 1876, followed by a lightweight version in 1885, so that only in 1894 did the first commercial production of motorcycles finally begin. That machine was the Hildebrand und Wolfmüller, whose German makers also trademarked the name *Motorrad* (motorcycle), by which we still know these machines today.

After the Hildebrand brothers produced their own small steam engine in 1889, they were joined by Alois Wolfmüller initially to make a two-stroke internal combustion engine followed quickly in 1893 by a four-stroke engine. However, finding the bicycle frames of the time to be too flimsy to hold their new engine, they designed their own frame. The resulting Hildebrand und Wolfmüller of 1894 incorporated the newly developed drawn steel tubing and had steel connecting rods directly attached to the rear wheel.

Both the Perreaux steam velocipede and the Hildebrand und Wolfmüller used some of the most advanced materials available at the time the machines were created. To follow subsequent technological developments, it is useful to examine the evolution of racing and sporting motorcycles over the next 150 years since these machines were the ones that most quickly incorporated the latest developments in technology, for a simple economic reason.

ABOVE: Drawing from Louis-Guillaume Perreaux's 1871 patent.

RIGHT: Sectional drawing of the 1894 Hildebrand und Wolfmüller motorcycle.

TECHNOLOGY

58 THE MOTORCYCLE

Detail of the Hildebrand und Wolfmüller showing the inlet valve and the connecting rod attached directly to a gear in the rear wheel.

Motorcycles and cars use similar fabrication techniques (forging, welding, machining, etc.) and similar materials (steel, aluminium, plastic composites, etc.) in their construction. Because of this, the technologies incorporated in a given machine can be judged from the dollars per kilogram it costs compared with any other machine produced in the same time period. Such a 'cost analysis' demonstrates why advanced technologies have historically been incorporated first in high-performance motorcycles rather than in mass-produced cars.

Currently, a few months' wages of a construction worker in an industrialized country will buy a Honda CBR650R, a motorcycle capable of 240 kph (150 mph), directly from the dealer's showroom. In contrast, it requires twenty per cent more than that to buy the least expensive two-door car on the market, with a top speed of a modest 175 kph (108 mph). It certainly is possible for a car to have comparable performance to that of the Honda motorcycle, but that performance comes at a price. For example, a BMW 540i has a similar top speed of 250 kph (155 mph), but it costs nine times more than the Honda. In essence, motorcycles weigh much less than cars, but are manufactured using the same materials and production techniques. What this difference in weight means is that motorcycles are able to incorporate more advanced technologies while still achieving a reasonable total cost. These prices and relative levels of technology and performance can better be understood by the following comparison: the 'high-performance' BMW and Honda both cost about the same per kilogram, whereas a 'modest-performance' car is only one-quarter the cost per kilogram.

At the end of the nineteenth century, motorcycles used surface carburettors and open-flame, hot-tube ignitions. The former were basically pans filled with a volatile fuel whose vapours were sucked into the engine, and the latter were metal rods heated by an external flame that ignited the vapour once it was in the engine. Clearly, this made those early machines potential conflagrations on wheels, resulting in the early popularity of tricycles, such as the 1898 Cleveland, that were less susceptible to tipping over. However, by 1903, the engine had found its final location between the frame tubes, and 'modern' spray carburettors and magnetos had been developed to replace the surface carburettor and hot-tube ignition. At that point everything was essentially in place for motorcycles powered by internal combustion engines, and the changes since then have mostly been gradual refinements, which have nevertheless improved performance many times over.

The 1906 Spencer weighs some 50 kg (110 lb) and produces no more than 2 hp from its 475 cc engine. However, by the 1920s, developments in engine technology that originated in the aircraft industry of World War I had boosted the output of the 500 cc engine in the BMW R32 four-fold to more than 8 hp; harnessing this additional power without twisting or distorting the frame only required an increase in kerb weight to 122 kg (269 lb). Continuing this technology trend, the 2007 Bimota Tesi 3D produces ten times the power of the BMW R32, but weighs only forty per cent more. This progress was made possible by the development of materials technology that allowed engineers to design structures of tremendous strength without a corresponding increase in weight. A simple example is the substitution of aluminium for steel. Although the reduced weight of aluminium provides significant performance advantages over low-carbon structural steels, a typical aluminium alloy costs roughly five times as much per kilogram as steel.

The top speed of 240 kph (150 mph) of this 2019 Honda CBR650R is similar to automobiles costing nine times as much.

TECHNOLOGY

RIGHT: **Designers tried various engine locations and drive mechanisms in the early years of the motorcycle before finally arriving at the location between the frame tubes that was to become the standard.**

BELOW LEFT: **The de Dion-Bouton engine used an open flame (T) to heat an open tube (U) that ignited the mixture.**

BELOW RIGHT: **A surface carburettor was used to collect the vapour from a volatile fuel.**

62 THE MOTORCYCLE

RIGHT: This 1906 Spencer weighs 50 kg (110 lb) and produced around 2 hp from its 470 cc engine.

BELOW: By 1923 the BMW R32's 500 cc engine could produce 8 hp with only a twofold increase in weight to 122 kg (269 lb).

TECHNOLOGY

63

OPPOSITE: Poster for Griffon Motorcycles showing a rider on a board track, c.1904.

ABOVE: Advertisement for Indian Motocycle, 1916.

Board track racing developed before World War I; the boards provided low rolling resistance and the banking of the tracks kept the riders from sliding off, leaving only wind resistance to limit the speed. This resulted in machines like the 1916 Indian. Anything that added weight or didn't aid the maximum speed, such as silencers or brakes, was omitted. Motorcycles benefit from having small, lightweight engines that at the same time produce high power. However, although weight was saved wherever it could be on these motorcycles, in order to extract the maximum power the designers concentrated on the engine's head.

While an engine has a number of components that serve various essential purposes, all of the power is produced in the combustion chamber of the head. The 1916 Indian has an eight-valve head, two for the inlet and two for the exhaust on each of its two cylinders. The reason for the additional complexity of having two inlet valves is that the total area under the valves when opened is greater than if a single, large valve were used, and the more fuel and air that can be ingested, the higher the power that will be developed.

Unfortunately, in any internal combustion engine only twenty per cent of the energy extracted from the burning fuel ends up as power to the rear wheel, while the other seventy-five per cent is wasted in the form of heat. This is fundamental to the conversion of chemical energy (petrol) to mechanical energy (horsepower), and is a serious issue for this form of engine in the twenty-first century. This heat must be extracted from the engine, or parts will fail due to their reduced strength at elevated temperatures. While some of the heat of combustion naturally leaves the head through the exhaust pipe in the form of hot combustion by products, the rest must be conducted away

OPPOSITE: 1916 Indian board track racer with narrow tyres and a streamlined shape for minimal wind resistance.

RIGHT: The connecting rod and crankshaft convert the linear motion of the piston to the rotary motion of the wheel.

BELOW: Drawing of possible engine configurations showing common single-cylinder and two-cylinder varieties, c.1928.

VARIETY IN ENGINE DESIGN
Types of Power Units fitted in Present Day Motor Cycles

TECHNOLOGY

67

Drawing demonstrating the four stages of operation of a four-stroke internal combustion engine, c.1928.

The 1956 BSA Catalina was developed with very large fins in its engine head to dissipate heat and increase power.

through the material of the head itself. Here, the thermal conductivity and strength at high temperature become key limiting factors.

When the air-cooled BSA ZB-series Gold Star engine appeared in 1949, the technology available for casting aluminium restricted the size of the cooling fins that transfer heat to the outside air, and hence limited the amount of power that could be produced by this engine. Improvements in casting technology over the next seven years resulted in the final 'DBD' form of this engine used in the 1956 BSA Catalina, which has a head with significantly deeper cooling fins than the 'ZB'. During this period, the technology issue facing BSA's engineers was not that of being able to generate more power, but that the inability to extract the additional heat from the engine would have caused components in the engine head to lose too much strength.

The past forty years have seen a slow transition from air-cooled engines to water-cooled. Actually, the latter are also air-cooled, but with the air cooling the water in a radiator which is then used to cool the engine. There are technical advantages to water cooling, such as better control over thermal expansion of the components allowing greater horsepower, but much of the push has been legislative. Increased control over internal tolerances results in reduced exhaust emissions, and the water jacket damps vibrations and thus reduces engine sounds. Although incorporating water cooling with the necessary radiator in aesthetically pleasing ways has been a challenge, nearly all new motorcycle designs have water-cooled engines.

What about electricity? An electric motor can almost noiselessly convert up to eighty-five per cent of the energy to mechanical power so, even with the power losses at a

BELOW: **Early 'ZB' engine heads (above) had significantly smaller cooling fins than the later 'DBD' form (below).**

OPPOSITE: **The 1956 BSA Catalina's large air filter box filtered out dust without restricting air flow through the carburettor.**

Fig. 437.—The Electromobile

—PLAN OF CHASSIS.

Plan of an early four-wheeled 'electromobile' showing the large area necessary for the battery, c.1902.

TECHNOLOGY

73

THE MOTORCYCLE

This c.1942 Socovel electric motorcycle was heavy and limited in range and speed due to the batteries available at the time.

generating station and over transmission lines, electric motors have a significant advantage over the twenty per cent efficiency of internal combustion engines. Because of this it shouldn't be surprising that, despite the overwhelming dominance of the internal combustion engine since the first commercially produced motorcycle in 1884, already 120 years ago electricity was seen as preferable to gasoline. As the first sentence in a chapter on electric motor vehicles in William Worby Beaumont's *Motor Vehicles and Motors* (1900) says: 'Given the electricity supply, nothing would be better than the electric motor for the propulsion of vehicles.'

Inventors pursued this idea from the start, resulting in machines such as the c.1942 Socovel and 1996 Peugeot Scoot'Elec, but the limitation throughout the twentieth century was always battery technology. The problem for use on a motorcycle is that the battery must be able to store energy comparable to that in a 15 litre (3.3 gallon) tank of fuel, within a volume and weight – and cost – that doesn't make it impractical or prohibitively expensive. However, after more than 200 years of steady progress since Alessandro Volta invented the storage battery, twenty-first-century-battery technology is finally reaching the point where electric motors are becoming a practical alternative to internal combustion engines in motorcycles. This is at a time when environmental concerns require non-hydrocarbon approaches to personal transportation.

New materials and fabrication technologies will continue to play major roles in the motorcycles of both industrialized and developing nations, in both cases helping provide people with the benefits of affordable personal transportation. In 1998 the eminent physicist Freeman Dyson noted: 'The technologies that raise the fewest ethical problems are those that work on a human scale, brightening the lives of individual people. For my father ninety years ago, technology was a motorcycle.' For a significant fraction of the world's population, these words will continue to apply into the twenty-first century.

4

THE MOTORCYCLE

DESIRE

Marianne Faithfull in her iconic leather suit in *The Girl On A Motorcycle*, 1968.

Where Clint Eastwood rode a horse into the Western sunset, and into popular culture, Steve McQueen rode a stolen German Army motorcycle. In an earlier era, Marlon Brando rode his Triumph into pop culture fame and it is an image that adorns a million T-shirts and posters. As a rebuttal to all this machismo, the impossibly hip and cool Marianne Faithfull unzipped her leather jacket at the beginning of the 1968 film *The Girl on a Motorcycle* – a moment that created a generation of Faithfull fans.

More recently, Tom Cruise fled fire, brimstone and the 'bad guys' in *Mission: Impossible 2* (2000) and *Mission: Impossible –Rogue Nation* (2015), making his getaways on a very fast motorcycle, performing extravagant stunts, wheelies and stoppies, en route to freedom. Over the last decade, in their series of genre-defining *Long Way* travel documentaries, we have seen Ewan McGregor and Charley Boorman, actor 'Lads' pointing their BMWs into the sunset and riding, apparently alone, around the world and back. Then they did it again, and again. Boys and girls everywhere, longing to emulate The Lads, swooned and followed along, if only in their imaginations.

DESIRE

Tom Cruise escapes his foes on a BMW S1000RR in *Mission: Impossible – Rogue Nation,* 2015.

Cary Grant and Audrey Hepburn cruise around Rome on an early Vespa in *Roman Holiday*, 1953.

Love, Sex, Speed, Danger, Death, Romance, Adventure, Escape, Freedom. Each of these pop-cultural motifs involves desire. And each has been applied to the motorcycle and those who ride it. It's a miracle that this bicycle with an engine, this mundane little machine, can breathe under the weight of all this baggage. And yet it does.

The machines themselves can be relatively innocent – think of the Vespa in *Roman Holiday*. But everything around and about motorcycles is food for mythology: the appeal of danger, the possibility of death. 'Death-defying' is one of those overused phrases that, when examined, seems ridiculous. Why would anyone want to put themselves in a position where defiance of death was even an option? But we love to watch it, we love to read about it, we love to imagine it. And we long to be with the person who did it.

And sometimes, the appeal of the outsider biker takes a dark, dangerous turn. The Hells Angels, a club of Harley-Davidson riders founded in California just after World War II, came to be seen as outlaws, and not just romantic ones. Involved in criminal activities and violence, the Hells Angels came to embrace, indeed, to personify, the very idea of bad boy bikers, and equally bad 'biker chicks'. White, grumpy, if not downright angry, undeniably outsiders, tending towards right-wing politics, the Hells Angels have never really tried to soften their image, even as their reach has now become polyglot and global. The Russian version, the Night Wolves, have come to symbolize the idea of the Strong Man, the autocratic, fascist, political loner. Perhaps not surprisingly, they are closely associated with Vladimir Putin, and apparently received significant funding from the Russian government. The 'outsider' motorcycle gang has become part of the establishment machine.

THE MOTORCYCLE

Hells Angels members near Bakersfield, California, 1965.

In Japan, the Bosozoku (literally 'the out-of-control tribe') evolved in the 1950s and 60s as a motorcycle gang interested in antisocial activities. Their lasting legacy, however, has centred around extravagantly customized motorcycles and riding gear, creating a proto-fashion movement that is hip, while borrowing the aesthetics and traditions of the Japanese military, especially World War II fighter pilots. The Bosozoku girls bypassed the gang mentality altogether, and went straight for fashion statements, both in their costumes and in their brilliantly painted bikes.

The high-fashion, seductive, erotic appeal of the motorcycle is clear. In her television series *Fleabag*, which depicts the aching loneliness of an adventurous young woman, Phoebe Waller-Bridge closes one episode astride her lover's motorcycle. As they ride away, Fleabag looks over her shoulder and gives a knowing look to the camera. We all know what happens next. Desire fulfilled, with a motorcycle as the mythological agent of fulfilment. Fleabag did not drive away to her erotic and romantic destiny in a Tesla …

Riding away to freedom is the enduring image of the motorcyclist, and it was made real in a memorable scene from *The Great Escape*, Steve McQueen's World War II epic of 1963. McQueen's character has escaped from a German POW camp, riding a stolen military motorcycle. It should have been a BMW, but it was actually a Triumph TR6, thinly disguised. Fleeing his captors, McQueen rides up to a barbed wire fence, his escape route apparently blocked. Undaunted, McQueen sizes up the fence, gives himself some room to accelerate, and jumps over it in a daring and, at that time, unimaginable leap of motorcycling brilliance. It is a pop-cultural moment frozen in time, and it secured McQueen's place as the coolest guy on the planet.

Straight from the factory in Meriden, Steve McQueen, cruises on his ISDT-equipped Triumph TR6SC, 1964.

DESIRE

Poster for *The Great Escape*, 1963. Steve McQueen's bike was a Triumph, dressed up as a German Army BMW.

Tom Cruise has often favoured motorcycles in his films, understanding their sex appeal. In *Top Gun*, Cruise rode a Kawasaki. Aboard a Triumph Speed Triple, Cruise emerges unscathed from a fireball in *Mission: Impossible 2* – the implication being that he could not have escaped in a car. Cruise does it again in the fifth installment *Mission: Impossible – Rogue Nation*, when his character gives epic chase to the villain, played by Rebecca Ferguson. Best of all, Tom Cruise carried out most of his own motorcycle stunts, with only the extreme acrobatics being done by his stunt double.

This pop-cultural legacy, played out across a hundred years, and in every medium from trashy novels to blockbuster movies, featuring society's sexiest characters imaginable, either real or invented, has secured the motorcycle's place as the principal agent of desire in our time.

There is, however, a darker side to desire unrelated to eroticism. It is the very real need to escape, to flee tyranny, violence and oppression. Unknowable is the number of souls who have made their escape from these forces on motorcycles, perhaps millions. The motorcycle is a relatively cheap, easily accessible and quick way to get from one place to another: from imminent danger to potential safety. As the wars go on and the walls go up, the urgent need to escape, the critical longing for freedom, the profound desire for personal safety and fulfilment, only grows with each new conflict. This is not the stuff of pulp fiction; it is very real, and the motorcycle is at its centre. Literal escape on a motorcycle, for entire families, is often the only option.

Our twenty-first century has barely emerged from its own teenage years, and still hasn't really formed its own identity. Hi-tech certainly. Social media and the smartphone dominant, to be sure. Global, yes, but with strong nationalist undercurrents that seek to restrict our identities, rather than expand them. And yet, the motorcycle still calls us with real feelings of desire, as the staggering numbers of new motorcycles manufactured today show. In India alone, twelve million motorcycles are sold every year. To put this astonishing number in perspective, this is twice the number of Harley-Davidsons made since the company was founded in 1903. China is not far behind, although it easily leads the field in the production of electric bikes.

The fracturing of community, and the isolation of the individual, had already begun in the era of social media and the internet. History tells us that, in moments of isolation, the desire for connection only grows stronger. The motorcycle, perhaps uniquely, serves as both an instrument of connection, as a hundred years of biker gangs has shown us, and a machine of escape. What is certain is that the motorcycle, as a symbol of desire, in its many forms, is with us for the long haul.

THE MOTORCYCLE

Tom Cruise rides his first-year Kawasaki Ninja GPZ900R in the 1986 hit *Top Gun*.

5

THE MOTORCYCLE

ART

French-American graphic designer Jöe Bridge (Jean Barrez) portrayed the Swiss Motosacoche flying on this classic 1929 poster. Flying was a recurring image in Art Deco art and design.

The twentieth century brought a flurry of scientific and technological innovation from the word go. In the first decade alone, Einstein formulated his theory of relativity, the Ford Model T was born and the Wright brothers flew. Diesel-powered ships and submarines were launched for the first time. The world was hungry for motion, for energy, for speed. Speed as a concept might have been as old as time, but the idea that human beings could travel at breakneck speeds without dying was an entirely twentieth-century notion.

At this point, motorcycles had substantial visibility. Major manufacturers were cropping up on both sides of the Atlantic – Royal Enfield, Triumph, Harley-Davidson, Indian – and demand for motorcycles in France had grown to the extent that there was already an industry developing. On a motorcycle, a rider could experience speed and danger in a way never before possible. The rider *became* the machine, leaning along with it at extreme angles, all while controlling its velocity. The experience was exhilarating. Revolutionary. It appealed to young, hip, in-the-know creative minds; among them serious artists, who saw those new machines in the skies and along the streets of urban centres as legitimate subject matter.

The result was Futurism, a movement whose very manifesto, articulated by poet FT Marinetti in 1909, embraced the speed, danger and excitement of the machine age: 'The world's splendour has been enriched by a new beauty: the beauty of speed … A roaring automobile … that seems to run on shrapnel, is more beautiful than the Victory of Samothrace [a celebrated sculpture of Nike, goddess of victory, now held in the Louvre, Paris].' The words Marinetti used tell us everything: the beauty of speed! Roaring!

Cars, trains, aeroplanes and motorcycles, symbols of modern progress, were the subject of work by Futurist artists such as Giacomo Balla, Umberto Boccioni, Ivo Pannaggi and Mario Sironi. Curved lines, fractured forms and prismatic colours showed a world that raced forward, aggressively and ecstatically. There was crossover between Futurist art and commercial advertising. Sometimes this merger was explicit, as when Futurist artist Fortunato Depero overpainted his ad design for Bianchi motorcycles to create the 1932 painting *Il Motociclista (Solido in velocità)*. Other times, advertisers simply appropriated the bold Futurist aesthetic. Promotions for the new, sexy and, ultimately, dangerous technology of cars and motorcycles were given a fine art sheen.

RIGHT: The abstract and colourful design on the tank of this 1928 Harley-Davidson 'Bobber' is in keeping with the flamboyant chopper art of mid-20th century.

BELOW: Production art direction was more conservative than 'street' art, but was still stylish and elegant, as in this 1928 Indian Model 401 tank.

96 THE MOTORCYCLE

Mid-century British graphic design was reserved and stoic, as seen in these classic English logos for Triumph (right) and Royal Enfield (below).

ART

97

Fortunato Depero, *Il Motociclista (Solido in velocità)*, 1928.

A decade after Depero's classic painting, the British Matchless poster is clearly influenced by the art and design styles of Europe.

French manufacturer Gnome et Rhône commissioned consistently beautiful graphic design, including this 'Three Swallows' poster of 1928.

This 1952 poster for the famous German Feldbergrennen captures the spirit of post-war German optimism.

The graphic representation of motorcycles as dynamic and exciting machines continued in the second half of the twentieth century. But there were shifts along the way. In the optimistic 1950s, with two world wars in the history books and a new prosperity fuelling an emergent middle class, graphic designers turned away from an aesthetic that conveyed speed and danger, towards safer, more socially acceptable imagery, pitched at the suburban user. In 1962, Honda launched its famous ad campaign, 'You meet the nicest people on a Honda'. The advertisements showed friendly looking people on their Honda motorcycles with their pets, shopping bags, surfboards and children. Hondas became extremely popular as Christmas presents in the United States, and Santa came to join the riders in the ads. This historic campaign changed how motorcycles were marketed at the time, particularly in the United States. It changed what motorcycles meant to buyers and signified to those around them. These niceties wouldn't last for ever, of course; in the decades to follow, motorcycle ads started being sexy again, to connote speed and danger.

Pop art took hold in the United States and United Kingdom at the same time as Americans were moving to the suburbs and driving consumerism with new-found wealth. These artists took the language of mass culture as raw material. Advertisements, images of celebrities, newspaper clippings, logos: all were ripe to appropriate for comment and critique. Vehicles were interesting subject matter for Pop artists for several reasons. First, vehicle manufacturers had long histories of branding. Branding centred around basic human desires: for sex, danger and rebellion, or – in that moment – for safety, comfort and commuting. Second, vehicles were mass-produced machines, symbols of the machine–industrial age that so fascinated Pop artists. 'Paintings are too hard,' Andy Warhol once said. 'The things I want to show are mechanical. Machines have less problems. I'd like to be a machine, wouldn't you?' As the Futurists anticipated, man and machine were merging.

In addition to illustrating cars, and literally hand-painting a BMW M1 racing car, Warhol depicted motorcycles. In one of his best-known works from the 1960s, *Marlon,* Warhol silk-screened actor Marlon Brando sitting broodily on his Triumph from the bad-biker movie *The Wild One* (1953). Later on in his career, in the 1980s, Warhol made a painting of an advertisement for Mineola, a motorcycle shipping company, and went on to incorporate that image into a painting of the Last Supper. In showing an iconic, sexy picture of an actor astride a motorcycle on one hand, and a motorcycle ad embedded in a hallowed religious icon on the other, Warhol showed us all the ways in which we continue to be obsessed with these otherwise everyday modes of personal transportation.

Fashion, too, caught on to the allure of the motorcycle, drawn to its associations with sex and danger like a moth to a light. In the photo of Brando that Warhol borrowed, the actor is wearing the black leather jacket that was, and remains, the iconic image of biker chic. Uniquely American, the black leather biker jacket had utilitarian beginnings: in the early part of the century, it was seen as a 'sports' jacket, used by pilots of open-cockpit aircraft for warmth and protection. Manufacturers such as Schott and Simmons Bilt adapted their lines of sports gear for the motorcyclist, and companies such as Harley-Davidson promoted them heavily.

For the next fifty years, couture fashion houses, including Yves Saint Laurent and Prada among others, took the Brando jacket and reimagined it for the beautiful young things of discos and catwalks. It wasn't just the jacket: *(cont. page 111)*

Honda's pitch to the nicest people in 1960s suburban America was perhaps the most influential advertisement of all.

YOU MEET THE NICEST PEOPLE ON A HONDA

Maybe it's the incredibly low price, $245 (plus a modest set-up charge). Or the fact it doesn't gulp gas. Just sips it — 200 miles to the gallon. Or the way the masterful 4-stroke 50cc OHV engine carries you along at 45 mph without a murmur.

Or it could be the ease of 3-speed transmission, automatic clutch and the extra safety of Honda's cam-type brakes on both wheels. The optional push-button starter makes you feel right at home, too.

But most likely it's the fun. Evidently nothing catches on like the fun of owning a Honda. You see so many around these days. And the nicest people riding them. Merry Christmas. For address of your nearest dealer or other information, write: Dept. AB, American Honda Motor Co., Inc., 100 West Alondra, Gardena, Calif.

HONDA — world's biggest seller!

ABOVE: Andy Warhol's *Marlon* (1966) took an iconic image of Marlon Brando from *The Wild One* (1953) and turned it into high art, an early case of pop culture appropriation.

OPPOSITE: The original film still from *The Wild One* (1953) shows Brando in his Schott 'One Star' leather jacket that would soon define cool motorcycle attire.

ART

Andy Warhol, *The Last Supper (the Big C)*, 1986. The work incorporates Warhol's own *Mineola Motorcycle* (page 108).

Andy Warhol,
Mineola Motorcycle,
1985–86.

An early Harley-Davidson racer dressed in leathers, c.1920.

THE MOTORCYCLE

British artist Grayson Perry created the Kenilworth AM1 for a performance art motorcycle trip across Europe in 2010.

leather pants, boots, the very look of the motorcyclist in leather defined sexy and cool. Motorcycle fashion took the spotlight as one of the defining trends of 2015. At Paris Fashion Week, models for AF Vandevorst strutted the runway wearing not only clothing inspired by motorcycle culture, but also motorcycle helmets that obscured their faces. They had all arrived at the show on motorcycles, too.

Now more than ever, fashion and contemporary art underscore that motorcycles don't only belong to white, straight, cisgender men: the appeal of bike culture has long been more expansive than it was made out to be. In the UK, Grayson Perry, a cross-dressing artist who won the Turner Prize in 2003, decked out a customized Harley-Davidson Knucklehead with kitschy pink hearts, lacy detailing and a shrine for his teddy bear. His creation recalled the customized glittery hot pink bikes of the Bosozoku 'girl gangs' who ride the streets of Japan. Perry's motorbike became widely known when he gifted the design to Queen Elizabeth II. In Australia, artist Patricia Piccinini produced fibreglass sculptures that depict motorcycles as embodied, living creatures: a contemporary reinterpretation of the image, initiated by the Futurists, of man and machine merging. And in Morocco, artist Hassan Hajjaj created brightly coloured photographs of the young women bikers who ride around Marrakesh. The images are often framed by pictures of commercial consumables such as soup and soft drink cans and his *'Kesh Angels* series clearly nods to Warhol's motifs of motorbikes and advertising.

These contemporary artists are just several of many who, like the Futurists and Pop artists before them, explore the image and idea of the motorcycle: its smooth curves and sleek lines, its growls and roars, its appeal to our deepest desires, its ability to race us towards the future. These have all become shared terrain in the popular imagination. And it all began with Futurism, with that groundbreaking declaration that speed was beauty.

THE MOTORCYCLE

Hassan Hajjaj, *'Kesh Angels*, 2010.

6

THE MOTORCYCLE

MOTORCYCLES

PERREAUX STEAM VELOCIPEDE

1871
France
Prototype
30 cc steam at 3.5 kg/cm² (50 psi)
1–2 hp
Louis-Guillaume Perreaux

OPPOSITE: The Perreaux in the stable yard of the Château de Sceaux, near Paris.

The frame of this steam-powered motorcycle is modelled on that of the Michaux bicycle and is thus commonly referred to as a Michaux-Perreaux. However, the design is so heavily modified that arguably it should be credited only to Louis-Guillaume Perreaux. Perreaux's earlier patents of 1868, 1869 and 1870 show other versions similar to this final machine. Although the frame has the same almost-vertical steering geometry as the Michaux bicycle, that form of steering had already been in use for five decades on a number of 'draisienne' hobby-horses, to which Pierre Michaux attached pedals in the 1860s to create the first 'boneshaker' bicycle. Rather than the solid, largely straight, diamond section, wrought iron backbone that is split to straddle the rear wheel, patented by Michaux in 1867, Perreaux used an S-shaped backbone of hollow tubing to create a lighter and stronger frame that gives additional clearance for the engine. Another of Perreaux's innovations is that he made the tension of the spokes adjustable by using threaded steel rather than the fixed wooden spokes of the Michaux. The result was a 1–2 hp motorcycle with iron 'tyres' to cope with the cobblestone streets of Paris while the rider sat just above a boiler pressurized to 3.5 kg/cm² (50 psi). CMF

CLEVELAND TRICYCLE

1898
USA
1898–1901
185 cc four-stroke single
1.5 hp
Designer unknown

RIGHT: The looping spring is an early attempt to add suspension to the front forks.

118 THE MOTORCYCLE

RIGHT: An air-cooled, de Dion-Bouton-style single-cylinder engine provided the power.

BELOW: A triangular petrol tank and a rectangular battery holder below the crossbar add to the tricycle's charm.

MOTORCYCLES

119

MINERVA WITH MILLS AND FULFORD FORECAR

1903
Belgium
1901–1914
239 cc side-valve single
2 hp
Société Anonyme Minerva

For more than one hundred years, motorcycle passengers have sat behind the rider on either the same long seat or on a separate 'pillion' seat. A second option – the sidecar – allows for carrying two and sometimes more. Although those two solutions might seem obvious now, that wasn't the case for manufacturers in the early 1900s facing the problem of where to place a passenger. As is evident with this model, Minerva hadn't quite figured out the best location for the engine either. A trailer was one possible solution for carrying a passenger, although it exposed them to engine fumes and whatever was thrown up by the tyres from the roads at the time, which often included droppings from horses. The Minerva shows another solution: placing the passenger in front of the rider in a forecar. This particular forecar was manufactured in the UK by the Mills and Fulford company, formed in 1899 to produce trailers, sidecars and carriages. While in a forecar, the passenger wasn't subjected to exhaust fumes and road debris, but it did place them in a vulnerable position where they partially obscured the rider's vision. Because of this, forecars, like the trailer, were only produced for a few years. CMF

ABOVE: **The leather Brooks-style saddle is still used in bicycles today.**

RIGHT: **Unusually, the engine is positioned below the frame down tube.**

MOTORCYCLES

121

SPENCER

1906
Australia
1903–1910
475 cc side-valve single
2 hp
David Spencer

This machine is one of only two known survivors of at least eight motorcycles that David Spencer is known to have made in and near Brisbane before 1910. It is one of very few examples of a motorcycle made almost entirely within Australia – more commonly, machines were assembled using parts sourced from a variety of overseas manufacturers. Spencer's engine is of a conventional side-valve layout, although it is of his own design rather than a copy of an existing engine. Interestingly, although it would have been easier to use proprietary components such as brakes, carburettor and various levers, he made most of these himself. Some aspects are rather rudimentary, but reflect the time in which they were made, such as the long lever under the handlebar that operates the brake. This has limited stopping power because it simply presses a block into the rim of the wheel, as is done on much lighter bicycles. Spencer was successful in various competitions while riding his own machines, and they were well regarded at the time. Indeed, Queensland Police Force requested fifty of them; however, apparently Spencer was not in a financial position to fulfil such a large order, and he declined the undertaking. CMF

ABOVE: Carburettor of Spencer's own design.

RIGHT: Hand-carved wooden moulds for the crankcase and cylinder parts.

OPPOSITE: A head-on view shows the bicycle design at the heart of the Spencer.

124 THE MOTORCYCLE

INDIAN SINGLE C'DORA

1908
USA
1903–1908
750 cc inlet-over-exhaust single
3.5 hp
Carl Oscar Hedstrom

In the early part of the twentieth century, the Globe of Death was a popular novelty act at circuses and carnivals consisting of a fully enclosed sphere of steel in which intrepid riders would defy gravity – and death – by riding loops in all directions. The curiously named C'Dora was one such rider, made all the more 'exotic' by virtue of being a woman. She rode her specially commissioned Indian single for eleven years and appeared before huge crowds including at the famous New York Hippodrome, where Houdini also performed. C'Dora was ahead of her time in other ways, too, and was reputed to be the first woman to appear in public wearing shorts. She was photographed for the April 1909 edition of the *Motorcycle News*, wearing above-the-knee shorts, white pumps and bare legs. The motorcycle itself is really a bicycle with a powerful 750 cc racing engine attached. It features shortened, curved pedal cranks to stop them from hitting the ground, and small wheels to make it more manoeuverable in the Globe. Very few of these stunt Indians were made and this is the only one known to have survived. UG

RIGHT: This Indian was custom-made for stunt rider C'Dora.

BELOW: In a strikingly modern design, the single-cylinder engine forms the seat tube of the frame.

MOTORCYCLES 127

HENDERSON FOUR

1912
USA
1911–1931
965 cc inlet-over-exhaust in-line four
7 hp
William Henderson

Founded in 1912, the Henderson Motorcycle Company went against the prevailing single-cylinder and V-twin engine types from the start. In a shrewd move, founders William and Tom Henderson instead produced a series of in-line four-cylinder designs that were the fastest two-wheeled machines of their time. Four-cylinder engines were more typical in cars, but the Henderson was not only fast and light, it was reliable, setting many long-distance and speed records. The long four-cylinder engine demanded a long frame, and the Henderson had a 165 cm (65 in) wheelbase, long even by the standards of the day. This allowed plenty of room for passengers, the only question being where to put this extra person. This variant of the Henderson has the passenger sitting in front of the rider. Such a tandem arrangement was shortlived, perhaps because the Hendersons realized that would-be passengers might themselves be shortlived should the machine be ridden off the road. This first-year Henderson may be the best, most original example of the marque in existence. UG

ABOVE: The tandem arrangement of the seats placed the passenger in front of the rider.

RIGHT: The valve rocker and spring are exposed to the elements as was then usual, even in aeroplane engines.

MOTORCYCLES 129

HARLEY-DAVIDSON 10F

1914
USA
1911–1921
988 cc inlet-over-exhaust 45° V-twin
8 hp
William S Harley

RIGHT: Jack Fletcher on the cover of the 1919 edition of *The Harley-Davidson Enthusiast* climbing Mount San Antonio.

OPPOSITE: The V-twin configuration remains the basic Harley-Davidson design.

130 THE MOTORCYCLE

WHITING

1914
Australia
1914
500 cc JAP side-valve V-twin
4 hp
Saville Whiting

The most unusual feature of this Whiting motorcycle is the suspension, which consists of semi-elliptical leaf springs at both ends. While not unheard of, rear suspension with leaf springs was unusual, and this machine extended the concept by using the same type of springs on the front end as well in order to deal with the poor condition of Australia's roads. Saville Whiting had designed his first spring frame in Melbourne using a Douglas engine for power, then, satisfied that his idea had promise, he made this second machine using a John A Prestwich (JAP) V-twin engine. He took his designs to England in 1914 in the hopes of interesting a manufacturer in producing them, but those prospects were dashed with the onset of World War I. However, while in England, he designed and fabricated a V4 engine that he brought back to Australia in 1920, along with the V-twin machine shown here, with plans to produce them commercially. Although he purchased a factory in Melbourne his plans never got any further. CMF

ABOVE: The Spring Frame was an important Whiting selling point in the days of unmade roads.

RIGHT: An acetylene-burning carbide lamp, widely used in the late 19th and early 20th centuries.

MOTORCYCLES

INDIAN 8-VALVE

1916
USA
1911–1918
1000 cc 8-valve 42° V-twin
20 hp
Carl Oscar Hedstrom

RIGHT: The distinctly low profile of a racer.

134 THE MOTORCYCLE

RIGHT: The short, open, exhaust pipes did little more than direct flames away from the rider's legs.

BELOW: A crankcase casting showing the Indian logo of the time.

MOTORCYCLES 135

ABC

1919
UK
1919–1921
398 cc OHV boxer twin
7 hp
Granville Bradshaw

RIGHT: A sight-glass and knob allowed the rider to control the oil flow to the engine.

OPPOSITE: The integrated gearbox with its car-style shifting pattern was highly unusual for the time.

136 THE MOTORCYCLE

INDIAN SCOUT SPECIAL

1920 (engine)
USA (engine); New Zealand (body)
Special, competition
750 cc OHV 42° V-twin
100 hp (estimated)
Burt Munro

Burt Munro was, by any measure, a remarkable man. With limited engineering training, but brilliant skill, Munro took a very basic Indian motorcycle, and over the course of many years and many high-speed attempts, developed it into a world-record beater. The bike was initially barely capable of a top speed of 96 kph (60 mph), but Munro continuously tuned the engine, making many of its parts by hand, and installed it in a streamlined chassis of his own design. He eventually set three world records at Bonneville Salt Flats, Utah with single-run speeds exceeding 320 kph (200 mph). Munro left nothing to chance, making every single component as light as possible; the engine was so delicate that it had to be stripped completely after every two or three runs. What is all the more remarkable about Munro is that he was a man of limited means, with no major sponsors; he reportedly arrived in the United States with a suitcase full of engine parts that he assembled in a friend's workshop. There are two remaining Munro Specials: one is on display at the Hayes family emporium in Invercargill, New Zealand. This is the machine on which Munro made his final Bonneville speed run in 1967, at the age of sixty-eight. UG

ABOVE: The streamliner fairing can be split in two which allows quick access to the frame and engine.

RIGHT: The intricately engineered valve train and engine parts drilled for lightness.

OPPOSITE: The Pierce family assisted Munro with parts, storage space and accommodation during his annual trips to the USA.

140 THE MOTORCYCLE

Assisted by
PIERCE
Indian
SAN GABRIEL, CALIF.

NER-A-CAR

1921
USA
1920–1926
255 cc two-stroke single
2.5 hp
Carl A Neracher

RIGHT: Graphic design for the Ner-a-Car, 1926.

OPPOSITE: The petrol tank positioned directly underneath the rider's saddle.

142 THE MOTORCYCLE

BMW R32

1924
Germany
1923–1926
494 cc side-valve boxer twin
8.5 hp
Max Friz

OPPOSITE: The R32's boxer engine design, with the cylinder heads taking advantage of the airflow.

A prominent manufacturer of aircraft during World War I, BMW had to scramble to stay in business following Germany's defeat. Against the backdrop of post-war Europe, which saw many people on the move, either fleeing poverty and oppression or seeking opportunity, BMW identified an opportunity to put its manufacturing capability and engineering expertise to use in producing a reliable motorcycle. The talented engineer and designer Max Friz was the man chosen to create the R32. The engine was a masterpiece: an air-cooled, horizontally opposed, 494 cc engine with a three-speed gearbox, delivering power through a shaft drive. Light and powerful, and sitting transversely in the frame so that the cylinders would be cooled in the flowing air, it might have been lifted from the front of an aeroplane. It became the basis for BMW's motorcycle engines for the next hundred years. Friz was alive to the design world around him, including the Bauhaus, founded four years earlier in 1919, and the frame of the R32 reflects the era's design thinking. Symmetry, line, form and balance come together in a play between the triangular frame and the circular wheels and mudguards, finished with a pinstripe and the unmistakable BMW roundel on the tank. UG

MOTORCYCLES

MOTO GUZZI TIPO NORMALE

1924
Italy
1921–1924
498 cc inlet-over-exhaust single
7 hp
Carlo Guzzi

RIGHT: The magneto with elegant cast-in branding.

ABOVE: The horizontal engine squeezed between the frame tubes.

RIGHT: A tool box placed, in easy reach, atop the frame.

INDIAN HILLCLIMBER

1926
USA
1922–1938
737 cc OHV 42° V-twin
45 hp
Indian Motocycle Company

OPPOSITE: The rudimentary V-twin engine nevertheless provided abundant and reliable power.

PEUGEOT P104

1926
France
1926–1928
348 cc OHV single
4 hp
Motorcycles Peugeot

RIGHT: Copper plumbing feeds the carburettor.

OPPOSITE: The tachometer (left) and speedometer (right).

150 THE MOTORCYCLE

HARLEY-DAVIDSON FHA

1927
USA
1916–1927
1000 cc 8-valve 45° V-twin
45 hp
Harley-Davidson Motor Company

Harley-Davidson 8-valve racing motorcycles have acquired almost mythical status, partly due to their rarity, and partly due to their phenomenal performances in the early part of the twentieth century. Their hemi-head 8-valve engines were powerful, reliable and very fast. With their racing success in the United States, it was inevitable that racers overseas would want these engines, and they were exported to Europe, New Zealand and Australia. One such 8-valve machine was raced by the great motorcycle and car champion Freddie Dixon, who is also believed to have invented the banking sidecar system, where the sidecar leans in the same direction as the motorcycle. This glorious, unrestored example of a Harley-Davidson 8-valve racer, named 27FHA81 after its engine number, features that same banking sidecar. It was imported into Melbourne in 1932, and raced with great success by Rothie and Digger Smith and their brother-in-law Robert Bennell all sharing rider and passenger duties. It was retired as a still-running, complete machine, rare for a bike of such historic importance. UG

ABOVE: The hemi-head 8-valve engine and battered tank.

RIGHT: The banking sidecar placed the passenger precariously close to the wheels.

MOTORCYCLES

HARLEY-DAVIDSON JDH SPECIAL

1928
USA
1928–1929
1200 cc inlet-over-exhaust 45° V-twin
29 hp
Harley-Davidson Motor Company

RIGHT: With no rear suspension, the seat had to be comfortable.

ABOVE: Cutaways in the tank make room for the rockers and valves.

RIGHT: A Corbin speedometer, manufactured by the Corbin Screw Corporation, Connecticut.

MOTORCYCLES 155

HARLEY-DAVIDSON MODEL SA PEASHOOTER

1928
USA
1928–1934
350 cc OHV single
25 hp
Harley-Davidson Motor Company

RIGHT: Wide handlebars are a classic US design.

156 THE MOTORCYCLE

ABOVE: A hand-operated pump feeds oil to the engine.

RIGHT: Twin stub exhaust pipes.

MOTORCYCLES

SCOTT FLYING SQUIRREL

1928
UK
1926–1951
596 cc two-stroke twin
25 hp
Alfred Angas Scott; Harry Shackleton

RIGHT: The springer forks were high performance suspension for the time.

RIGHT: A liquid-cooled two-stroke twin was a radical concept for motorcycles of the early 20th century.

BELOW: The company was named after founder and prolific designer Alfred Angas Scott.

MOTORCYCLES 159

INDIAN MODEL 401

1928
USA
1927–1942
1265 cc inlet-over-exhaust in-line four
30 hp
Arthur Lemmon

RIGHT: The in-line four-cylinder engine was unusual for a motorcycle.

160 THE MOTORCYCLE

NORTON CS1

1929
UK
1927–1939
500 cc OHV single
25 hp
Walter Moore

RIGHT: The overhead camshaft, with Norton cast into the cover, gave the CS1 its name.

MOTORCYCLES

DOUGLAS DT/5 SPEEDWAY

1929
UK
1929–1932
494 cc OHV boxer twin
38 hp
Cyril Pullin; Freddie Dixon

This motorcycle owes its existence to the sport of speedway racing, which was given to the world by Australia. The first speedway race as we know the sport today, run on relatively short cinder-covered tracks, took place at the showground of West Maitland, New South Wales, in December 1923. Within four years, speedway racing had spread to tracks across the country and it became an international sport when the first overseas race was held in the UK in February 1928. With its fore–aft cylinders giving it the lowest possible centre of gravity, and its long wheelbase, the Douglas turned out to be ideal for this new form of racing during the initial years in Australia. The factory had achieved success in other forms of racing during the 1920s and it was quick to capitalize on its speedway successes by introducing the first Douglas dirt track model just five months after the sport came to the UK. The next year, 1,300 of these models were sold. CMF

OPEL MOTOCLUB NEANDER

1929
Germany
1929–1930
Side-valve V-twin
25 hp
Ernst Neumann

RIGHT: design detail showing Ernst Neumann's attention to shape and form.

OPPOSITE: Detail of the pressed fork legs and curved frame member.

MAJESTIC

1930
France
1930–1933
350 cc OHV single
11 hp
Georges Roy

RIGHT: Instrument plate with clock, speedometer and cast-in Art Deco logo.

OPPOSITE: Unusual hub-centre steering.

DRESCH MONOBLOC

1931
France
1930–1938
500 cc side-valve in-line twin
14 hp
Usines Dresch

RIGHT: Perfect French graphic design and a tiny adjusting knob for the suspension.

168 THE MOTORCYCLE

HARLEY-DAVIDSON DAH

1933
USA
1929–1933
737 cc OHV 45° V-twin
40 hp
Harley-Davidson Motor Company

RIGHT: The straight-through exhaust pipe is designed for speed.

MOTORCYCLES

169

CROCKER SPEEDWAY

1934
USA
1932–1936
500 cc OHV single
40 hp
Albert G Crocker; Paul A Bigsby

MOTORCYCLES

BROUGH SUPERIOR 11-50

1935
UK
1933–1941
1096 cc side-valve 60° V-twin
32 hp
George Brough

George Brough produced his first Brough Superior in late 1920, immodestly named to distinguish it from his father's company that produced Brough motorcycles. And, superior it was, as the first luxury motorcycle to be introduced after World War I, with such features as a John A Prestwich (JAP) engine with several modifications to Brough's specifications and a saddle tank that straddled the frame when the competition was still using flat tanks that were sandwiched between the frame rails. A number of famous people rode Brough Superiors, perhaps most notably TE Lawrence, Lawrence of Arabia, who owned seven of these machines between 1922 and his death on one in 1935. In the early years of the Great Depression, Brough designed the Model 11-50 specifically with the overseas police market in mind and priced it without the lighting, speedometer and horn that were standard on his other machines. Although it had an 1096 cc engine, the name was a marketing ploy, not to indicate engine capacity, but based on the then-current convention of listing both the nominal horsepower, calculated from an old formula based on the bore and stroke, and the actual horsepower. Hence, 11-50 would imply this model had 50 hp, whereas it actually had 32 hp. CMF

ABOVE: Perfect fit and finish of all components was a hallmark of the Brough Superior.

RIGHT: The long chrome tank is another signature feature.

MOTORCYCLES 173

KOEHLER-ESCOFFIER MOTOBALL SPECIAL

1936
France
Production on demand
350 cc OHV single
9 hp
Koehler-Escoffier

RIGHT: Custom-built for the sport of Motoball, popular in Britain and France in the 1930s, the number 3 here identifies the rider.

BELOW: Luxury touches include leather-wrapped cables.

MOTORCYCLES

175

CROCKER

1938
USA
1936–1942
1016 cc OHV 45° V-twin
51 hp
Albert G Crocker; Paul A Bigsby

Crocker is a motorcycle that has become a machine of almost mythical status. The first Crocker was built in 1936; the last in 1942. In that time, Crocker built just over seventy bikes, making them among the most sought-after, and expensive, motorcycles in the world. A shortage of materials during World War II ended production of these luxury machines. Crocker combined his speedway racing experience and refinements offered by engineer (and fellow racer) Paul A Bigsby to produce a machine that would become the greatest American V-twin ever made. Crockers were a riders' motorcycle: powerful, comfortable and easy to ride. It was said that if anyone actually rode a Crocker, they would never ride anything else. According to Crocker expert and collector Don Whalen, it was Bigsby's brilliant engineering that meant Crockers were 'so far ahead of their time, it's beyond measure'. This particular model is no.31, and was built for California veterinarian and author Dr Harry Sucher. Sucher wrote widely about American motorcycles, and was a noted authority on Crocker motorcycles. UG

RIGHT: Engine details including the cast carburettor cover show engineer Paul Bigsby's influence on the design.

BELOW: California-cool is apparent in the Crocker's graphic style.

MOTORCYCLES

TRIUMPH SPEED TWIN

1938
UK
1938–1940; 1947–1957
498 cc OHV vertical twin
23 hp
Edward Turner

In a 'parallel twin' engine, the two pistons rise and fall in unison, but because a 'four-stroke' internal combustion engine requires two complete rotations of the crankshaft for intake, compression, ignition and exhaust, the spark ignites the mixture of one cylinder near the top of the first rotation and the other cylinder on the second rotation. A vertical twin engine supplies power on every rotation, so the delivery of power is smoother than that from a single cylinder engine, which only supplies power every second rotation. Since this engine configuration has certain advantages, it had been used as early as the Hildebrand und Wolfmüller of 1894; Triumph itself already had a parallel twin in the 1930s, in the form of the 650 cc Model 6/1 designed by Valentine Page in 1933. However, parallel twin machines did not have notable success in the market until Edward Turner's inspired design of the Triumph Speed Twin in 1938. Turner's engine design for the Speed Twin started life at 498 cc, then grew in steps to 650 cc in the 1950s and eventually to 750 cc in the 1970s. However, it was Turner's flair for style that first caught the customer's eye, as can be seen in this Speed Twin. CMF

RIGHT: A Triumph advertisement, 1931.

BELOW: The triangular Triumph timing cover is a recurrent and distinctive design.

MOTORCYCLES

BMW R12

1939
Germany
1935–1942
745 cc side-valve boxer twin
20 hp
Bayerische Motoren Werke

RIGHT: Finned cylinder-head detail on the flathead engine.

OPPOSITE: The famous BMW roundel stands out on the characteristic triangular frame detail.

INDIAN CHIEF WITH SIDECAR

1940
USA
1922–1953
1210 cc side-valve 42° V-twin
8.5 hp
Charles B Franklin

OPPOSITE: Classic Indian styling with the deep enclosure of the rear mudguard and body.

ABOVE: The Indian Chief was built for comfort and the open road.

BELOW: Seen from behind the whole outfit is as wide as a car.

OPPOSITE: The large-capacity Indian engine is somewhat shoehorned into the frame.

184 THE MOTORCYCLE

SOCOVEL ELECTRIC

c.1942
Belgium
1936–1948
Electric motor with 1.6 kWh battery
0.9 kW (1 hp)
Maurice de Limelette

An 1870 French patent by Louis-Guillaume Perreaux for an electric-powered bicycle shows that interest in electric motorcycles has been with us since even before the first self-propelled motorcycle was built. However, a century and a half later, battery technology remains the obstacle to widespread adoption of this clean form of personal transportation. Nevertheless, starting early in the twentieth century, various people experimented with electric motorcycles, with the first mass-produced machine created in Belgium by Maurice and Albert de Limelette. Despite tests at the time that found a range of only around 40 km (25 miles) at a top speed of 32 kph (20 mph), by 1936 the brothers had sold an estimated 1,000 of their machines; even though batteries weighed 90 kg (200 lb), resulting in an overall weight of 200 kg (440 lb). Socovel continued producing these machines during the German occupation when petrol was rationed to civilians, but demand disappeared once the war ended and riders were no longer willing to accept the short range and low speed necessitated by the batteries of the time. CMF

HARLEY-DAVIDSON FL

1943
USA
1941–1947
1213 cc OHV 45° V-twin
45 hp
Harley-Davidson Motor Company

RIGHT: Classic Harley-Davidson cockpit with a tank-mounted gear knob on the left.

OPPOSITE: The two muscular rocker boxes, just below the tank, give the Knucklehead its nickname.

HARLEY-DAVIDSON

MOTO GUZZI
SUPER ALCE

1948
Italy
1946–1957
498 cc OHV single
18.5 hp
Moto Guzzi

IMME R100

1949
West Germany
1948–1951
99 cc two-stroke single
4.5 hp
Norbert Riedel

Amid conditions where access to raw materials was severely limited and industrial output near zero, the motorcycle produced by Norbert Riedel is quite remarkable. Motorcycles share with aircraft the need to be as light as possible, so there is a distinct advantage if one component can be designed to do the task of two. While conventional motorcycles separate the tasks of providing suspension and exhausting fumes from the engine, Riedel recognized that if he made the exhaust pipe of thicker metal than usual, he could make it do double duty as an element of suspension as well. In this way it performed both tasks while using less total metal than separate components would, something that was of critical importance in resource-starved post-war Germany. Similarly, using a single-sided front fork required heavier metal for the one side, but it still used less metal than two sides of a conventional fork. It's possible his design was inspired by the single-sided landing gear used by aircraft in the just-ended war. CMF

OPPOSITE: The single-sided front suspension is typical of the many design innovations on the Imme.

HUCK FYNN JAP SPEEDWAY

c.1949–1950
UK
Special, competition
500 cc JAP OHV single
45 hp
Huck Fynn

RIGHT: Both light and extremely powerful, the JAP engine was highly specialized for speedway racing.

BELOW: Comfort was an afterthought for speedway motorcycles.

MOTORCYCLES 195

MV AGUSTA 125 TEL TURISMO

1949
Italy
1949–1953
124 cc two-stroke single
5 hp
Meccanica Verghera

RIGHT: The MV has both a rear shock absorber and an unusual damper mechanism.

ABOVE: Striking MV Agusta logo and tank.

RIGHT: Girder fork suspension worked reasonably well and was inexpensive to produce.

MOTORCYCLES

VINCENT BLACK LIGHTNING

1951
UK
1948–1953
998 cc 50° V-twin
70 hp
Phil Vincent; Phil Irving

The Vincent Black Lightning had as its origin the 1936 Vincent Rapide, a V-twin designed by Englishman Phil Vincent and Australian Phil Irving based heavily on components from the company's 500 cc single-cylinder engine. They improved upon their design of both the engine and frame with the post-World War II Rapide in 1946, which at the time it was introduced was the world's fastest production motorcycle. The innovative design has the engine 'hang' from a stiff backbone rather than surrounded by tubes, improving the handling by allowing the motorcycle to be several inches shorter than if it had a conventional frame. The Rapide was soon followed by a tuned version, the famous Black Shadow, in 1948. That same year Rollie Free set the USA speed record at Bonneville Salt Flats, Utah at 241.85 kph (150.31 mph) on a specially tuned Vincent V-twin, resulting in the Vincent Black Lightning model, of which only about thirty were made in total Subsequently, Black Lightnings set national speed records in Ireland, New Zealand and South Africa, as well as in Australia; in 1953 this particular machine was used by Jack Ehret to set the Australian speed record at 227.7 kph (141.5 mph) on a short stretch of road near Gunnedah in New South Wales. CMF

ABOVE: The V-twin engine is intimidatingly large and powerful.

RIGHT: Detail commemorating Jack Ehret's Australian land speed record set on this machine in 1953.

GNOME ET RHÔNE LC531

1954
France
1954
175 cc two-stroke single
12 hp
Motos Gnome-Rhône

MOTORCYCLES

PUCH SGS

1955
Austria
1953–1969
248 cc two-stroke split twin
16.5 hp
Steyr-Daimler-Puch

OPPOSITE: In its pressed steel frame construction and split single engine, the Puch was ahead of its time.

TILBROOK PROTOTYPE

1956
Australia
1947–1956
197 cc two-stroke Villiers single
8 hp
Rex Tilbrook

RIGHT: Tilbrook used proprietary two-stroke Villiers engines made in England.

ABOVE: Tilbrook had an excellent design sense, seen here in this graphic logo. and the one-piece tank and seat.

RIGHT: The speedometer optimistically goes to 80 mph whereas 50 mph might have been more realistic.

MOTORCYCLES 205

AERMACCHI CHIMERA

1957
Italy
1956–1964
178 cc OHV single
13 hp
Alfredo Bianchi

OPPOSITE: The Chimera's bodywork was styled after a jet aircraft.

With sleek, jet-age styling and brilliant engineering, the Italian Aermacchi Chimera seemed to be a perfect motorcycle for its mid-century moment. Instead, it flopped – its failure a near-disaster for Aermacchi. Originating from a now-famous conversation between its designer Alfredo Bianchi and noted car designer Mario Revelli, the Chimera is a sleek combination of technical brilliance and clever body in cast aluminium and pressed steel. Underneath the bodywork is a frame with a monoshock rear suspension and a light and powerful horizontal OHV engine. The cast-alloy duct enclosing the engine resembles the intake of a jet engine, and has a similar function: to draw cold air in and around the single cylinder. The new Chimera earned rave reviews at the Milan Motorcycle Show, but customers simply didn't get it. Expensive to produce, the Aermacchi was a sales disaster, the losses threatening the entire Aermacchi business. Bianchi immediately got to work, making his design look more like a motorcycle. Out went the stylized bodywork and the rear monoshock, in favour of traditional rear suspension. It did the trick, and the 1957 Ala d'Oro (Gold Wing) was an instant success. It took more than forty years for Bianchi's dream to be recognized for the classic it is. UG

HARLEY-DAVIDSON SPORTSTER XL

1958
USA
1957–1985
838 cc OHV 45° V-twin
40 hp
Harley-Davidson Motor Company

By the early 1950s, Harley-Davidson was the only remaining motorcycle company in the United States and, as in other periods of its history, it was extremely slow to keep up with the zeitgeist. In Europe, engineering research and development, not to mention modern styling, were propelling designers in new and exciting directions. European motorcycles were sexy, fast and nimble; Harley-Davidsons were none of those things. That changed in 1957 with the Sportster. Its engine was the soon-to-be iconic Ironhead, with an enclosed overhead valve cylinder head replacing the ageing side-valve, flathead engine. With this technical advance, Harleys gained a much-needed increase in power. It was a leap forward in styling, too. Admittedly, the Sportster owes some of its styling to pre-war motorcycle icons, especially the Crocker, but on its own, the Sportster sings 'Fifties USA' like no other – the young Elvis Presley rode a Sportster. To some aficionados, the Sportster represents a high-water mark in Harley-Davidson design and there is no question that it captures the optimistic, can-do spirit of 1950s America better than any other. UG

VESPA 150GS

1960
Italy
1946– present
146 cc two-stroke single
7.8 hp
Corradino d'Ascanio

The immediate aftermath of World War II in northern Italy looked desolate: industry was all but destroyed, poverty was rife and jobs were extremely scarce. Additionally the roads were in terrible condition. Enrico Piaggio saw a need for affordable transportation that could handle rough terrain. He commissioned aeronautical designer Corradino d'Ascanio to design a simple, cheap motorcycle that could be ridden safely and would afford some protection from the elements. D'Ascanio hated the assignment but he took it on and scoured the aeronautical factory for parts that might come in useful: a tail-wheel from an aeroplane, small and tough, seemed a good place to start. A trailing link suspension unit, from the same aeroplane tail-wheel, formed a suspension unit. Aircraft cowlings would enclose the engine, which was directly attached to the rear wheel, avoiding the need for a chain and further keeping oil, mud and grime from the rider's clothes. When d'Ascanio showed his prototype to Piaggio, Enrico exclaimed, *Sembra una vespa!* (It looks like a wasp!) – the name stuck. Introduced in 1955, the 150GS with a 146 cc engine and improved suspension was a significant upgrade on the basic design; Vespas are still among the best-loved scooters in the world. UG

OPPOSITE: **Aesthetic and functional bodywork: the left side provides a spacious storage compartment and the right side covers the engine.**

RIGHT: **The Vespa body provided room for a spare wheel.**

BELOW: **Veglia speedometer incorporating the Piaggio logo.**

HONDA C102 SUPER CUB

1960
Japan
1958–1967
50 cc OHV four-stroke single
4.5 hp
Honda Motor Company

OPPOSITE: Like the Vespa, the Super Cub used leg shields in its landmark design.

This diminutive machine, half-scooter, half-motorcycle, as easy to ride as a bicycle, reliable, clean, stylish and modern, was Soichiro Honda's entry into the international arena of automotive production. In a world that looked sceptically, if not with hostility, on motorcycles generally, Honda knew that he had to win over mums and teenagers if his Honda Fifty were to succeed. At the heart of his design was a remarkable 50 cc overhead valve (OHV) four-stroke engine that was light, quiet, powerful and virtually unbreakable. With such a small engine, and with electrics that worked every time, it was simple to kickstart. Honda enclosed the engine, all the hoses, wires and the rear chain, so that no oil could migrate on to the rider's clothes, a bane of traditional motorcycles. Borrowing from Vespa, a plastic fairing kept the rider's legs clean and dry. The red-and-cream bodywork and the step-through frame looked appealing, innocent and non-threatening, exactly the aesthetic that would appeal to non-motorcyclists. Its marketing slogan 'You Meet the Nicest People on a Honda' has become a case study in how to sell an idea and a machine. Still in production, more than 100 million have been manufactured, making the Honda Super Cub the best-selling motor vehicle of all time. UG

TRIUMPH BONNEVILLE

1961
UK
1959–1983
649 cc OHV vertical twin
40 hp
Edward Turner

RIGHT: The Triumph logo's 'T' represents a piston.

OPPOSITE: A bag could be strapped to the grille on top of the tank.

BSA GOLD STAR CATALINA

1963
UK
1956–1963
499 cc OHV single
40 hp
Valentine Page

Many features in the Catalina's engine can be traced back to 1920, and through engines from John A Prestwich (JAP) and Ariel, where Valentine Page worked as chief designer before designing the original Gold Star for BSA. In 1937, Walter Handley received a gold star for lapping the Brooklands race circuit at more than 160 kph (100 mph) on a 500 cc BSA Empire Star designed by Page. The next year, BSA introduced a modified version whose engine had an aluminium alloy head and cylinder in a rigid frame. The first post-World War II Gold Star appeared in 1948 in rigid and plunger frames, with a swinging arm frame added in 1953. Each engine was individually tested on a dynamometer and only released when it met the minimum horsepower specification. Thanks to a range of options and tuning parts from the factory and from after-market suppliers, Gold Stars enjoyed success for more than a decade in both on-road and off-road competition. Because of the importance of the export market, the USA-only Catalina model was introduced in 1956, named after a famous off-road race on Catalina island off the coast of southern California. The machine here is one of the last Gold Stars ever made. CMF

RIGHT: The swept-back exhaust pipe and megaphone were used on late-model Catalinas.

BELOW: Tachometer only; a speedometer is unnecessary in a racing machine.

MOTORCYCLES

219

HUSQVARNA 250

1967
Sweden
1968–1971
Two-stroke single
24 hp
Husqvarna Vapenfabrik

RIGHT: The two-stroke engine outclassed its rivals which were mainly heavy four-strokes.

220 THE MOTORCYCLE

BSA ROCKET 3

1969
UK
1969–1972
741 cc OHV in-line triple
50 hp
BSA Motorcycles; Ogle Design

RIGHT: Valiant British styling and a three-cylinder engine could not save BSA from a wave of superior Japanese machines.

VELOCETTE SPORTSMAN

1969
UK
1969–70
500 cc OHV single
39 hp
Veloce

KAWASAKI MACH III

1969
Japan
1969–1975
500 cc wo-stroke in-line triple
60 hp
Kawasaki Motor Corporation

RIGHT: Electronic ignition quickly became the new standard for sporting Japanese motorcycles.

RIGHT: Kawasaki Mach III sales brochure, c.1973.

BELOW: Mach III implied rocket-like performance, and the Kawasaki delivered.

BULTACO SHERPA T

1971
Spain
1964–1981
326 cc two-stroke single
19.8 hp
Bultaco; Sammy Miller

In the 1950s and early 60s, the rather eccentric sport of motorcycle trials was dominated by one man, Sammy Miller, who was virtually unbeatable on his 500 cc Ariel. Trials is a sport of supreme control, where the rider negotiates a short but very difficult 'section' of rough terrain and is marked on how well they do this. Miller, as well as being a brilliant rider, was also a master development engineer and the work he did to improve his heavy, four-stroke single caught the attention of Francesc 'Paco' Bultó, the founder of motorcycle company Bultaco. In 1963, Bultó invited Miller to Barcelona to work on a new lightweight trials bike. In development, Miller would ride difficult sections first on his Ariel, then on the Bultaco. Over a period of weeks, Miller, Bultó and his mechanics would make whatever changes were necessary to enable him to replicate on the new bike, what he could do on his Ariel. Eventually the Bultaco outclassed the Ariel in every way, and that was that: trials and the world of off-road motorcycle sport were changed for ever. UG

OPPOSITE: A large-finned cylinder head gave the Sherpa T superior cooling.

BULTACO

HONDA
CB750

1972
Japan
1969–1978
750 cc OHC in-line four
67 hp
Honda Motor Company

When Honda introduced its CB750 four-cylinder motorcycle in 1969, it immediately outclassed its British, German and Italian competitors. The CB750 was the first production four-cylinder motorcycle on the market. It had a disc brake as standard, a reliable electric starter and an in-line, overhead cam (OHC) four-cylinder engine that looked great, sounded even better and went very, very fast. By comparison, BSA and Triumph were still struggling to make reliable three-cylinder machines and Norton was sticking with a twin, the Commando. Some of the credit for the CB750 goes to Honda's US dealers, who were clamouring for something to compete with those lumpen and unreliable British bikes and the retro offerings from Harley-Davidson. Drawing on its racing success in the 1960s, Honda took its reliable and race-winning engine and applied it to the CB750 – assured of a 500 cc four-cylinder engine around which it could build a luxurious and fast road machine. It is said that the arrival of the Honda CB750 marked the demise of the British motorcycle industry. What is certain is that the CB750 changed the world of large high-powered sportbike designs forever after. UG

MV AGUSTA 750S

1972
Italy
1971–1977
750 cc DOHC in-line four
69 hp
Meccanica Verghera

RIGHT: The distinctive DOHC cylinder head evokes the MV's racing heritage.

OPPOSITE: The *disco volante* (flying saucer) tank and finned sump create an Italian industrial design look.

HONDA ELSINORE

1973
Japan
1973–2007
249 cc two-stroke single
48 hp
Honda Motor Company

RIGHT: The Elsinore shone in competition, setting new standards in 250 cc motocross.

NORTON COMMANDO

1973
UK
1967–1978
828 cc OHV vertical twin
58 hp
Bert Hopwood; Dr Stefan Bauer;
Bernard Hooper; Bob Trigg; Charles Udall

RIGHT: The Commando engine is fixed in rubber, 'isolastic' mounts, which damp the big four-stroke twin.

MOTORCYCLES

TRIUMPH X-75 HURRICANE

1973
USA
1972–1973
741 cc OHV in-line triple
58 hp
Triumph Engineering; Craig Vetter

The Triumph Hurricane was introduced as a factory custom at a time when that was a new concept. Further, it was designed by an American for the American market. Although it was eventually badged as a Triumph when it went on sale, it was created as a styling exercise for BSA, who commissioned Craig Vetter, based on several motorcycles he had previously modified. BSA asked the young industrial designer to turn its British-designed Rocket III into a machine that looked fast and looked American. Vetter was given a Rocket III bike at BSA's New Jersey headquarters in June 1969, rode it back to his studio in Illinois, and by September had completed its transformation. In creating his design he examined every detail and even specified modifying the head of the engine with larger fins despite that requiring an expensive new casting. The factory complied, although only 1,171 of these machines would be produced, starting in 1972. By that time the overall BSA corporation was bankrupt and no longer trading in the United States, so the machines were rebadged as Triumphs, another marque owned by the same company. CMF

RIGHT: The three-cylinder Triumph engine was good for its day, but not good enough.

BELOW: The triple exhausts contribute to the spage-age feel of the design.

MOTORCYCLES 235

HARLEY-DAVIDSON KNUCKLEHEAD CHOPPER

c.1973 (engine: 1941)
USA
Custom
1213 cc OHV 45° V-twin
45 hp
Designer unknown

MOTORCYCLES

DUCATI 750SS

1974
Italy
1973–1974
748 cc desmodromic OHC 90° V-twin
65 hp
Fabio Taglioni

By the end of the 1960s, Ducati's owners were looking for a way to revive their fortunes, and they tasked engineer Fabio Taglioni to begin work on a V-twin. The Ducati 750 Super Sport was a motorcycle of astonishing speed and immense technical bravura, featuring a desmodromic valve operation that is still a feature of Ducati engines. The bike was so good that it won its first race, the Imola 200, in April 1972, beating the best of the world's factory machines. The firm brought out a road-going version of the race bike, the 750 Super Sport, in 1973. Its *eau de Nil* frame and silver fibreglass tank set it apart from the big, sporty motorcycles of the time. With a half-fairing, a minimal, tubular frame and a low-slung engine, the 750SS looked and felt long, low and light. The 90° V-twin engine was another Taglioni miracle: he squeezed his heavy, powerful engine into a light frame, another indication that the word engineer does not quite do justice to Taglioni's genius as a designer. The racing success of the Imola Ducatis was enough to ensure Ducati's future, with a range of fast, light, beautiful desmodromic V-twin sportbikes that continues to this day. UG

ABOVE: The round cases and desmo heads of the 750SS engine are hallmarks of design engineer Fabio Taglioni.

RIGHT: Requiring a long reach in its rider the 750SS looks fast even at a stand-still.

MOTORCYCLES

HARLEY-DAVIDSON XLCR

1977
USA
1977
997 cc OHV 45° V-twin
61 hp
Willie G Davidson

RIGHT: Willie G Davidson brought a Euro-style café-racing flourish to the XLCR.

HARLEY-DAVIDSON XR750

1977
USA
1972– present
748 cc OHV 45° V-twin
82 hp
Dick O'Brien; Pieter Zylstra

RIGHT: The high-powered V-twin engine set many records in American flat-track races.

LAVERDA JOTA

1981
Italy
1976–1982
981 cc OHC in-line three cylinder
90 hp
Moto Laverda

RIGHT: **A Laverda** advertisement conveys a sense of speed without showing the motorcycle itself.

OPPOSITE: **Reaching** speeds of over 160 kph (100 mph), the engine powered the fastest production motorcycle of the time.

KAWASAKI NINJA

1984
Japan
1984–90
908 cc DOHC 4-valve in-line four
113 hp
Kawasaki Heavy Industries Motorcycle & Engine Company

DUCATI 851 KIT

1988
Italy
1987–1992
851 cc desmodromic OHC 4-valve 90° V-twin
93 hp
Fabio Taglioni; Massimo Bordi

RIGHT: Built for World Superbike, the 851 Kit won the championship in 1990.

SUZUKI GSX1100 KATANA

1990
Japan
1981–1985; 1990–2001
112 cc DOHC in-line four
111 hp
Hans Muth

With the arrival of the Honda CB750 in 1969, the business of large-capacity motorcycles was changed for ever. All the Japanese manufacturers followed suit, until it was almost impossible to distinguish one Japanese four-cylinder 'superbike' from another. By the end of the 1970s, the era of the Universal Japanese Bike (UJB) was firmly established. They all performed flawlessly, they were fast and easy to ride. But for all their technical brilliance, the bikes lacked any distinct style. In 1979 Hans Muth, designer of the fabulous BMW R90S, was asked by Suzuki to redesign its series of transverse in-line fours. The result was the Katana, and it shocked the world. With a brilliant, fully integrated line flowing from the front of its half-fairing to the tip of its tail, it was truly a designed machine; for the first time in the era of Japanese superbikes, the Katana was celebrated for its looks and its performance. The result was a big commercial success for Suzuki, who kept the Katana (named after a gently curved Japanese sword) in production for twenty-five years. UG

BMW R80GS

1991
Germany
1981–1992
797 cc OHV boxer twin
50 hp
Rüdiger Gutsche

RIGHT: The robust cage protects the headlamp necessary for night-time running.

BELOW: Simple, easy-to-read, speedometer and tachometer are essential for long-distance enduro-competitions.

MOTORCYCLES

YAMAHA V-MAX

1992
Japan
1985–present
1198 cc DOHC 70° V4
120 hp
Atsushi Ichijo, GK Design Group

From the late 1950s until 2015, every Yamaha was designed by GK Design Group. With offices around the world, GK produced many of Yamaha's designs with local sensibilities in mind. This was illustrated by the V-Max, which was inspired by the straight-line highways of the United States rather than the needs of the commuters of Jakarta. The original design was so successful that it remained unchanged for nearly twenty-five years. Even though it finally underwent a redesign in 2009 (including dropping the hyphen), the new VMax retained the unmistakable design element of an in-your-face engine that wouldn't look out of place in the latest *Mad Max* movie. The technical specifications include a V4 engine with dual overhead camshafts and four valves per cylinder. It produced an impressive 120 hp in its original form in 1985 – provided the power was applied to straight roads or drag strips, since handling must not have been part of the design brief. The model shown here could reach over 200 kph in 400 m (125 mph in just one-quarter of a mile). CMF

ABOVE: The heart of the V-Max is a huge, V4, liquid-cooled engine.

RIGHT: Enormous air scoops sit either side of the fake gas tank, delivering the air required by four carburettors.

BRITTEN
V1000

1994
New Zealand
1991–1998
997 cc DOHC 60° V-twin
165 hp
John Britten

The Britten V1000, created by design engineer John Britten, may well be the greatest motorcycle ever made. Conceived, designed and built to be raced arrow-fast, it did just that, setting world records on the way. In addition are its superb design features such as the lipstick-pink-and-powder-blue colour scheme, unheard of in the macho world of motorcycles. Or the lines, flowing effortlessly from the tip of its dragon's nose, through the intestinal twists of its twin exhaust pipes, to the end of its cantilevered tail. Or the flash of its three dainty pink cowlings: the front, almost a mudguard, tightly hugging the front wheel and forks, the second, smoothing the airflow past the engine, the third hugging the rear wheel – all creating downforce as they do so. In a final flourish, there are the four stars of the New Zealand Southern Cross on the tank, and John Britten's signature. Beyond the seductive lines and colours, there is an extraordinary collection of innovative materials and technical genius: carbon fibre in the bodywork, a seat cantilevered straight back from the top of the engine to which it is bolted. Everything is balanced, light and perfectly formed. Britten died young, of cancer, aged just forty-five, having achieved greatness. The expression 'renaissance man' is not quite renaissance enough to describe John Britten. UG

ABOVE: **The striking colours of the Britten had not been seen before (or since) on a race track.**

OPPOSITE: **The intestinal exhaust pipes were carefully designed to maximize engine gas flow.**

DUCATI M900 MONSTER

1994
Italy
1993–2002
904 cc desmodromic OHC 90° V-twin
67 hp
Miguel Angel Galluzzi

The 1970s and 80s are generally regarded as a dull period for motorcycle design. The bikes were technically excellent, but they were bland, uninteresting and so fully enclosed in featureless bodywork that it was hard to tell one from another. Ducati designer Miguel Angel Galluzzi envisioned something completely different: a bike without bodywork, a naked, muscular bike, with the engine showing; one that would have broad appeal: fast and sporty, but easy and comfortable to ride. Galluzzi and his colleagues picked parts from other Ducati models until they had what they wanted. The bike was so ugly that the mechanics in the factory nicknamed it *Il Mostro*, the Monster. Officially released as the M900, the Monster became one of the most successful motorcycle designs of all time, and, more than twenty-five years later, abeit with a variety of different engines and bodywork, it is still in production. Although Ducati has tweaked various aesthetic and technical elements over the years, the Monster remains essentially unchanged from Galluzzi's original: sexy, sporty and still as naked as the day it was born. UG

RIGHT: The Monster, stripped of all bodywork, was both powerful and influential.

BELOW: Attention to detail in the lockable, flush-mounted gas cap.

APRILIA
MOTO 6.5

1995
Italy
1995–2002
649 cc DOHC single
42 hp
Philippe Starck

Rarely in the history of motorcycle design has a machine so divided its audience. Beloved of design aficionados and many critics, but unloved by riders, crucially the Aprilia Moto 6.5 was a failure in the marketplace. French architect and designer Philippe Starck is one of the most influential and prolific designers of the late twentieth and early twenty-first centuries; nevertheless, it was a surprise when Aprilia asked him to design a comfortable and sporty city bike, using a single-cylinder 649 cc four-stroke engine as its core. The result is striking, and typical Starck: a blazing, two-tone silver-and-orange tank (it was also available in cream), set against the rest of the machine in a uniform matt grey. With its curving radiator providing a shield, the engine is tightly compressed into an egg-shaped cradle that seems to merge with the cocoon of the tank. Everything about the machine was designed to be taut, tight and cool, but this design masterpiece was rejected by riders who wanted something different; a real motorcycle, a Ducati Monster, say. The Aprilia Moto 6.5 is still gorgeous, and is now collectable, if you can find one. UG

ABOVE: Philippe Starck integrated the engine gauges around a simple speedometer.

RIGHT: Starck's signature adorns the matt-grey rear fender.

DUCATI 916 SP

1996
Italy
1994–1998
916 cc desmodromic OHC 90° V-twin
109 hp
Massimo Tamburini

RIGHT: The shark-like fairing is highly aerodynamic.

260 THE MOTORCYCLE

RIGHT: A single-sided swingarm shock absorber was a radical Tamburini flourish eliminating excess weight.

BELOW: The exhaust routing leads to twin pipes emerging from under the seat.

HONDA
CR250R

1996
Japan
1973–2007
249 cc two-stroke single
48 hp
Honda Motor Company

BIMOTA V-DUE

2002
Italy
1997–1998; 2002–2004
499 cc two-stroke 90° V-twin
105 hp
Massimo Tamburini

RIGHT: The fairing incorporated twin headlamps and a windshield.

HARLEY-DAVIDSON VRSCA V-ROD

2003
USA
2001–2017
1130 cc 60° V-twin
115 hp
Porsche Engineering (engine)

MOTORCYCLES

MV AGUSTA
F4 AGO

2005
Italy
2004–2006
998 cc DOHC in-line four
166 hp
Massimo Tamburini

Massimo Tamburini had already achieved many notable successes as a designer before he joined the Cagiva Research Centre (CRC) in 1985 to work on Ducati and MV Agusta motorcycle designs. His own company, Bimota, had produced a succession of outstanding designs, including the legendary 'Tesi'. His first knockout success working with a talented team at CRC was the Ducati 916, heralded as the greatest sportbike of all time when it was introduced in 1994. Ducati was sold in 1996, but Tamburini stayed at CRC and started working on the MV F4. The engine was a brilliant collaboration with Ferrari, resulting in an in-line four-cylinder engine, a break from the V-twins of Ducati, and a gearbox that featured a gear cluster 'cassette' that could readily be swapped, depending on the rider's preferences. Other signature Tamburini features include a single-sided swinging arm and ageless styling that keeps it looking contemporary, almost twenty years after it was introduced. This iteration of the MV Agusta F4 is the first in the series to feature a larger engine, increased from 750 cc to 998 cc, and is named after Giacomo 'Ago' Agostini, who won fifteen world championships, most of them riding for MV Agusta. UG

RIGHT: **As with the Ducati 916, Tamburini's MV exhausts emerge from under the seat cowl.**

BELOW: **A simple cockpit, featuring the transverse steering damper.**

KTM SUPER DUKE

2006
Austria
2005–2013
999 cc 75° V-twin
118 hp
Gerald Kiska

SEGWAY PT

2006
USA
2001–2020
Two electric motors with 11.4 A-hr battery
3 kW (4 hp)
Dean Kamen

Two-wheeled electrical personal transport vehicles had been mass produced as early as 1936 by Socovel with lead-acid batteries, and more recently in 1996 by Peugeot using nickel-cadmium batteries for its Scoot'Elec scooters. However, these kept the same layout that had been common since the late nineteenth century, and simply replaced internal combustion engines and petrol tanks with electric motors and batteries. In the late 1990s, inventor Dean Kamen identified a need that was not filled by conventional designs and took advantage of miniature solid-state sensors and microprocessors to create something quite different. His design of the Segway PT (personal transporter) used nickel–metal hydride batteries to power the two main motors and gyroscopes to keep the Segway balanced even when stationary – something no motorcycle could do. The result was a 'pedestrian enhancer' that enabled a person to travel as far as 16 km (10 miles) at speeds up to 16 kph (10 mph). While neither of those specifications would have been acceptable in a conventional vehicle, they were impressive for this new class of vehicles. Now, with the latest generation of even lighter, higher power density lithium ion batteries, Kamen's original idea is expanding into electrical transport 'vehicles' not imagined prior to the Segway. CMF

THE DROVER'S DOG

2009
Australia
Custom
399 cc SOHC 2-valve single
30 hp (27 hp stock)
Dare Jennings; Carby Tuckwell

Dare Jennings and Carby Tuckwell, the founders of Australian custom motorcycle and fashion brand Deus ex Machina, bring both Bondi cool and characteristic Aussie humour to the many custom designs that have emerged since 2006 from the Deus workshop in Camperdown, Sydney. If their stock-in-trade is an understated, minimal way with their motorcycles, the exception might be the Drover's Dog. Named after the working dogs on outback sheep farms – always on the lookout for something – the bike has a surfboard attached, always at the ready to head to the beach. Based on a Yamaha SR400, the Drover's Dog is transformed by the brilliant engineering evident in the stripped-down frame, the low-slung exhaust pipe with a shorty muffler, the huge Brembo front disc, the ice-cool tank graphics and, of course, the surfboard attached to the left side of the motorcycle. Deus bikes eschew the big, bulging, macho custom designs being made in the United States, and are eminently rideable, eccentric and quite beautiful designs for the rider who is cool, and wants to stay that way. UG

SUZUKI HAYABUSA

2016
Japan
1999–present
1409 cc
550 hp
Black Art Racing

RIGHT: Without its fairing, the extreme engineering is built purely for straight-line speed.

BANDIT9
EVE MK II

2016
Vietnam
Custom
Technical specifications dependent on design
Daryl Villanueva

Sleek, highly polished and seemingly simple, Eve is one of a range of designs offered by designer Daryl Villanueva, based on some of the most basic motorcycles ever made. Eve started life as a single-cylinder Honda, with a 125 cc horizontal, four-stroke engine in its original, pressed-steel frame, but through Villanueva's alchemy of fantasy, imagination and brilliant engineering, this everyday workhorse is transformed into an entirely different, sci-fi comic-book reality. With a background in both graphic design and advertising, Villanueva pays careful attention to form, gesture and line. Add an utter refusal to play to stereotypical, macho biker clichés and a sly sense of humour, and the result is cool, deliberately androgynous and highly stylized. These concepts are realized through Villanueva's bravura sheet metal sculpture and breathtaking engineering skills: a squiggle of polished steel becomes a fluid, barely-there swinging arm; a twinset of shock absorbers, tightly paired and placed under the seat, acts as the rear suspension; a molten polished metal flash, the 'unibody', is at once a tank, seat and tail piece. Ironically, this futuristic machine that looks like it can orbit at Mach II, is limited by the engine to modest earthbound speeds. UG

RIGHT: Every angle on the Eve is designed, including the front fairing which covers the steering.

BELOW: The sinewy swingarm is damped by a twinset of tightly paired shock absorbers.

MOTORCYCLES

273

HAZAN BLACK KNIGHT

2016
USA
Custom
500 cc OHV single
25 hp
Max Hazan

RIGHT: A pedestrian BSA 500 cc engine is transformed by Max Hazan's engineering.

OPPOSITE: This brilliant custom is designed to look like a knight's steed.

KTM RALLY 450 DAKAR

2016
Austria
1999–present
449 cc SOHC 4-valve single
51 hp
KTM

If ever a sporting event required a purpose-built machine, then the Dakar Rally is surely it. Started in 1978 as a supposedly straightforward ride from Paris to Dakar in Senegal, the rally is renowned for its particular gruelling qualities. With speeds increasing and terrain becoming especially hostile, competing motorcycles have become more and more specialized. Enter the KTM Rally 450, a variation on a true motocross machine, but with a light, long-range tank and tall handlebars, allowing the rider to stand up for long periods. The engine is the heart of the machine and is a masterpiece of compact engineering, as the race rules restrict it to 450 cc. A liquid-cooled, single cylinder, with an overhead cam and electronic ignition, it is so light that it can easily be swapped out by a single rider or mechanic. Toby Price, a champion off-road racer since his childhood, has won the Dakar twice on a KTM Rally 450, in 2016 and 2019. He might have won too in 2020, in Saudi Arabia, but for stopping to render aid to a fellow rider, who sadly died. Price lost an hour and twenty minutes. He still came third. UG

ABOVE: The extreme angle of the exhaust pipe lifts it clear of rugged terrain.

RIGHT: Rider Toby Price's blood type is painted on the bike in case of emergency.

MOTORCYCLES

ONEWHEEL XR

2017
USA
2017–present
Electric motor with 0.32 kWh battery
750 W (1 hp)
Kyle Doerksen

RIGHT: The 'fat' wheel allows for a surfboard stance and is easier to balance.

RODSMITH CORPS LÉGER

2018
USA
Custom
150 cc BSA two-stroke single
5 hp
Craig Rodsmith

RIGHT: Bravura metalwork is designed to evoke a jet's airscoop.

INDIAN SCOUT

2018
USA
2015–present
1130 cc OHV 60° V-twin
100 hp
Rich Christoph

RIGHT: The extreme lines of the rear suspension point forward into the stars and stripes on the tank.

RIGHT: Dramatic engine castings of the V-twin rocker covers.

BELOW: 1960s-era psychedelia styling on the stars and stripes.

MOTORCYCLES

CAKE KALK OR

2019
Sweden
2018–present
Electric motor with 2.6 kWh battery
11 kW (14.8 hp)
Stefan Ytterborn

Stefan Ytterborn, founder and philosopher-in-chief of Cake, discovered zero-emission electric motorcycles through his love of the outdoors. He hated the noise and smell of conventional-engine dirt bikes, and their impact on off-road trails. In designing the Kalk he looked to mountain bikes and their lack of noise, their relatively small physical footprint and, of course, their zero emissions. The Kalk is an off-road machine with the power and capability of a conventional 250 cc off-road motorcycle. What sets it apart immediately is the design, one that is rooted in its own language and owes nothing to Honda, KTM or any of the other mainstream off-road motorcycle makers. A plain, boxy frame encloses an 11 kW motor and battery pack. With that power, and the remarkable torque of an electric engine, this motorcycle will go anywhere, quickly. Eschewing the hyperactive colour schemes of conventional dirt bikes, the Kalk is a two-tone grey, the only flashes coming from the brassy, specially designed Öhlins upside-down front forks, and, if you can catch a glimpse, the rear shock, poking out from under the seat. The rest of the components, from hubs and wheels to panels and hardware, are elegantly designed and engineered. The overall look of the Kalk is a cool, zero-emission design whisper. UG

RIGHT: The elegant, brushed-aluminium controls are reminiscent of Philippe Starck's Aprilia Moto 6.5.

BELOW: The tread pattern of the Trailsaver tyres is designed to have a very light touch.

MOTORCYCLES

FULLER MOTO 2029

2019
USA
Custom
Electric motor with 3.2 kWh battery
20 kW (27 hp)
Craig Fuller

OPPOSITE ABOVE:
Hub centre steering recalls the 1930 Majestic.

OPPOSITE BELOW:
The skeletal swingarm is a masterpiece of high-tech metal fabrication.

MOTORCYCLES

NINEBOT ONE S2

2019
China
2016– present
Electric motor with 310 kWh battery
500 W (⅔ hp)
Segway-Ninebot

VESPA ELETTRICA

2019
Italy
2018–present
Electric motor with 4.2 kWh battery
4 kW (5.3 hp)
Piaggio

RIGHT: The original Vespa had room for a spare tyre; the contemporary Vespa has room for a helmet.

ZOOZ
CONCEPT 01

2019
USA
Custom
Electric motor with 0.84 kWh battery
4.3 kW (5.7 hp)
Christopher Zahner

OPPOSITE: **Tiny forks provide suspension for the minimalist welded frame.**

The Zooz is designer Chris Zahner's solution to his need for a daily motorcycle 'fix'. Requiring an urban bike with a small electric motor, he created the Zooz 'urban ultralight' concept to help him zip quickly through the streets of Chicago. Development of the Zooz is entwined with Zahner's own history: from building wooden go-karts at the age of five, to a proper motorcycle, based on a 1978 Kawasaki KZ750 twin, at eighteen, Zahner's dedication has led to his signature style with an emphasis on line, proportion and 'packaging'. The Zooz is an incredibly simple concept, in an elegant, linear package. But, for something so apparently minimal, it is brimming with design references. The handlebars, which suggest something from a BMX bike, are, in fact, moto-low-rise bars, turned upside down. The seat evokes the Chopper bicycles of the late 1960s and early 70s. The battery is concealed under the seat. When Zahner saw the first e-bikes, he knew he could produce something much better, something cool. Created with design intelligence and the attention needed to make it a great ride, the Zooz aims to define urban cool for the new world of electric personal motorcycles. UG

CLEVELAND CYCLEWERKS FALCON BLK FOUNDERS EDITION

2020
USA
2020–present
Electric motor with 8.8 kWh battery
13 kW (17.5 hp)
Scott Colosimo

OPPOSITE, ABOVE LEFT: The electric engine and battery pack are integrated within a light, tubular frame.

OPPOSITE, ABOVE RIGHT: Pedal detail is spare, minimal, functional.

OPPOSITE BELOW: An elegant swingarm anchors the single shock absorber.

MOTORCYCLES

SUR-RON
LIGHT BEE X

2020
China
2018–present
Electric motor with 1.9 kWh battery
6 kW (8 hp)
Sur-Ron

As the twentieth century ended, some people predicted the end of the motorcycle: the theory was that engine technology could not go much further, bikes couldn't get any better and therefore they would simply fade away. Yet even with the arrival of internet-enabled taxi services and the prospect of autonomous cars, motorcycle design and production are increasing at a remarkable pace. Much of this change is driven by technology, particularly the advent of electric vehicles (EVs), of which the Sur-Ron Light Bee X is a brilliant example. Motorcycle designers in the electric era are pulled in many different directions. Some stick with traditional notions of what a motorcycle should look like; others take the form in a completely different direction. All have to deal with the issue of an angular battery and power unit, which have, somehow, to be shoehorned into a frame. The Sur-Ron prefers to strike out on its own with an angular aluminium frame that nestles the engine comfortably within the overall design. It combines the best of the current thinking in motocross design and graphics with the most radical expression of mountain bike styles. And, in a pointed riposte to policy makers who sought to distinguish between 'pedal-assist' e-bikes and throttle EVs, the design is offered either with, or without, pedals. UG

SAVIC
C-SERIES

2020
Australia
2020–present
Electric motor with 11 kWh battery
60 kW (80 hp)
Dennis Savic

RIGHT: Dual Brembo brakes look to classic Italian sportbike design.

OPPOSITE: The dual headlamp cluster and the extreme front mudguard show a forward-thinking design flourish.

MOTORCYCLES

TARFORM LUNA FOUNDERS EDITION

2020
USA
2020–present
Electric motor with 10 kWh battery
40 kW (53 hp)
Taras Kravtchouk

OPPOSITE: Subtle, spare integration of otherwise mundane components is a hallmark of the Tarform.

RIGHT: Integrated one-piece tail and seat.

296 THE MOTORCYCLE

7

THE MOTORCYCLE

BIBLIOGRAPHY

SELECTED BIBLIOGRAPHY

CHARLES M FALCO

GENERAL AND HISTORICAL

Aamidor, Abe. *Shooting Star: The Rise & Fall of the British Motocycle Industry*. Toronto: ECW Press, 2009.

Allmann, Frank and Simon Everett. *Streetfighter Motorbikes: The Ultimate Collection*. London: Arcturus Publishing, 2000.

Ansell, David. *Military Motor Cycles*. London: B.T. Batsford, 1985.

Ansell, David. *The Illustrated History of Military Motorcycles*. London: Osprey Publishing, 1996.

Ashby, JB and DJ Angier. *Catalog of British Motor Cycles*. Los Angeles: Floyd Clymer, 1951

Axon, Jo. *Sidecars*. Princes Risborough, UK: Shire Publications, 1997.

Ayton, Cyril J. *Great Japanese Motorcycles, The: Honda, Kawasaki, Suzuki, Yamaha*. Abbotsham, UK: Herridge, 1981.

Ayton, Cyril J. *A-Z Guide to British Motorcycles*. Bideford, UK: Bay View, 1991.

Ayton, Cyril. Bob Holliday, Cyril Posthumus and Mike Winfield. *The History of Motor Cycling*, London: Orbis, 1979.

Bacon, Roy. *Military Motorcycles of World War 2*. London: Osprey Publishing, 1985.

Bacon, Roy. *An Illustrated History of Motorcycles*. London: Sunburst Books, 1995.

Bacon, Roy. *Foreign Racing Motorcycles*. Sparkford, UK: Haynes Publishing, 1979

Bacon, Roy and Ken Hallworth. *British Motorcycle Directory: Over 1,100 Marques from 1888*. Ramsbury, UK: Crowood Press, 2004.

Beaulieu, Lord Montagu and Marcus W Bourdon, eds. *Cars and Motorcycles*, vols 1–3. London: Sir Isaac Pitman and Sons, 1928.

Beaumont, W Worby. *Motor Vehicles and Motors*, 2nd edition. London: A Constable, 1902.

Beaumont, W Worby. *Motor Vehicles and Motors*, Vol. 2. London: A Constable, 1906.

Belker, Harald. *Ride, Futuristic Electric Motorcycle Concept*. Culver City, CA: Design Studio Press, 2013.

Berk, Joseph. *The Complete Book of Police and Military Motorcycles*. Boulder, CO: Paladin Press, 2001.

Birch, Gavin. *Images of War, Motorcycles at War*. Barnsley, UK: Pen & Sword Military, 2006.

Bishop, George and Shaun Barrington. *Encyclopedia of Motorcycling*. New York: Southmark, 1995.

Bourne, Arthur B, ed. *Motor Cycle Engines*. London: Iliffe & Sons, 1951.

Bourdache. *La Motocyclette en France 1894–1914*. N.p.: Edifree, 1989

Brown, Roland. *Superbikes: Road Machines of the 60s, 70s, 80s and 90s*. Secaucus, NJ: Chartwell, 1993.

Brown, Roland. *The Encyclopedia of Motorcycles*. New York: Smithmark, 1996.

Brutlag, HH. *Vintage Sprint Bikes*. London: Rennsport Sidecars, 2001.

Burton, Ron. *Illustrated Buyer's Guide: Classic Japanese Motorcycles*. Osceola, WI: MBI Publishing, 2000.

Carroll, John. *The Motorcycle: A Definitive History*. New York: Smithmark, 1997.

Carroll, John. *Classic American Motorcycles*. Edison, NJ: Chartwell Books, 1997.

Carroll, John. *The Complete British Motorcycle: The Classics from 1907 to the Present*. Osceola, WI: MBI Publishing, 2001.

Cathcart, Alan. *Road Racers Revealed*. London: Osprey Publishing, 1987.

Cathcart, Alan. *The Ultimate Racers*. Osceola, WI: Motorbooks International, 1990.

Caunter, CF. *Motorcycles: A Technical History*, 3rd edition. London: Her Majesty's Stationery Office, 1982.

Clarke, Massimo. *100 Years of Motorcycles*. New York: Portland House, 1988.

Clew, Jeff. *Veteran Motorcycles*. Buckinghamshire, UK: Shire, 1995.

Clew, Jeff. *Vintage Motorcycles*. Buckinghamshire, UK: Shire, 1995.

Cloesen, Uli. *Japanese Custom Motorcycles*. Poundbury, UK: Veloce Publishing, 2013.

Cloesen, Uli. *Italian Custom Motorcycles: The Italian Chop* Poundbury, UK Veloce Publishing, 2013.

Cloesen, Uli. *British Custom Motorcycles: The Brit Chop*. Poundbury, UK: Veloce Publishing, 2014.

Cloesen, Uli *Italian Cafe Racers* Poundbury, UK Veloce Publishing 2014

Cloesen, Uli *British Cafe Racers* Poundbury, UK Veloce Publishing 2016

Clymer, Floyd. *Floyd Clymer's Historical Motor Scrapbook*, No. 1 Los Angeles: Floyd Clymer, 1944.

Clymer, Floyd. *Floyd Clymer's Historical Motor Scrapbook*, No. 2 Los Angeles: Floyd Clymer, 1944.

Clymer, Floyd. *Floyd Clymer's Historical Motor Scrapbook*, No. 3 Los Angeles: Floyd Clymer, 1946.

Clymer, Floyd. *Floyd Clymer's Historical Motor Scrapbook*, No. 4 Los Angeles: Floyd Clymer, 1947.

Clymer, Floyd. *Floyd Clymer's Historical Motor Scrapbook*, No. 5 Los Angeles: Floyd Clymer, 1948.

Clymer, Floyd. *Floyd Clymer's Historical Motor Scrapbook*, No. 6 Los Angeles: Floyd Clymer, 1950.

Clymer, Floyd. *Floyd Clymer's Historical Motor Scrapbook*, No. 7 Los Angeles: Floyd Clymer, 1954.

Clymer, Floyd. *Floyd Clymer's Historical Motor Scrapbook*, No. 8 Los Angeles: Floyd Clymer, 1955

Connolly, Harold. *Motorcycle Story: 1875–1905*. Peterborough, UK: E.M. Art & Publishing, 1962.

Corbetta, Luigi. *Legendary Motorcycles*. Vercelli, Italy: VMB Publishers, 2009.

Crawford, Mathew B. *Shop Class as Soulcraft: An Inquiry Into the Value of Work*. New York: Penguin Press, 2009.

Crowley, TE. *Discovering Old Motor Cycles*, 2nd edition. Buckinghamshire, UK: Shire, 1977

Currie, Bob. *Classic Competition Motorcycles*. Cambridge, UK: Patrick Stephens, 1987.

Cutts, John and Michael Scott. *The World's Fastest Motor Cycles*. London: Apple, 1990.

Davies, Robert. *Custom Rides: The Coolest Motorcycle Builds Around the World*. Stroud, UK: The History Press, 2018.

De Cet, Mirco, ed. *The Complete Encyclopedia of World Motorcycles*. Philadelphia: Courage Books, 2001.

Desmond, Kevin. Electric *Motorcycles and Bicycles*. Jefferson, NC: McFarland, 2019.

Drutt, Matthew, ed. *The Art of the Motorcycle*. New York: Solomon R Guggenheim Foundation, 1998.

Drutt, Matthew, ed. *EL Arte de la Motocicleta*. New York: Solomon R Guggenheim Foundation, 1999.

Drutt, Matthew, ed. *The Art of the Motorcycle: Über die Schönheit der Technik*. New York: Solomon R Guggenheim Foundation, 1999.

Drutt, Matthew, ed. *L'Art de la Moto*. New York: Solomon R Guggenheim Foundation, 1999.

Dumble, David B. *Veteran Motorcycles in Australia*. Noble Park, Australia: Vintate Motorcycle Club of Victoria, 1974.

Dumble, David B. *Classic Motorcycles in Australia*. Noble Park, Australia: Dumble, 1977.

Duncan, HO. *The World on Wheels*. Paris: HO. Duncan, 1924.

Ganneau, Didier and François-Marie Dumas.

A Century of Japanese Motorcycles. St Paul, MN: MBI Publishing, 2001.

Gardiner, Mark. *Classic Motorcycles.* New York: Metro Books, 1997.

Gaspard, Gilbert. *Les Dames de la Basse-Meuse.* Liege,: Vaillant, 1978.

Gaspard, Gilbert. *Les Demoiselles de Herstal.* Liege: Vaillant, 1975.

Gomola, Miroslav. *CZ Motorcycles: The History of Strakonice Arms Factory.* Brno: AGM CZ, 2004.

Goyard, Jean and Dom Pascal. *Tous Les Scooters Du Monde.* Paris: Ch. Massin, 1993.

Goyard, Jean. *Le Temps des Mobs.* Paris: E.P.A. 1995.

Griffith, John. *Historic Racing Motorcycles.* London: Temple Press, 1963.

Griffith, John. *Famous Racing Motorcycles.* London:Temple Press, 1961.

Hahn, Pat. *Classic Motorcycles: The Art of Speed.* Minneapolis: Motorbooks International, 2016.

Hatfield, Jerry. *American Racing Motorcycles.* Sparkford, UK: Haynes Publishing, 1982.

Henshaw, Peter. *The Encyclopedia of the Motorcycle.* Edison, NJ: Chartwell, 1999.

Hatfield, Jerry. *Antique American Motorcycle Buyer's Guide.* Osceola, WI: Motorbooks International, 1996.

Hatfield, Jerry. *Standard Catalog of American Motorcycles 1898–1981.* Iola, WI: Krause Publications, 2006.

Hicks, Roger. *V-Twins: The Classic Motorcycle.* Dorset, UK: Blandford, 1985.

Hicks, Roger W. *Classic Motorbikes.* London: Tiger, 1992.

Hicks, Roger, ed. *The Encyclopedia of Motorcycles.* San Diego, CA: Thunder Bay Press, 2001.

Hinrichsen, Horst. *German Military Motorcycles in the Reichswehr and Wehrmacht, 1934–1945.* Atglen, PA: Schiffer, 1997.

Hodgdon, TA. *Motorcycling's Golden Age of the Fours.* Lake Arrowhead, CA: Bagnall, 1974.

Holliday, Bob. *Motor Cycle Parade.* New York: David and Charles, 1974.

Holliday, Bob. *Motorcycle Panorama.* New York: Arco Publishing, 1975.

Holmes, Mark. *Ultimate Motorcycles: The Most Exotic & Exclusive Bikes on Earth.* London: Kandour, 2007.

Hough, Richard and LJK. Setright. *A History of The World's Motorcycles,* Revised edition. New York: Harper and Row, 1973.

Hunter, Chris and Robert Klanten. *The Ride: New Custom Motorcycles and Their Builders.* Berlin: Gestalten, 2013.

Johnstone, Gary. *Classic Motorcycles.* Osceola, WI: Motorbooks International, 1993

Jones, Peter. *Historic Motor Cycling.* Rushcutters Bay, Australia: Modern Magazines, 1978.

Keig, SR and Bill Snelling. *The Keig Collection*, vol. 1. Leatherhead, UK: Bruce Main-Smith, 1975.

Keig, SR and Bill Snelling. *The Keig Collection*, vol. 2. Leatherhead, UK: Bruce Main-Smith, 1975.

Keig, SR and Bill Snelling. *The Keig Collection*, vol. 3. Leatherhead, UK: Bruce Main-Smith, 1975.

Keig, SR and Bill Snelling. *The Keig Collection*, vol. 4. Leatherhead, UK: Bruce Main-Smith, 1984.

Keig, SR and Bill Snelling. *The Keig Collection*, vol. 5. Laxey, UK: Amulree, 1996.

Kelly, Howard. *Today's Top Custom Bike Builders.* Minneapolis: Motorbooks, 2009.

Kemp, Hans. *Bikes of Burden.* Hong Kong: Visionary World, 2003.

Klanten, Robert and Maximilian Funk, eds. *The Current: New Wheels for the Post-Petrol Age.* Berlin: Gestalten, 2018.

Knittel, Stefan. *German Motorcycles in World War II.* West Chester, PA: Schiffer, 1990.

Koerner, Steve. *The Strange Death of the British Motor Cycle Industry.* Leicester, UK: Crucible Books, 2012.

Lacombe, Christian. *The Motorcycle.* New York: Grossett Dunlap, 1974.

Louis, Harry and Bob Currie. *The Classic Motorcycles 1896–1950.* New York: E.P. Dutton , 1976.

Luraschi, Abramo Giovanni. *Storia Della Motocicletta,* vol. 1. Milan: La Moto, 1962.

Luraschi, Abramo Giovanni. *Storia Della Motocicletta (1915–1925),* vol. 2. Milan: Edisport, c.1975.

Luraschi, Abramo Giovanni. *Storia Della Motocicletta (1926–1940),* vol. 3. Milan: Edisport, c.1975.

Luraschi, Abramo Giovanni. *Storia Della Motocicletta (1940–1955),* vol. 4. Milan: Edisport, c.1975.

Luraschi, Abramo Giovanni. *Storia Della Motocicletta (Gli Ultima 20 Ani),* vol. 5. Milan: Edisport, c.1975.

Mayes, Alan. *Old School Choppers: No-Frill Bikes for Real Bikers.* Iola, WI: Krause Publications, 2006.

Mitchel, Doug. *Choppers Field Guide: Custom Bikes 1950s–Present.* Iola, WI: kp Books, 2004.

Mitchel, Doug. *Choppers and Custom Motorcycles.* Lincolnwood, IL: Publications International, 2005.

Mitchel, Doug. *Standard Catalog of Japanese Motorcycles, 1959–2007.* Iola WI: Krause Publications, 2007.

Miyato, Kimiaki, ed. *Japanese Motorcycle History, 1945–1997.* Tokyo: Yaesu-shuppan, 1997.

Morley, Don. *Spanish Trials Bikes.* London: Osprey Publishing, 1988.

Nabinger, Manfred. *Deutsche Fahrrad Motoren, 1898 bis 1988.* Brilon, Germany: Podszun, 1988.

Negro, Patrick. *Motos Françaises, 1869–1962.* Boulogne-Billancourt, France: E.T.A.I., 2009.

Nichols, Dave and Michael Lichter. *Top Chops: Master Chopper Builders.* St Paul, MN: Motorbooks, 2005.

Olyslager, Piet. *Motorcycles to 1945.* London: Frederick Warne & Company, 1974.

Olyslager, Piet. *Motorcycles and Scooters from 1945.* London: Frederick Warne & Company 1975.

Parker, Tim. *Italian Motorcycles: Classic Sport Bikes.* London: Osprey Publishing, 1984.

Parker, Tim. *Japanese Motorcycles.* London: Osprey Publishing, 1985.

Partridge, M. *Motorcycle Pioneers: The Men, The Machines, The Events, 1860–1930.* New York: Arco Publishing, 1977.

Pascal, Dominique. *50 Ans de Motocyclettes Françaises.* Paris: E.P.A., 1979.

Pascal, Dominique. *Le Grand Dictionnaire des Motos Françaises.* Paris: Ch. Massin c.1980.

Patrignani, Roberto and Brizio Pignacca. *Le Moto Da Corsa Italiane.* Novara, Italy: Agostini, 1985.

Pavey, Adrian, ed. *100 Years of Japanese Motorcycles.* Loughborough, UK: Vintage Japanese Motorcycle Club, 2000.

Peirce, Daniel. *The Fine Art of the Motorcycle Engine.* Dorchester, UK: Veloce Publishing, 2008.

Posthumus, Cyril and Dave Richmond. *Fifty Years of Motorcycles.* London: Phoebus, 1978.

Rafferty, Tod. *The Illustrated Directory of Classic American Motorcycles.* London: Salamander Books, 2001.

Reynaud, Claude. *Le Mythe des 4 Cylindres en Ligne 1904–1954.* Domazan, France: C Reynaud, 1991.

Rösler, Hans. *Bonneville: World's Fastest Motorcycles.* Stillwater, MN: Wolfgang Publications, 2007.

Salvat, Bernard. *Motos de Course 1902–1958.* Charnay-les Macon, France: A.H.M.A., 1988.

Salvat, Bernard. *Les Motos Francaises: Cent ans d'histoire.* Paris: E.P.A., 1994.

Saward, Robert. *A-Z of Australian-Made Motorcycles, 1893–1942.* Sydney: Turton & Armstrong, 1996.

Schultz, Jean-Paul. *Histoire de la Moto Militaire.* Brussels: Sagato, c.1980s.

Seate, Mike. *Choppers: Heavy Metal Art*. St Paul, MN: Motorbooks, 2004.
Seate, Mike. *Techno-Chop: The New Breed of Chopper Builders*. St. Paul, MN: Motorbooks, 2005.
Setright, LJK. *Motorcycles*. London: Arthur Barker, 1976.
Setright, LJK. *Some Unusual Engines*. London: Mechanical Engineering Publications, 1975.
Sheldon, James. *Veteran and Vintage Motor Cycles*. London: B.T. Batsford, 1961.
Shilling, Phil. *The Motorcycle World*. New York: Ridge, 1974.
Sims, Josh. *Scootermania: A Celebration of Style and Speed*. London: Conway, 2015.
Swanson, Kerry. *Classic Motorcycles in New Zealand*. Palmerston, New Zealand: Dunmore Press, 1997.
Tagliaferri, Mariarosaria, ed. *Motorcycles and Stars*. Antwerp: Tectum Publishers, 2010.
Tessera, Vittorio. *Scooters: Made in Italy*. Milan: Giorgio Nada Editore, 1993.
Toll, Micah. *Electric Motorcycles 2019: A Guide to the Best Electric Motorcycles & Scooters*. N.p: Toll Publishing, 2019.
Tooth, Phillip. *The Art of the Racing Motorcycle*. New York: Universe Publishing, 2010.
Tragatsch, Erwin, ed with Kevin Ash. *The New Illustrated Encyclopedia of Motorcycles*. Edison, NJ: Chartwell, 2000.
Walford, Eric W. *Early Days in the British Motor Cycle Industry*. Coventry: British Cycle 1932.
Walker, Alastair. *Scooterama: Café Chic and Urban Cool*. Osceola, WI: MBI Publishing, 1999.
Walker, Mick. *Spanish Post-War Road and Racing Motorcycles*. London: Osprey Publishing, 1986.
Walker, Mick. *German Motorcycles: Road and Racing Bikes*. London: Osprey Publishing, 1989.
Walker, Mick. *Motorcycle: Evolution, Design, Passion*. London: Mitchell Beazley, 2006.
Ware, Pat. *An Illustrated History of Miltary Motorcycles*. Wigston, UK: Southwater, 2012.
Webster, Mike. *Classic Scooters*. Bristol: Parragon, 1998.
Willoughby, Vic. *Classic Motorcycles*, 2nd edition. Feltham, UK: Temple Press, 1983.
Willoughby, Vic. *Exotic Motorcycles*. London: Osprey Publishing, 1982.
Willoughby, Vic. *Classic Motorcycle Engines*. Croydon, UK: Motor Racing Publications, 1986.
Wright, Stephen. *The American Motorcycle: A Chronological History, 1869–1914*, vol. 1. N.p.: Megden Publishing Company, 2001.

RIDING AND MOTORCYCLING

Alexander, Jeffrey W. *Japan's Motorcycle Wars: An Industry History*. Honolulu: Univiersity of Hawai'i Press, 2009.
Alford, Steven E and Suzanne Ferriss. *An Alternative History of Bicycles and Motorcycles*. Lanham, MD: Rowman & Littlefield, 2016.
Barnes, Richard. *Mods!* London: Plexus, 1979.
Beard, Elspeth. *Lone Rider: The First British Woman to Motorcycle Around the World*. London: Michael O'Mara Books, 2017.
Bertoia, Rich. *Antique Motorcycle Toys*. Atglen, PA: Schiffer Publishing, 1999.
Bowers, Jack L. *Around Australia: The Hard Way in 1929*. Kenthurst, Australia: Kangaroo Press, 1995.
Clay, Mike. *Cafe' Racers*. London: Osprey Publishing, 1990.
Clew, Jeff. *Motorcycling in the 50s*. Godmanstone, UK: Veloce Publishing, 1995.
Cotter, Tom. *The Vincent in the Barn: Great Stories of Motorcycle Archaeology*. Beverly, MA: Motorbooks, 2009.
D'Orléans, Paul and Michael Lichter. *Cafe Racers: Speed, Style and Ton-Up Culture*. Minneapolis: Motorbooks International, 2014.
D'Orléans, Paul. *The Chopper*. Berlin: Gestalten, 2014.
D'Orléans, Paul. *Ton Up! A Century of Café Racer Speed and Style*. Beverly, MA: Motorbooks, 2020.
Debenham, Betty and Nancy Debenham. *Motor-Cycling for Women*. London: Sir Isaac Pitman & Sons, 1928.
Dixon, Martin Brooklyn. *Kings: New York City's Black Bikers*. New York: Powerhouse Books, 2000.
Fowles, Sally-Anne. *Fast Women: Pioneering Australian Motorcyclists*. Warriewood, Australia: Woodslane Press, 2017.
Fulton, Jr, Robert E. *One Man Caravan*. New York: Harcourt Brace, 1937.
Grant, Malcolm and Harold H Paynting, eds. *The James Flood Book of Motorcycling in Australia:1899–1980*. Footscray, Australia: James Flood Charity Trust, 1982.
Guevara, Ernesto 'Che'. *The Motorcycle Diaries*. Translated by Ann Wright. London: Verso, 1995.
Haefele, Fred. *Rebuilding the Indian: A Memoir*. New York: Riverhead Books, 1998.
Harris, Maz. *Bikers: Birth of a Modern Day Outlaw*. London: Faber & Faber, 1985.
Hill, Geoff and Colin O'Carroll. *Oz: Around Australia: on a Triumph*. Belfast: Blackstaff Press, 2010.
Hollern, Susie. *Women and Motorcycling*. Freeville, NY: Hollern, 1992.
Hollern, Susie. *Women and Motorcycling: The Early Years*. Locke, NY: Pink Rose Publications and Marketing, 1999.
Holmes, Tim and Rebekka Smith. *Collecting, Restoring and Riding Classic Motor Cycles*. Cambridge, UK: Patrick Stephens, 1986.
Hopwood, Bert. *Whatever Happened to the British Motorcycle Industry?* Sparkford, UK: Haynes Publishing, 1981.
Irving, Phil. *Rich Mixture*. Surry Hills, Australia: Vincent, 1976.
Irving, Phil. *Black Smoke*. Surry Hills, Australia: Research Publications, 1978.
Ixion (BH Davies). *Motor Cycle Reminiscences*. London: Iliffe & Sons, 1920.
Ixion (BH Davies). *Further Motor Cycle Reminiscences*. London: Iliffe & Sons, 1928.
Ixion (BH Davies). *Motor Cycle Cavalcade*. London: Iliffe & Sons, 1950.
Lahman, Lynda. *The Women's Guide to Motorcycling*. Irvine, CA: Lumina Media, 2016.
Lichter, Michael. *Sturgis: The Photography of Michael Lichter*. St Paul, MN: Motorbooks International, 2003.
Lyon, Danny. *The Bikeriders*. New York: Macmillan, 1968.
MacDonald, Bowran Cruickshank. *Motor Cyclist's Handbook*. London: Sir Isaac Pitman & Sons, 1951.
Marriott, Michael. *Two-Up by Scooter to Australia*. London: Travel Book Club, 1960.
Miller, Sandro and Prosper Keating. *American Bikers: Photographs by Sandro*. New York: te Neues Publishing, 1998.
Miyake, Esperanza. *The Gendered Motorcycle: Representations in Society, Media and Popular Culture*. London: Bloomsbury, 2018.
Morris, Lester. *Motor Cycling in Australia*. Melbourne: McMillan, 1976.
Mortimer, Charles. *The Constant Search: Collecting Motoring and Motorcycling Books*. Sparkford, UK: Haynes Publishing, 1982.
Pierson, Melissa Holbrook. *The Perfect Vehicle: What It Is About Motorcycles*. New York: W.W. Norton, 1997.
Pirsig, Robert M. *Zen and the Art of Motorcycle Maintenance*. New York: William Morrow & Company, 1974.
Sato, Ikuya. *Kamikaze Biker: Parody and Anomy in Affluent Japan*. Chicago: University of Chicago Press, 1991.
Scaysbrook, Jim. *Australia's Motorcycling Heritage: 1946–2003*, 2nd edition. Punchbowl, Australia: Bookworks, 2004.

Seate, Mike. *Two Wheels on Two Reels: A History of Biker Movies.* North Conway, NH: Whitehorse Press, 2000.

Setright, LJK, ed. *Twistgrip.* London: Allen and Unwin, 1969.

Shand, Adam. *Outlaws: The Truth about Australian Bikers.* Sydney: Allen & Unwin, 2013.

Shannon, Alyn Marie. *Women of the Road.* Minneapolis: Shannon, 1995.

Shook, Christina. *Chicks on Bikes.* Orinda, CA: Paper Wings Publishing, 2009.

Simon, Ted. *Jupiter's Travels Garden City.* New York: Doubleday, 1980.

Stuart, Johnny. *Rockers!* London: Plexus, 1987.

Sucher, Harry V. *Inside American Motorcycling.* Laguna Niguel, CA: Infosport, 1995.

Sulkowsky, Zoltán. *Around the World on a Motorcycle: 1928–1936.* Translated by Noémi M. Najbauer. Austin: Octane Press, 2008.

Tanaka, Rin. *Motorcycle Jackets: A Century of Leather Design.* Atglen, PA: Schiffer Publishing, 2000.

Tanaka, Rin. *The Motorcycle Helmet: The 1930s to the 1990s.* Atglen, PA: Schiffer Publishing, 2002.

Thévenet, Jean-Marc. *Motorbikes and Counterculture.* Berkeley: Ginko Press, 2019.

Thompson, William E. *Hogs, Blogs, Leathers and Lattes: The Sociology of Modern American Motorcycling.* London: McFarland and Company, 2012.

van Poppel, Ad. *100 Ans de Motocyclisme en Belgique.* N.p.: Editions Snoeck, 2012.

van Vlerah, Abagail. *Women Who Ride the Hoka Hey.* Jefferson, NC: McFarland, 2019.

Walker, Alastair. *The Café Racer Phenomenon.* Dorchester, UK: Veloce Publishing, 2009.

Warren, Lady. *Through Algeria and Tunisia on a Motor-Bicycle.* Boston: Houghton Mifflin, 1923.

Winterhalder, Edward and Wil de Clercq. *Biker Chicz of North America.* Owasso, OK: Blockhead City Press, 2010.

Yeager, Trisha. *How to be Sexy with Bugs in Your Teeth.* Chicago Contemporary, 1978.

Zanetti, Geno, ed. *She's a Bad Motorcycle: Writers on Riding.* New York: Thunder's Mouth Press, 2002.

INDIVIDUAL MARQUES

AERMACCHI
Walker, Mick. *Aermacchi.* N.p: Transport, 1995.

AJS
Walker, Mick. AJS: *The Complete Story.* Ramsbury, UK: Crowood Press, 2005.

APRILIA
Walker, Mick. *Aprilia: The Compete Story.* Ramsbury, UK: Crowood Press, 2000.

ARIEL
Hartley, Peter. *The Ariel Story.* Watford, UK: Argus, 1980.

BENELLI
Walker, Mick. *Benelli.* Ipswich, UK: Transport, 1995.

BETA
Fiorentino, Massimo. *Beta Motorcycles: Over a Century of Technology and Sport.* Milan: Giorgio Nada Editore, 2018.

BIANCHI
Gentile, Antonio. *Edoardo Bianchi.* Milan: Giorgio Nada Editore, 1992.

BIMOTA
Sarti, Giorgio. *Bimota: 25 Years of Excellence.* Milan: Giorgio Nada Editore, 1999.

BMW
Falloon, Ian. *The BMW Story,* 2nd edition. Poundbury, UK: Veloce Publishing, 2019.

BROUGH-SUPERIOR
Miller, Peter. *Brough-Superior: The Complete Story.* Ramsbury, UK: Crowood Press, 2010.

BSA
Ryerson, Barry. *The Giants of Small Heath: The History of BSA.* Sparkford, UK: Haynes Publishing, 1980.

BULTACO
Two Wheel Horse: The Enjoyment of Dynamic Balance. Barcelona: Fullgraf, 1971.

CCM
Lawless, Bill. *Rolling Thunder: The History of the BSA-Based CCM Four-Strokes.* Newport, UK: Willow, 1990.

COTTON
Collin, Eddie. *The Chronicle of the Cotton,* Grantham, UK: Collin, 1987.

CUSHMAN
Somerville, Bill. *The Complete Guide to Cushman Motor Scooters.* Springfield, MO: Cantrell-Barnes, 1988.

DKW
Rauch, Siegfried with Frank Ronicke. *DKW: The Complete History of a World Marque.* Atglen, PA: Schiffer, 2014.

DOUGLAS
Briercliffe, H and E Brockway. *The Illustrated History of Douglas Motorcycles.* Sparkford, UK: Haynes Publishing, 1991.

DUCATI
Falloon, Ian. *The Ducati Story,* 2nd edition Sparkford, UK: Haynes Publishing, 1998.

EXCELSIOR
Collin, Eddie. *The History of Excelsior.* Grantham, UK: Grantley, 1987.

FRANCIS-BARNETT
Gent, Arthur. *Francis-Barnett: The Complete Story.* Ramsbury, UK: Crowood Press, 2011.

GARELLI
Agrati, Daniele and Roberto Patrignani. *Garelli, Ottant' Anni di Storia.* Milan: Giorgio Nada Editore, 1999.

GILERA
Walker, Mick. *Gilera: The Complete Story.* Ramsbury, UK: Crowood Press, 2000.

GILLET
Campion, Yves. *Les Motos Gillet Herstal, 1919–1959.* Verviers, Belgium: Nostalgia Editions, 2000.

GREEVES
Sparrow, Colin. *Greeves: The Complete Story.* Ramsbury, UK: Crowood Press, 2014.

HARLEY-DAVIDSON
Sucher, Harry V. *Harley-Davidson: The Milwaukee Marvel,* 4th edition. Sparkford, UK: Haynes Publishing, 1990.

HENDERSON
Schultz, Richard Henry. *Hendersons: Those Elegant Machines.* Freeman, SD: Pine Hill Press, 1994.

HODAKA
Smith, Ken. *Hodaka: The Complete Story of America's Favorite Trail Bike.* Austin, TX: Octane Press, 2014.

HONDA
Mitchel, Doug. *Honda Enthusiasts Guide: Motorcycles, 1959–1985.* Stillwater, MN: Wolfgang Publications, 2013.

HUMBER
Freeman, Tony. *Humber: An Illustrated History, 1868–1976.* London: Academy, 1991.

INDIAN
Holmstrom, Darwin. *Indian Motorcycle: America's first Motorcycle Company.* Beverly, MA: Motorbooks, 2016.

J.A.P.
Clew, Jeff. *JAP: The Vintage Years.* Sparkford, UK: Haynes Publishing, 1985.
Clew, Jeff. *JAP: The End of an Era.* Sparkford, UK: Haynes Publishing, 1988.

JAMES
Miller, Peter. *The Famous James: Military Lightweight.* Stroud, UK: Amberley, 2016.

KAWASAKI
Falloon, Ian. *The Kawasaki Story.* Sparkford, UK: Haynes Publishing, 2000.

LAMBRETTA
Cox, Nigel. *Lambretta Innocenti: An Illustrated History.* Sparkford, UK: Haynes Publishing, 1996.

LAVERDA
Ainscoe, Raymond. *Laverda.* London: Osprey Publishing, 1991.

LEA-FRANCIS
Price, Barrie. *The Lea-Francis Story.* London: B.T. Batsford, 1978.

LEVIS
Collin, Eddie. *The Story of Levis.* Grantham, UK: Grantley, 1989.

MATCHLESS
Walker, Mick. *Matchless: The Complete Story.* Ramsbury, UK: Crowood Press, 2004.

MONDIAL
Perrone, Gianni and Jolanda Croesi. *Mondial, Rimettersi in Moto: The History.* Milan: Giorgio Nada Editore, 2000.

MONET & GOYON
Gagnaire, Michel and Franck Meneret. *Monet & Goyon, La Moto Française.* Boulogne-Billancourt, France: E.T.A.I., 2006.

MORBIDELLI
Porrozzi, Claudio. *Morbidelli, dalla 50 alla 500.* Pesaro, Italy: Morbidelli, 1984.

MORGAN
Alderson, Dr. JD and DM Rushton. *Morgan Sweeps the Board: The Three-Wheeler Story.* London: Gentry, 1978.

MOTOBECANE
Barrabés, Patrick. *Motobécane: Les Quatre-Temps, 1927–1984.* Antony, France: E.T.A.I, 2013.

MOTO G.D.
Ruffini, Enrico. *Moto G.D.* Milan: Giorgio Nada Editore, 1990.

MOTO GUZZI
Colombo, Mario. *80 Years of Moto Guzzi Motorcycles,* 3rd edition. Milan: Giorgio Nada Editore, 2000.

MOTO MM
Ruffini, Enrico and Giampaolo Tozzi. *Moto MM.* Milan: Giorgio Nada Editore, 1988.

MOTO MORINI
Walker, Mick. *Morini.* Ipswich, UK: Transport Source Books, 1996.

MÜNCH
Scheibe, Winni. *Münch: The Legend, Friedel Münch and his Motorcycles.* Rosrath, Germany: Art Motor, 1995.

MV AGUSTA
Colombo, Mario and Roberto Patrignani. *Moto MV Agusta,* 2nd edition. Milan: Giorgio Nada Editore, 1997.

MZ
Walker, Mick. *MZ. Ipswich,* UK: Transport Source Books, 1996.

NEW IMPERIAL
Collin, Eddie. *The History of New Imperial.* Grantham, UK: Collin, 1990.

NIMBUS
Jørgensen, Knud. *Nimbus: Technical Developments.* Copenhagen: Book on Demand, 2016.

NORTON
Magrath, D. *Norton: The Complete Story.* Ramsbury, UK: Crowood Press, 1991.

NSU
Better Riding: A Journal for All Who Enjoy the Open Road. N.p.: NSU, 1957.

OEC
Collin, Eddie. *History of OEC, The* Grantham, UK: Grantley, 1987.

PANTHER
Jones, Barry M. *The Panther Story: The Story of Phelon & Moore Ltd.* High Wycombe, UK: Panther Publishing, 1999.

PEUGEOT
Salvat, Bernard and Didier Ganneau. *Motos Peugeot 1898–1998: 100 Ans d'Histoire.* Charnay-les-Mâcon, France: E.B.S., 1998.

POLARIS
Dapper, Michael and Lee Klancher. *The Victory Motorcycle.* Osceola, WI: MBI Publishing, 1998.

RALEIGH
Collin, Eddie. *The History of Raleigh.* Grantham, UK: Grantley, 1991.

REX-ACME
Collin, Eddie. *The History of Rex-Acme.* Grantham, UK: Grantley, 1988.

RICKMAN
Gittins, Dave. *The Rickman Story.* St. Harmon, UK: Ariel Publishing, 2001.

ROYAL ENFIELD
Walker, Mick. *Royal Enfield: The Complete Story.* Ramsbury, UK: Crowood Press, 2003.

RUDGE
Reynolds, Bryan. *Rudge-Whitworth: The Complete Story.* Ramsbury, UK: Crowood Press, 2014.

RUMI
Crippa, Riccardo. *Moto Rumi: The Complete Story.* Milan: Giorgio Nada Editore, 2005.

SAROLÉA
De Becker, Guy. *La Maison Saroléa.* Verviers, Belgium: Nostalgia Editions, 2001.

SCOTT
Clew, Jeff. *The Scott Motorcycle: The Yowling Two-Stroke.* Sparkford, UK: Haynes Publishing, 1974.

SOLEX
Salvat, Bernard. *Le VeloSolex: La Bicyclette qui Roule Toute Seule.* Paris: Massin Editeur, 1985.

SUNBEAM
Champ, Robert. *Cordon Sunbeam Bicycles and Motorcycles.* Sparkford, UK: Haynes Publishing, 1989.

SUZUKI
Clew, Jeff. *Suzuki.* Sparkford, UK: Haynes Publishing, 1980.

TRIUMPH
Brooke, Lindsay. *Triumph Motorcycles: A Century of Passion and Power.* St. Paul, MN: MBI Publishing, 2002.

TRIUMPH (German)
Knittel, Stefan. *Triumph Motorräder.* Rosrath, Germany: Schrader, 1991.

VELOCETTE
Burgess, RW and JR Clew. *Always in the Picture: A History of the Velocette Motorcycle.* Sparkford, UK: Haynes Publishing, 1980.

VESPA
Brockway, Eric. *Vespa: An Illustrated History.* Sparkford, UK: Foulis, 1993.

VICTORY
Dapper, Michael and Lee Klancher. *Victory Motorcycles, 1998–2017/* Austin, TX: Octane Press, 2017.

VILLIERS
Bacon, Roy. *Villiers Singles and Twins.* London: Osprey Publishing, 1983.

VINCENT/H.R.D.
Wright, David. *Vincent: The Complete Story.* Ramsbury, UK: Crowood Press, 2002.

YAMAHA
Macauley, Ted. *Yamaha.* London: Cadogan, 1983.

ZENITH
Collin, Eddie. *The History of Zenith.* Grantham, UK: Grantley, 1988.

RACES, RACING, AND COMPETITION

ROAD RACING
Blair, Alan. *Race to Win! A Complete Guide to Winning in Racing.* Gainesville, GA: Alan Blair Books, 2019.

Broadbent, Rick. *That Near-Death Thing: Inside the TT, The World's Most Dangerous Race* London: Orion, 2012.

Büla, Maurice. *Continental Circus: 1949–2000.* St. Sulpice, Switzerland: Chronosports, 2001.

Carrick, Peter. *Motor Cycle Racing.* London: Hamlyn, 1969.

Clifford, Peter. *The Art and Science of Motor Cycle Road Racing,* 2nd edition. Richmond, UK: Hazleton, 1985.

Code, Keith. *A Twist of the Wrist.* Los Angeles: Acrobat, 1983.

Crellin, Ralph. *Japanese Riders in the Isle of Man.* Laxey, UK Amulree, 1995.

Currie, Bob. *The Glory of the Manx TT.* London: New English Library, 1976.

Duckworth, Mick. *Classic Racing Motorcycles.* St. Paul, MN: Motorbooks International, 2003.

Duckworth, Mick. *TT100: The Official Authorised History of Isle of Man Tourist Trophy Racing.* Ramsey, UK: Lily Publications, 2007.

Duckworth, Mick and Alan Seeley. *Legendary Racing Motorcycles.* Leicestershire, UK: Abbeydale Press, 2007.

Emde, Don. *Daytona, 200: The Laguna.* Niguel, CA: Motorcycle Heritage, 1991.

Freudenberg, M. *The Isle of Man T.T: An Illustrated History, 1907-80.* Bourne End, UK: Aston, 1990.

Hailwood, Mike and Murray Walker. *The Art of Motorcycle Racing: 4th edition.* London: Cassell, 1966.

Harris, Nick. *Never Say Never: The Inside Story of the Motorcycle World Championships.* New York: Virgin Books, 2019.

Hartley, Peter. *Bikes at Brooklands in the Pioneer Years.* Norwich, UK: Goose, 1973.

Hendricks, J. *Superbike Preparation.* Osceola, WI: Motorbooks International, 1988.

Jenkinson, Denis. *Motorcycle Road Racing: The 1950s in Photographs.* Bourne End, UK: Aston, 1989.

Knight, Ray. *Road Bike Racing and Preparation.* London: Osprey Publishing, 1989.

Larson, Kent, Pat Hahn, Jason Bishop and Max McAllister. *Motorcycle Track Day Handbook.* St Paul, MN: Motorbooks, 2004.

Morrison, Ian. *Guinness Motorcycle Sport Fact Book.* Enfield, UK: Guinness, 1991.

Mortimer, Charles. *Brooklands and Beyond* Norwich: Goose & Son, 1974.

Noyes, Dennis, ed. *Motocourse: 50 Years of Moto Grand Prix.* Richmond, UK: Hazleton Publishing, 1999.

Robinson, John. *Ride It! The Complete Book of Endurance Racing.* Sparkford, UK: Haynes Publishing, 1979.

Scott, Michael. *MotoGP: The Illustrated History.* London: Carlton Books, 2010.

Tooth, Phillip. *The Art of the Racing Motorcycle.* New York: Universe Publishing, 2010.

Wernham, M and M Walker. *World Motorcycle Endurance Racing.* London: Osprey Publishing, 1994.

MOTOCROSS, ENDURO, AND CROSS COUNTRY
Bailey, Gary and C Shipman. *How to Win Motocross.* Tucson: HP Books, 1974.

Bonnello, Joe. *Supercross.* Osceola, WI: Motorbooks International, 1977.

Boonstra, Piet W. *The Golden Age of Enduros.* Buchanan, NY: Adventure Touring, 2005.

Brown, Don J. and Evan Aiken, eds. *How to Ride and Win!* Los Angeles: National Sports, 1956.

Gorr, Eric and Kevin Cameron. *Four-Stroke Motocross and Off-Road Performance Handbook.* Minneapolis: Motorbooks, 2011.

Gorr, Eric. *Motocross and Off-Road Motorcycle Performance Handbook.* Osceola, WI: Motorbooks International, 1996.

Milan, Garth. *Freestyle Motocross: Jump Tricks from the Pros.* Osceola, WI: MBI Publishing, 2000.

Sandham, Tommy. *The 'Scottish': 1900-1962.* Newport, UK: Willow, 1988.

Sandham, Tommy *The 'Scottish': 1963-1989.* Newport, UK: Willow,1989.

Smith, Jeff and Bob Currie. *The Art of Moto-Cross.* London: Cassell, 1966.

Smith, Jeff. *Jeff Smith on Scrambling.* London: Iliffe & Sons, 1960.

Thompson, Mark. *Motocross & Off-Road Training Handbook.* St Paul, MN: Motorbooks, 2006.

Venables, Ralph. *British Scrambles Motorcycles:* Leatherhead, UK: Bruce Main-Smith, 1986.

Westlake, Andy. *Off-Road Giants!* Poundbury, UK: Veloce Publishing, 2008.

OBSERVED TRIALS
Beesley, Tom. *The Mick Andrews Book of Trials.* Irvine, CA: Trippe, Cox Specialist Publications, 1976.

Bourne, Arthur B. *Trials and Trials Riding.* London: Iliffe & Sons, 1939.

Miller, Sammy. *Sammy Miller on Trials,* 2nd edition. Newport Beach, CA: Parkhurst, 1971.

Morley, Don. *Trials: A Rider's Guide*. London: Osprey Publishing, 1990.

SPEEDWAY

Bamford, Rober and Glynn Shailes. *A History of the World Speedway Championship*. Stroud, UK: Tempus Publishing, 2002.

Briggs, Barry. *Trackin' with Briggo*. London: Souvenir, 1975.

Elder, Sprouts. *The Romance of the Speedway*. London: Frederick Warne, 1930.

Hoare, Ron *Speedway Panorama Sparkford*, UK: Haynes Publishing, 1979.

Jacobs, Norman and Chris Broadbent. *Speedway's Classic Meetings*. Stroud, UK: Tempus Publishing, 2005.

Patrick, Mike. *Speedway Through the Lens of Mike Patrick*. Stroud, UK: Tempus Publishing 2003.

MISCELLANEOUS COMPETITION AND RACING-RELATED

Carrick, Peter. *Motor Cycle Racing*. London: Hamlyn Publishing, 1969.

Carrick, Peter. *Encyclopedia of Motor Cycle Sport*. New York: St. Martin's, 1977.

Emde, Don. *The Speed Kings: The Rise and Fall of Motodrome Racing*. Laguna Niguel, CA: Emde Publications, 2019.

Foster, Gerald. *Ride It! The Complete Book of Flat Track Racing*. Sparkford, UK: Haynes Publishing, 1978.

Hughes, Lynn. *Pendine Races: Motor Racing over Fifty Years*. Llandysul, UK: Gomer Press 2000.

Murphy, Tom. *The Fastest Motorcycles on Earth: The History of Land Speed Record Motorcycles*. North Conway, NH: Whitehorse Press, 2000.

Nelson, Mike. *A Guide to Motorcycle Drag Racing*. Englewood, OH: Atlantic Digital, 1992.

Wright, Stephen. *American Racer, 1900-1940*. Huntington Beach, CA: Megden, 1979.

Wright, Stephen. *American Racer 1940-1980*. Huntington Beach, CA: Megden, 1986.

TECHNICAL

Abdo, Edward. *Modern Motorcycle Technology* Clifton Park, NY: Delmar Cengage Learning, 2009.

Bacon, Roy. *Restoring Motorcycles 1: Four-Stroke Engines*. London: Osprey Publishing, 1988.

Bacon, Roy. *Restoring Motorcycles 2: Electrics*. London: Osprey Publishing, 1988.

Bacon, Roy. *Restoring Motorcycles 3: Transmissions*. London: Osprey Publishing, 1989.

Bacon, Roy. *Restoring Motorcycles 4: Two-Stroke Engines*. London: Osprey Publishing, 1989.

Bacon, Roy. *Restoring Motorcycles 5: Carburettors*. London: Osprey Publishing, 1989.

Bacon, Roy. *Restoring Motorcycles 6: Frames and Forks*. London: Osprey Publishing, 1989.

Bell, A Graham. *Two-Stroke Performance Tuning*. Sparkford, UK: Haynes Publishing, 1983.

Bell, A Graham. *Four-Stroke Performance Tuning*. 2nd edition Sparkford, UK: Haynes Publishing, 1998.

Bossaglia, Cesare. *Two-Stroke High Performance Engine Design and Tuning*. Chislehurst, UK: Lodgemark, 1972.

Bradley, John. *The Racing Motorcycle: A Technical Guide for Constructors*. York: Broadland Leisure Publications, 1996.

Cameron, Kevin. *Sportbike Performance Handbook*. Osceola, WI: MBI Publishing, 1998.

Clark, Nigel. *Classic Motorcycle Restoration and Maintenance*. Ramsbury, UK: Veloce Publishing, 2015.

Clew, Jeff. *The Restoration of Vintage and Thoroughbred Motorcycles*, new edition. Sparkford, UK: Haynes Publishing, 1990.

Cocco, Gaetano. *How and Why Motorcycle Design and Technology*. Milan: Giorgio Nada Editore, 1999.

Foale, T and V Willoughby. *Motor-Cycle Chassis Design: The Theory and Practice*. London: Osprey Publishing, 1984.

Gorr, Eric. *Motocross & Off-Road Performance Handbook*. St Paul, MN: Motorbooks International, 2004.

Irving, PE. *Motorcycle Engineering*. London: Temple Press, 1961.

Irving, PE. *Tuning for Speed*. 6th edition Sydney: Turton Armstrong, 1987.

Irving, PE. *Motorcycle Engineering*. Los Angeles: Floyd Clymer, c.1965.

Irving, Phil. *Motorcycle Technicalities*. Sydney: Turton Armstrong, 1983.

Jennings, Gordon. *Two-Stroke Tuner's Handbook*. N.p.: Jennings, 1973.

Lane, Billy. *Billy Lane's How to Build Old School Choppers, Bobbers and Customs*. St Paul, MN: Motorbooks, 2005.

Mitchel, Doug. *HowTo: Advanced Custom Motorcycle Chassis*. Stillwater, MN: Wolfgang Publications, 2007.

Noakes, Keith. *Motorcycle Road & Racing Chassis*. Poundbury, UK: Veloce Publishing 2007.

Purnell, Geoff. *Motor Cycle Restorer's Workshop Companion*. Cambridge, UK: Patrick Stephens, 1992.

Radco (Frank Farrington). *The Vintage Motorcyclist's Workshop*. Sparkford, UK: Haynes Publishing, 1986.

Remus, Tim. *How to Build a Chopper: From Bare Frame to Finished Motorcycle*. Stillwater, MN: Wolfgang Publications, 2001.

Robinson, John. *Motorcycle Tuning: Two-Stroke*. Oxford: Newnes, 1986.

Robinson, John. *Motorcycle Tuning: Four-Stroke*. Oxford: Newnes, 1986.

Robinson, John. *Motorcycle Tuning: Chassis*. Oxford: Newnes, 1990.

Shoemark, Peter. *Motorcycle Workshop Practice Manual*. Sparkford, UK: Haynes Publishing, 1991.

Thede, Paul and Lee Parks. *Race Tech's Motorcycle Suspension Bible*. Minneapolis: Motorbooks International, 2010.

Thompson, Mark. *Motocross and Off-Road Motorcycle Setup Guide*. Minneapolis: Motorbooks, 2010.

Trevitt, Andrew. *Sportbike Suspension Tuning*. Phoenix: David Bull Publishing, 2008.

Vogel, Carl. *Build Your Own Electric Motorcycle*. New York: McGraw-Hill, 2009.

Young, Sid. *How to Rebuild and Restore Classic Japanese Motorcycles*, Beverly, MA: Motorbooks International 2015.

Zimmerman, Mark and Jeff Hackett. *How to Restore Your Motorcycle*, 2nd edition. Minneapolis: MBI Publishing, 2010.

BIOGRAPHIES AND AUTOBIOGRAPHIES

Barger, Ralph "Sonny" with Keith and Kent Zimmerman. *Hell's Angel: The Life and Times of Sonny Barger and the Hell's Angels Motorcycle Club*. New York: William Morrow, 2000.

Barker, Stuart. *Barry Sheene, 1950-2003: The Biography*. London: CollinsWillow, 2003.

Belton, Brian. *Fay Taylour: Queen of Speedway*. High Wycombe, UK: Panther Publishing, 2006.

Briggs, Barry. *Briggo*. London: Souvenir, 1972.

Carrick, Peter. *Great Motor-Cycle Riders*. London: Robert Hale, 1985.

Clew, Jeff. *Sammy Miller: The Will to Win*. Sparkford, UK: Haynes Publishing, 1977.

Clew, Jeff. *Francis Beart: A Single Purpose*. Sparkford, UK: Haynes Publishing, 1978.

Clew, Jeff. *Lucky All My Life: The Biography of Harry Weslake*. Sparkford, UK: Haynes Publishing, 1979.

Clew, Jeff. *Sammy Miller Story*. New Milton, UK: Chard, 1993.

Collins, Ace. *Evel Knievel: An American Hero.* New York: St. Martin's Press, 1999.

Cox, Don and Will Hagon. *Australian Motorcycle Heroes: 1949-1989.* North Ryde, Australia: Angus, 1989.

Davison, Stephen. *Joey Dunlop: King of the Roads.* Dublin: The O'Brian Press, 2015.

Donaldson, Roger. *The World's Fastest Indian: Burt Munro - A Scrapbook of his Life.* Auckland: Random House, 2009.

Duff, Michelle Ann. *The Mike Duff Story: Make Haste Slowly.* Toronto: mad8 Publishing, 1999.

Dunlop, Michael. *Road Racer: It's in my Blood.* London: Michael O'Mara Books, 2017.

Falsaperla, Filippo: *Valentino Rossi: Legend.* London: Yellow Jersey Press, 2006.

Faught, Ken. *Jeremy McGrath: Images of a Supercross Champion.* St Paul, MN: Motorbooks International, 2004.

Fogarty, Carl with Neil Bramwell. *Foggy.* N.p.: CollinsWillow, 2000.

Hailwood, Mike and Ted Macauley. *Hailwood.* London: Cassell, 1968.

Harris, Nick and Peter Clifford. *Fast Freddie.* Croydon, UK: Motor Racing Publicatioins, 1986.

Hartgerink, Nick. *The Wayne Gardner Story.* Waterloo, Australia: Fairfax, 1987.

Henry, Alan. *John Surtees: World Champion.* Richmond, UK: Hazelton, 1991.

Irving, PE. *Phil Irving: An Autobiography.* Sydney: Turton and Armstrong, 1992.

Martin, Guy. *We Need to Weaken the Mixture!* London: Virgin Books, 2018.

Mase, Akira. *Mister Honda: Biography of Honda Soichiro.* Tokyo: SEL International, 1998.

Oxley, Mat. *Mick Doohan, Thunder from Down Under,* 2nd edition Sparkford, UK: Haynes Publishing, 2000.

Parrish, Steve and Nick Harris. *Barry: The Story of Motorcycling Legend Barry Sheene.* London: Sphere, 2007.

Rossi, Valentino with Enrico Borghi. *What if I Had Never Tried it: Valentino Rossi, The Autobiography.* Minneapolis: Motorbooks International, 2009.

Savage, Mike. *TT Heroes.* Laxey, UK: Amulree, 1997.

Seate, Mike. *Jesse James: The Man and His Machines.* St Paul, MN: Motorbooks International, 2003.

Vincent, Philip. *P.C.V.: The Autobiography of Philip Vincent.* UK: Vincent Pub, 1976.

Wain, Phil. *Guy Martin: Portrait of a Bike Legend.* London: Carlton Books, 2015.

White, Tomothy. *Indian Larry.* London: Merrell Publishers, 2006.

Youngblood, Ed. *John Penton and the Off-Road Motorcycle Revolution.* N.p.: Motohistory, 2007.

JUVENILE AND YOUNG ADULT

Abels, Harriette Sheffer. *The Haunted Motorcycle Shop.* Chicago: Childrens Press, 1978.

Armitage, Barry. *Motorcycles.* N.p.: Sterling, 1988.

Alth, Max. *Motorcycles and Motorcycling.* New York: Franklin Watts, 1979.

Motor Cycle Book for Boys. London: Iliffe & Sons, 1928.

Avery, Derek. *Motorcycles.* N.p.: Wordsworth, 1994.

Bartell, Andrew. *The Motorcycle: From Invention to Innovation.* Self-published, 2019.

Baumann, Elwood D. *An Album of Motorcycles and Motorcycle Racing.* New York: Franklin Watts, 1982.

Bumble, William. *Speedy Wheels.* N.p.: Scholastic, 1988.

Butcher, Grace. *Women in Sports: Motorcycling.* N.p.: Harvey House, 1976.

Carter, Ernest F. *The Boys' Book of Cycles and Motor Cycles.* New York: Roy Publishers, 1962.

Christopher, Matt. *Dirt Bike Racer.* N.p.: Little Brown, 1979.

Cleary, Beverly. *The Mouse and the Motorcycle.* N.p.: W. Morrow, 1965.

Dean, Anabel. *Motorcycle Racer.* Westchester, IL: Benefic Press, 1976.

Diaz, Kristen. *The Step-by-Step Way to Draw Motorcycles.* Self-published, 2019.

Escott, John. *Girl on a Motorcycle.* Oxford: Oxford University Press, 2008.

Evans, Jeremy. *Adventurers: Motocross and Trials.* N.p.: Crestwood, 1993.

Fontes, Ron. *Hands Off My Bike! (Biker Mice from Mars).* N.p.: Bullseye, 1994.

Frances, Marian. *Witch on a Motorcycle.* Mahwah, NJ: Troll, 1972.

Freeman, Gary. *Motocross.* Chicago: Heinemann Library, 2003.

Gibbs, Lynne. *Mega Book of Motorcycles.* London: Zigzag Children's Books, 2002

Graham, Ian. *Super Bikes.* New York: Franklin Watts, 2001.

Greene, Janice. *Dirt Rider.* Belmont, CA: Fearon, 1987.

Griffin, John Q. *Motorcycles on the Move: A Brief History.* Minneapolis: Lerner, 1976.

Hewett, Joan. *Motorcycle on Patrol: The Story of a Highway Officer.* N.p.: Clarion, 1986.

Hill, Ray. *Dirt Bikes: Scramblers/Trials/Motocross.* New York: Golden Press, 1974.

Hintz, Martin and Kate. *Hintz Motorcycle Drag Racing.* Mankato, MN: Capstone, 1996.

Houlgate, Deke. *All About Motorcycles.* N.p.: Scholastic, 1974.

Kaatz, Evelyn. *Motorcycle Road Racer.* New York: Little, Brown & Company, 1977.

LaFontaine, Bruce. *Motorcycles Coloring Book.* N.p.: Dover, 1995.

Lawrie, Robin. *Two Wheel Wonder: How Motorcycles Run and How They are Ridden.* New York: Pantheon, 1973.

Martin, John. *The World's Fastest Motorcycles.* Mankato, MN: Capstone Books, 1994.

Moseley, Keith and G Leonard. *Classic Motorcycles in Three Dimensions.* New York: Compass, 1996.

Oxlade, Chris. *Motorbikes.* Bath, UK: Parragon, 2001.

Pupeza, Lori Kinstad. *Custom Bikes: The Ultimate Motorcycles.* Edina, MN: Abdo Publishing Company, 1998.

Quintero, Isabel. *My Papi Has a Motorcycle.* New York: Kokila, 2019.

Smith, Tony R. *How to Draw Motorcycles for Kids.* Self-published, 2019.

Spiteri, Helena, ed. *The Ultimate Motorcycle Sticker Book.* New York: Dorling Kindersley, 1995.

Stambler, Irwin. *Minibikes and Small Cycles.* N.p.: Putnam's, 1977.

Sullivan, Karen. *Super Bikes.* London: Caxton Editions, 1998.

Yerkow, Charles. *Here is Your Hobby... Motorcycling.* N.p.: Putnam's, 1973.

I

THE MOTORCYCLE

INDEX

Page numbers in *italics* refer to illustrations

A
ABC *136–7*
Aermacchi Chimera 206, *206–7*
AF Vandevorst 111
Agostini, Giacomo 'Ago' 266
Ala d'Oro 206
Apple 39
Aprilia Moto 6.5 *258, 258–9, 283*
Ariel 218, 226
Art Deco 7, *44–5, 95, 166*
ArtCenter College of Design, Pasadena 34
Australia 7–8, 31, 42, 111
 1953 speed record 198, *199*
 The Drover's Dog 270, *270*
 history of motorcycles in 19–22, *20–3*
 Savic C-Series *294–5*
 Spencer 19, *20–1, 60, 63, 122–5,* 123
 Tilbrook Prototype *204–5*
 Whiting 22, *22–3,* 132, *132–3*
Austria
 KTM Rally 450 Dakar 276, *276–7*
 KTM Super Duke *268*
 Puch SGS *202–3*

B
Balla, Giacomo 94
Bandit 9 Eve Mk II 272, *272–3*
Barrez, Jean *95*
Bauer, Dr Stefan, Norton Commando *233*
Bauhaus 7, 44, 49, 144
Bayerische Motoren Werke *see* BMW
Beaumont, William Worby 16, 75
Beaux Arts 42
Belgium
 Minerva with Mills and Fulford Forecar *18,* 19, 120, *120–1*
 Socovel Electric *186–7,* 187
Bennell, Robert 152
Bianchi 94
Bianchi, Alfredo, Aermacchi Chimera 206, *206–7*
Bigsby, Paul A
 Crocker 176, *176–7*
 Crocker Speedway *170–1*
Bimota 266
 Bimota Tesi 3D *28, 29, 31, 60,* 266
 Bimota V-Due *263*
Black Art Racing, Suzuki Hayabusa *271*
BMW (Bayerische Motoren Werke) 44, 49, 78
 BMW 540i 60
 BMW M1 102
 BMW R12 *180–1*
 BMW R32 44, *46–7,* 49, 60, 63, 144, *144–5*
 BMW R80GS *248–9*
 BMW R90S *247*
 BMW S1000RR *78–9*
 The Great Escape 86, *88*
Boccioni, Umberto 94
Bonneville Salt Flats, Utah 139, 198
Boorman, Charley 78
Bordi, Massimo 34
 Ducati 851 Kit *245*
Bosozoku 86, 111
Bouton, Georges 16
boxer engine 44, *47,* 144
Bradshaw, Granville *136–7*
Brando, Marlon 78, 102, *104, 105*
Brands Hatch Circuit, UK *26–7*
Brembo brakes *294*
Bridge, Jöe *95*
British Matchless *99*
Britten, John *252–5,* 253
Britten V1000 *252–5,* 253
Brooklands, UK *218*
Brooks-style saddles *121*
Brough, George 172, *172–3*
Brough Superior 11-50 172, *172–3*
BSA Motorcycles 26, 229
 500 cc engine *274*
 BSA Catalina *69, 70, 71,* 218
 BSA Empire Star 218
 BSA Gold Star Catalina 218, *218–19*
 BSA Rocket 3 26, *26–7, 221,* 234
 BSA ZB-series Gold Star engine 70, *70*
 Triumph X-75 Hurricane *234*
Bultaco 226
 Sherpa T 226, *226–7*
Bultó, Francesc 'Paco' 226

C
Cagiva Design Group 34
Cagiva Research Centre (CRC) 266
Cake 49, *50–1,* 56
 Cake Kalk OR 49, 51, *52–3, 282, 282–3*
 Cake Ösa 49, *50–1*
C'Dora 126, *127*
China 26, 89
 Ninebot One S2 *286*
 Sur-Ron Light Bee X *292–3,* 293
Chopper bicycles *288*
Christoph, Rich, Indian Scout *280–1*
Cleveland CycleWerks Falcon BLK Founders Edition *290–1*
Cleveland Tricycle *16,* 17, *60, 118–19*
Colosimo, Scott, Cleveland Cyclewerks Falcon BLK Founders Edition *290–1*
Corbin Screw Corporation *155*
Crocker 176, *176–7,* 209
Crocker, Albert G *170–1,* 176, *176–7,* 209
Crocker Speedway *170–1*
Cruise, Tom 78, *80–1,* 89, *90–1*
Cugnot, Nicolas-Joseph 12, *14–15*

D
Daimler, Gottlieb 12, *13*
Dakar Rally 276
d'Ascanio, Corradino, Vespa 150GS *48,* 49, *210–13,* 213
Davidson, Willie G, Harley-Davidson XLCR *240*
de Dion-Bouton engine 16, *16, 19, 62,* 119
de Dion-Bouton tricycle *16, 17,* 19
Depero, Fortunato, *Il Motociclista (Solido in velocità)* 94, *98*
Deus ex Machina 270
Dion, Count Jules-Albert de 16
Dixon, Freddie
 Douglas DT/5 Speedway *162–3,* 163
 Harley-Davidson FHA 152
Doerksen, Kyle, Onewheel XR *278*
Douglas 132
 Douglas DT/5 Speedway *162–3,* 163
Dresch, Usines 168
Dresch Monobloc *168*
The Drover's Dog 270, *270*
Ducati 34, 266
 Ducati 750SS *238, 238–9*
 Ducati 851 Kit *245*
 Ducati 916 34, *35*
 Ducati 916 SP *260–1,* 266, *267*
 Ducati engines *28,* 31
 Ducati M900 Monster 34, *35,* 256, *256–7,* 258
Dyson, Freeman 75

E
Eastwood, Clint 78
Easy Rider 7
Ehret, Jack 198, *199*
Einstein, Albert 94
'electromobile' *72–3*
Elizabeth II, Queen 111
Energica Ego Corsa *30,* 31
English Road Acts (1861 and 1865) 19

F
Faithfull, Marianne 78, *78–9*
Falco, Charles M 7, 8, 39
Feldbergrennen *101*
Ferguson, Rebecca 89
Ferrari 266
Fleabag 86
Fletcher, Jack *130*
Ford Model T 94
France 94
 Cugnot steam-powered car 12, *14–15*
 Dresch Monobloc *168*
 Gnome et Rhône LC531 *200–1*
 Koehler-Escoffier Motoball Special *174–5*
 La Pétrolette 12, *13*

Majestic 44, *44–5, 166–7, 285*
Michaux bicycle 56
motorcycle design in 39, 42, 44, *44–5*
Perreaux Steam Velocipede 7, *36–7*, 39, 56, *57*, 116, *116–17*, 187
Peugeot P104 *42–3, 150–1*
Franklin, Charles B *182–5*
Friz, Max, BMW R32 44, 144, *144–5*
Fuji 22
 Rabbit S-1 22, *24*
Fuller, Craig *284–5*
Fuller Moto 2029 *284–5*
Futurism 94, 102, 111
Fynn, Huck, Huck Fynn JAP Speedway *194–5*

G

Gallery of Modern Art, Brisbane 7
Galluzzi, Miguel Angel 34
 Ducati M900 Monster 256, *256–7*
Gehry, Frank 34, 42
Germany 12, 44
 BMW R12 *180–1*
 BMW R32 44, *46–7*, 49, 60, *63*, 144, *144–5*
 BMW R80GS *248–9*
 Imme R100 192, *192–3*
 Opel Motoclub Neander *164–5*
 The Girl on a Motorcycle 78, *78–9*
GK Design Group, Yamaha V-Max 250, *250–1*
Globe of Death 126
Gnome et Rhône 42, *100*
 Gnome et Rhône LC531 *200–1*
Grant, Cary 82
The Great Escape 86, *88*
Griffon Motorcycles *64*
Gropius, Walter 44
Guggenheim Museum Bilbao 34
Guggenheim Museum New York 42
Guilfoyle, Ultan 7, 8
Gutsche, Rüdiger, BMW R80GS *248–9*
Guzzi, Carlo *146–7*

H

Hadid, Zaha 34
Hajjaj, Hassan, 'Kesh Angels' 111, *112–13*
Handley, Walter 218
Harley, William S 42
 Harley-Davidson 10F *130–1*
The Harley-Davidson Enthusiast 130
Harley-Davidson Motor Company 89, 94, 229
 Harley-Davidson 10F *130–1*
 Harley-Davidson DAH *169*
 Harley-Davidson FHA 152, *152–3*
 Harley-Davidson FL *188–9*
 Harley-Davidson JDH Special 96, *154–5*
 Harley-Davidson Knucklehead Chopper *236–7*
 Harley-Davidson Knucklehead Kenilworth AM1 *110–11*, 111
 Harley-Davidson Model SA Peashooter *156–7*
 Harley-Davidson Sportster XL *208–9*, 209
 Harley-Davidson VRSCA V-Rod *264–5*
 Harley-Davidson XLCR *240*
 Harley-Davidson XR750 *241*
 Hells Angels 83, *84–5*
 in Japan 22, *24*
 leathers 102, 109
 V-twin racer *41*
Hayes family 139
Hazan, Max *274–5*
Hazan Black Knight *274–5*
Hedstrom, Carl Oscar 42
 Indian 8-Valve *134–5*
 Indian Single C'Dora 126, *126–7*
Hells Angels 83, *84–5*
Hendee, George M 42
Henderson, Tom 128
Henderson, William 128, *128–9*
Henderson Motorcycle Company, Henderson Four 128, *128–9*
Hepburn, Audrey *82*
Hildebrand, Henrich 12, *13*, 56
Hildebrand, Wilhelm 12, *13*, 56
Hildebrand und Wolfmüller 56, *57, 58–9*, 178
hobby-horses 37, 116
Honda, Soichiro, Honda C102 Super Cub 214, *214–15*
Honda Motor Company 22, 34, 272, 282
 adverts 102, *103*
 Honda C102 Super Cub 214, *214–15*
 Honda CB750 25, 26, *228–9*, 229, 247
 Honda CBR650R 60, *61*
 Honda CR250R *262*
 Honda Elsinore *232*
Hooper, Bernard, Norton Commando *233*
Hopwood, Bert, Norton Commando *233*
Houdini 126
Huck Fynn JAP Speedway *194–5*
Husqvarna Vapenfabrik, Husqvarna 250 *220*

I

Ichijo, Atsushi, Yamaha V-Max *250–1*, 250
Imme R100 192, *192–3*
India, motorcycle sales in 26, 89
Indian Motocycle Company 16, 94
 adverts *65*
 Indian 8-Valve 65, *66, 134–5*
 Indian Chief with Sidecar *182–5*
 Indian Hillclimber *148–9*
 Indian Model 401 *96, 160*
 Indian Scout *280–1*
 Indian Scout Special *138–41*, 139
 Indian Single C'Dora *19*, 126, *126–7*
Indonesia 7
International Style 42
Ironhead engine 209
Irving, Phil
 Vincent Black Lightning 198, *198–9*
 Vincent Rapide 198
Italy
 Aermacchi Chimera 206, *206–7*
 Aprilia Moto 6.5 258, *258–9, 283*
 Bimota V-Due *263*
 Ducati 750SS 238, *238–9*
 Ducati 851 Kit *245*
 Ducati 916 SP *260–1*, 266, *267*
 Ducati M900 Monster 34, *35*, 256, *256–7*, 258
 Laverda Jota *242–3*
 Moto Guzzi Super Alce *190–1*
 Moto Guzzi Tipo Normale *146–7*
 MV Agusta 125 Tel Turismo *196–7*
 MV Agusta 750S *230–1*
 MV Agusta F4 AGO 266, *266–7*
 Vespa 150GS 49, *210–13*, 213
 Vespa Elettrica *287*
Ive, Jonathan 39

J

Japan 22, 26
 Harley-Davidson motorcycles 22, 24
 Honda C102 Super Cub 214, *214–15*
 Honda CB750 25, 26, *228–9*, 229, 247
 Honda CR250R *262*
 Honda Elsinore *232*
 Kawasaki Mach III *224–5*
 Kawasaki Ninja *244*
 Suzuki GSX1100 Katana *246–7*, 247
 Suzuki Hayabusa *271*
 Yamaha V-Max 250, *250–1*
Jennings, Dare, The Drover's Dog 270, *270*
John A Prestwich (JAP) engines 132, 172, *195*, 218

K

Kamen, Dean, Segway PT 269, *269*
Kawasaki Heavy Industries Motorcycle & Engine Company, Kawasaki Ninja *244*
Kawasaki Motor Corporation 22, 26, 34
 Kawasaki KZ750 twin *288*
 Kawasaki Mach III *224–5*
 Kawasaki Ninja *244*
 Kawasaki Ninja GPZ900R 89, *90–1*
Kenilworth AM1 *110–11*
Kiska, Gerald, KTM Super Duke *268*
Koehler-Escoffier, Motoball Special *174–5*
Kravtchouk, Taras, Tarform Luna Founders Edition *296–7*
KTM 282
 KTM Rally 450 Dakar 276, *276–7*
 KTM Super Duke *268*

L

La Pétrolette 12, *13*
Laverda Jota *242–3*
Lawrence, TE (Lawrence of Arabia) 172
Lemmon, Arthur *160*
Limelette, Albert de 187
Limelette, Maurice de *186–7*, 187
Long Way 78

M

McGregor, Ewan 78
McQueen, Steve 78, 86, *86–7*, *88*
Majestic 44, *44–5*, *166–7*, *285*
Marinetti, FT 94
Meccanica Verghera
　MV Agusta 125 Tel Turismo *196–7*
　MV Agusta 750S *230–1*
Michaux, Pierre 39, 56, 116
Michaux bicycle 116
Mies van der Rohe, Ludwig 42
Milan Motorcycle Show 206
Miller, Sammy, Bultaco Sherpa T 226, *226–7*
Mills and Fulford forecar *18*, 120, *120–1*
Mineola 102, *108*
Minerva with Mills and Fulford Forecar *18*, 19, 120, *120–1*
Mission: Impossible 2 78, *89*
Mission: Impossible – Rogue Nation 78, *80–1*, *89*
Mitsubishi 22
Modernism 42
Monet-Goyon 42
Moore, Walter *161*
Moto Guzzi
　Moto Guzzi Super Alce *190–1*
　Moto Guzzi Tipo Normale *146–7*
Moto Laverda, Laverda Jota *242–3*
Motoball *175*
Motorcycle News 126
Motorcycles Peugeot, Peugeot P104 *150–1*
Motorrad 56
Motos Gnome-Rhône, Gnome et Rhône LC531 *200–1*
Motosacoche *95*
Munro, Burt *138–41*, 139
Museum of Modern Art, New York 7
Muth, Hans, Suzuki GSX1100 Katana *246–7*, 247
MV Agusta
　MV Agusta 125 Tel Turismo *196–7*
　MV Agusta 750S *230–1*
　MV Agusta F4 AGO 266, *266–7*

N

Ner-a-Car *142–3*
Neracher, Carl A *142–3*
Neumann, Ernst *164–5*
New York Hippodrome 126

New Zealand 152, 198
　Britten V1000 252–5, *253*
　Indian Scout Special *138–41*, 139
New Zealand Southern Cross 253
Night Wolves 83
Ninebot One S2 *286*
Norton 39, *40*
　Norton Commando 229, *233*
　Norton CS1 *161*
NS 22

O

O'Brien, Dick, Harley-Davidson XR750 241
Ogle Design, Rocket 3 221
Onewheel XR 278
Opel Motoclub Neander 164–5
'ordinaries' 37
Otto, Nikolaus 12

P

Page, Valentine
　BSA Gold Star Catalina 218, *218–19*
　Triumph Model 6/1 178
Pannaggi, Ivo 94
Paris Fashion Week (2015) 111
penny farthings 37
Perreaux, Louis-Guillaume 12, *36–7*, 39, 56, 116, *116–17*, 187
Perreaux Steam Velocipede 7, 12, 31, *36–7*, 39, 56, *57*, 116, *116–17*, 187
Perry, Grayson, Kenilworth AM1 *110–11*, 111
Peugeot 42
　Peugeot P104 *42–3*, *150–1*
　Scoot'Elec 75, 269
Piaggio 49
　Vespa 150GS *201–13*
　Vespa Elettrica *287*
Piaggio, Enrico 211, 215
Piccinini, Patricia 111
Pierce family *141*
POC (Piece of Cake) 49
Pop art 102, 111
Porsche Engineering, Harley-Davidson VRSCA V-Rod *264–5*
Prada 102
Presley, Elvis 209
Price, Toby 276, *277*
Puch SGS *202–3*
Pullin, Cyril *162–3*, 163
Putin, Vladimir 83

Q

Queensland Art Gallery | Gallery of Modern Art 7
Queensland Police Force 123

R

Rabbit 22, *24*
Reitwagen mit Petroleum Motor 12, *13*
Revelli, Mario 206
Riedel, Norbert, Imme R100 192, *192–3*
Rikuo 22, *24*
Rio 39
Rochas, Alphonse Beau de 12, 56
Rocket 3 26, *26–7*, 234
Rodsmith, Craig *279*
Rodsmith Corps Léger *279*
Rollie Free 198
Roman Holiday *82*, 83
Roper, Sylvester 12
Roy, Georges 44, *44–5*, *166–7*
Royal Enfield 39, 94, *97*

S

Savic, Dennis
Savic C-Series *294–5*
Schott 102, *105*
Scott, Alfred Angas *158–9*
Scott Flying Squirrel *158–9*
Seagram Building, New York 42
Segway-Ninebot 49
　Ninebot One S2 *286*
　Segway PT 269, *269*
Shackleton, Harry, Scott Flying Squirrel *158–9*
Shimazu, Narazo 22
Silver Pigeon 22
Simmons Bilt 102
Sironi, Mario 94
Smith, Rothie and Digger 152
Société Anonyme Minerva 120, *120–1*
Socovel 74, 75, 269
　Socovel Electric *186–7*, 187
Solomon R Guggenheim Museum, New York, *The Art of the Motorcycle* (1998) 7
Spain, Bultaco Sherpa T 226, *226–7*
Spencer 19, *20–1*, 60, *63*, *122–5*, 123
Spencer, David 8, 19, *20–1*, *122–5*, 123
Starck, Philippe, Aprilia Moto 6.5 258, *258–9*, *283*
Steyr-Daimler-Puch, Puch SGS *202–3*
Sucher, Dr Harry 176
Sur-Ron Light Bee X *292–3*, 293
Suzuki 22, 26
　Suzuki GSX1100 Katana *246–7*, 247
　Suzuki Hayabusa *271*
Sweden
　Cake Kalk OR 49, 51, 282, *282–3*
　Husqvarna 250 *220*
Sydney Opera House 42

T

Taglioni, Fabio
 Ducati 750SS 238, *238–9*
 Ducati 851 Kit *245*
Tamburini, Massimo
 Bimota V-Due *263*
 Ducati 916 SP 34, *35*, 260–1, 266, *267*
 MV Agusta F4 AGO 266, *266–7*
Tarform Luna Founders Edition *296–7*
Terrot 42
Thailand 7
Tilbrook, Rex *204–5*
Tilbrook Prototype *204–5*
Top Gun 89, *90–1*
Trailsaver tyres *283*
Trigg, Bob, Norton Commando *233*
Triumph Engineering 39, 94, 229
 adverts *179*
 in art 78, 102
 logos *41*, 97
 Triumph Bonneville *216–17*
 Triumph Model 6/1 *178*
 Triumph Speed Triple 89
 Triumph Speed Twin 178, *178–9*
 Triumph TR6 86, *88*
 Triumph TR6SC *86–7*
 Triumph X-75 Hurricane 234, *234–5*
Tuckwell, Carby, The Drover's Dog 270, *270*
Turner, Edward
 Triumph Bonneville *216–17*
 Triumph Speed Twin 178, *178–9*
Turner Prize 111

U

Udall, Charles, Norton Commando *233*
United Kingdom 39, 102
 ABC *136–7*
 Brough Superior 11-50 172, *172–3*
 BSA Gold Star Catalina 218, *218–19*
 BSA Rocket 3 26, *26–7*, 234
 Douglas DT/5 Speedway *162–3*, 163
 history of motorcycles in 12, 19, 26
 Huck Fynn JAP Speedway *194–5*
 Norton Commando 229, *233*
 Norton CS1 *161*
 Scott Flying Squirrel *158–9*
 Triumph Bonneville *216–17*
 Triumph Speed Twin 178, *178–9*
 Velocette Sportsman *222–3*
 Vincent Black Lightning 198, *198–9*
United States of America 12, 209
 Cleveland CycleWerks Falcon BLK Founders Edition *290–1*
 Cleveland Tricycle 16, *17*, 60, *118–19*
 Crocker 176, *176–7*, 209
 Crocker Speedway *170–1*
 Fuller Moto 2029 *284–5*
 Harley-Davidson 10F *130–1*
 Harley-Davidson DAH *169*
 Harley-Davidson FHA 152, *152–3*
 Harley-Davidson FL *188–9*
 Harley-Davidson JDH Special *154–5*
 Harley-Davidson Knucklehead Chopper *236–7*
 Harley-Davidson Model SA Peashooter *156–7*
 Harley-Davidson Sportster XL *208–9*, 209
 Harley-Davidson VRSCA V-Rod *264–5*
 Harley-Davidson XLCR *240*
 Harley-Davidson XR750 *241*
 Hazan Black Knight *274–5*
 Henderson Four 128, *128–9*
 history of motorcycles in 19, 26
 Indian 8-Valve *134–5*
 Indian Chief with Sidecar *182–5*
 Indian Hillclimber *148–9*
 Indian Model 401 *96*, *160*
 Indian Scout *280–1*
 Indian Scout Special *138–41*, 139
 Indian Single C'Dora 126, *126–7*
 motorcycle design and marketing 42, 102, *103*
 Ner-a-Car *142–3*
 number of households owning motorcycles 7
 Onewheel XR *278*
 Rodsmith Corps Léger *279*
 Segway 269, *269*
 Tarform Luna Founders Edition *296–7*
 Triumph X-75 Hurricane 234, *234–5*
 Zooz Concept 01 288, *288–9*
Universal Japanese Bike (UJB) 247
Utzon, Jørn 42

V

Veloce *222–3*
Velocette
 Velocette Sportsman *222–3*
 Velocette Thruxton *25*, 26
Vespa *48*, 49, *82*, 83, 214
 Vespa 150GS *210–13*, 213
 Vespa Elettrica *287*
Vetter, Craig, Triumph X-75 Hurricane 234, *234–5*
Vietnam 7
 Bandit 9 Eve Mk II 272, *272–3*
Villanueva, Daryl, Bandit 9 Eve Mk II 272, *272–3*
Villiers engines *204*
Vincent
 Vincent Black Lightning 198, *198–9*
 Vincent Black Shadow 198
 Vincent Rapide 198
Vincent, Phil 198, *198–9*
Volta, Alessandro 75

W

Waller-Bridge, Phoebe 86
Warhol, Andy 102, 111
 The Last Supper (the Big C) 102, *106–7*
 Marlon 102, *104*
 Mineola Motorcycle 102, *108*
Werner motocyclette *18*, 19
West Maitland, New South Wales, Australia 163
Whalen, Don 176
Whiting 22, *22–3*, 132, *132–3*
Whiting, Saville 22, *22–3*, 132, *132–3*
The Wild One 7, 102, *104*, *105*
Wolfmüller, Alois 12, *13*, 56
World Superbike 245
Wright, Frank Lloyd 42
Wright brothers 94

Y

Yamaha 22, 26, 34
 Yamaha SR400 270
 Yamaha V-Max 250, *250–1*
Ytterborn, Stefan 49, 51
 Cake Kalk OR 282, *282–3*
 Cake Ösa *50–1*
Yves Saint Laurent 102

Z

Zahner, Christopher 288, *288–9*
Zooz Concept 01 288, *288–9*
Zylstra, Pieter, Harley-Davidson XR750 *241*

PICTURE CREDITS

Courtesy A e-Bikes/Sur-Ron Australia: 292, 293; AF archive/Alamy Stock Photo/© Film Company Paramount Pictures: 80; Albatross/Alamy Stock Photo: 65; Courtesy American Honda Motor Company, Torrance, California and Solomon R Guggenheim Museum, New York/© American Honda Motor Company, Inc: 25t; ART Collection/Alamy Stock Photo: 97b; Arundel Collection/Photographs: Anne-Marie De Boni: 96b, 148, 149, 182, 183, 184, 185; Arundel Collection/Photographs: Natasha Harth; 66, 134,135, 160; The Australian Motorlife Museum - Paul Butler Collection/Photographs: Penelope Clay: 20, 63t, 122, 124, 125; The Barber Vintage Motorsports Museum, Birmingham, Alabama, USA/Photographs: Marc Bondarenko: 25b, 28, 29, 41t, 97t, 146, 147, 178, 179b, 192, 193, 206, 207, 216, 217, 228, 258, 259; Andrea Beavis: 236; Collection of Ruth Belin and Ivan Munro/© Solomon R Guggenheim Foundation, New York/Photographs: Marc Bondarenko: 250, 251; The Peter and Frances Bender Collection/© Bonhams Auctioneers: 198, 199; The Peter and Frances Bender Collection/Photographs: Tero Sade: 172, 173, 234, 235; BMW Historical Archives: 47t; Anne-Marie De Boni: 264; Collection of Andrew Boyes/Photographs: John Downs: 224, 225b; Bunch Family Collection/Don Whalen Curator/Photographs: Markus Cuff: 17, 19, 118, 119, 126, 127, 142b, 143; Cake: 50, 51, 282, 283b; Calleja Collection, Melbourne/Photographs: Anne-Marie De Boni: 190, 208, 233, 246, 248, 249; Classic Bike, Kettering, England/Images courtesy Solomon R Guggenheim Museum, New York: 225t, 242t; Penelope Clay: 162; Courtesy the Clyde Crouch Collection/Photographs: Robert LaPrelle: 128, 129, 136, 137, 138, 140, 141; © Musée des arts et métiers-Cnam/Photographs: A Doyere: 14; Culture Club/Getty Images: 18t; Daimler: 47b; Collection M and J Daley/Photographs: John Downs: 220; Collection Trevor Dean/Photographs: Penelope Clay: 46, 144, 145, 180, 181; Michel Descamps/Paris Match via Getty Images: 87; Deus Ex Machina: 270; John Downs: 35t; Energica: 30; Everett Collection, Inc/Alamy Stock Photo: 88; Feldbergrennen.de/Hansjorg Meister: 101; Collection of Gordon Forrester/Photographs: Anne-Marie De Boni: 240; Courtesy Johnny Gee's Antique Motorcycles/Photographs: Anne-Marie De Boni: 280, 281; Glasshouse Images/Alamy Stock Photo: 105; © Solomon R Guggenheim Foundation, New York/Photographs: David Heald: 63b, 254, 255, 238, 239; © Solomon R Guggenheim Foundation, New York/Photographs: Randy Leffingwell: 214, 215, 242b, 243; Courtesy Solomon R Guggenheim Museum, New York: 64, 95, 142t, 179t; © Haas Moto Galleries LLC/Photographs: Brent Graves: 18b, 120, 121; © Haas Moto Galleries LLC/Photographs: Grant Schwingle: 43, 45, 74, 150, 151, 164, 165, 166, 167, 168, 174, 175, 186, 200, 202, 203, 274, 275, 279, 284, 285; Harley City Collection/Photographs: Anne-Marie De Boni: 96t, 130b, 131, 152, 153, 154, 155, 156, 157, 169, 170, 176, 177, 241; Harley-Davidson Archives: 41b; Natasha Harth: 52, 282t; Heritage Image Partnership Ltd/Alamy Stock Photo: 99; Honda Australia Motorcycle and Power Equipment Pty Ltd: 262; Honda Australia: 61; George Jackman for Queensland Newspapers Pty Ltd/Image courtesy State Library of Queensland, Brisbane: 9; jansos/Stockimo/Alamy Stock Photo: 110; Kendal Maroney Collection (KMC)/Photographs: Anne-Marie De Boni: 188, 189; Kim Krebs and Greg Watters and Jim Higgins (Black Art Racing)/Photographs: Kim Krebs: 271; KTM GROUP: 268; Courtesy LAND/Cleveland CycleWerks: 290, 291; Lowe Family Collection/Photographs: Penelope Clay: 23, 132, 133; Courtesy: M.A.D. Gallery, Geneva: 272, 273; Collection of Robert Marro/Photographs: Anne Marie De Boni: 35b, 196, 197, 230, 231, 245, 260, 261, 263, 266, 267; Collection of Dennis Martin/Owner: Paul Martin/Photographs: Brayden Mann: 204, 205; Mercedes-Benz Classic: 13t; Motoring Picture Library/Alamy Stock Photo: 13b; Moviestore Collection Ltd/Alamy Stock Photo: 90; OneWheel: 278; Mick Osbaldeston/Flickr: 221; PA Images/Alamy Stock Photo: 27; © Film Company Paramount Pictures: 82; Jean-Pierre Praderes: 117; Courtesy Piaggio Historical Archive, Pontedera: 48; Toby Price Collection/Image courtesy KTM GROUP/Photographs: Future7Media: 276, 277; Collection Mr J and Master T Randel/Photographs: John Downs: 226, 227, 232; Bill Ray/The LIFE Picture Collection via Getty Images: 84; Michael Reilly Collection, Brisbane/Photographs: John Downs: 69, 71, 218, 219; Collection of John Richardson/Photographs: Anne-Marie De Boni: 40, 161; Courtesy Savic Motorcycles/Photographs: Jason Lau: 294, 295; © 2020 Photo Scala Florence/Heritage Images: 109 Scaysbrook Family Collection/Photographs: Jim Scaysbrook: 222; Collection Département des Hauts-de-Seine/Musée du Domaine départemental de Sceaux/Photographs: Olivier Ravoire: 116; Segway-Ninebot: 269, 286; Collection Mr and Mrs Hans Sprangers/Photographs: Penelope Clay: 158, 159; SSPL/Getty Images: 36; Sunset Boulevard/Corbis via Getty Images: 79; Swim Ink 2, LLC/CORBIS/Corbis via Getty Images: 100; Collection of Jerry Tamanini/Image courtesy Solomon R Guggenheim Museum, New York/© American Honda Motor Company, Inc: 103; Tarform Motorcycles: 296, 297; Museum of New Zealand Te Papa Tongarewa: 252, 253; Vespa Australia/Image courtesy PS Importers: 287; Vespa House and Frank Tonon/Photographs: Anne-Marie De Boni: 210, 211, 212, 213; Vigo Gallery, London: 112; Troyce Walls/WikiCommons: 24b; © The Andy Warhol Foundation for the Visual Arts, Inc/ARS. Copyright Agency, 2020: 104, 107, 108; Tony Webb Speedway Collection/Photographs: John Downs: 194, 195; The RJ Webber Desmo Collection, Gold Coast/Photographs: John Downs: 256, 257; Courtesy WheelsAge.org: 244; Wikimedia Commons: 37, 98; Collection of George and Milli Yarocki/Image courtesy Solomon R Guggenheim Museum, New York/© Harley-Davidson Motor Company: 130t; Zooz Bikes: 288, 289.

Cover image: courtesy Museum of New Zealand Te Papa Tongarewa

Every reasonable effort has been made to acknowledge the ownership of copyright for photographs included in this volume. Any errors that may have occurred are inadvertent, and will be corrected in subsequent editions provided notification is sent in writing to the publisher.

ACKNOWLEDGEMENTS

This book was published in conjunction with *The Motorcycle: Design, Art, Desire*, an exhibition organised by the Queensland Art Gallery | Gallery of Modern Art (QAGOMA) and held at GOMA, Brisbane, Australia, 28 November 2020 – 26 April 2021.

LENDERS

The Queensland Art Gallery | Gallery of Modern Art and the Curators gratefully acknowledge the following lenders of motorcycles to the exhibition:

A E-BIKES / SUR-RON AUSTRALIA
2020 Sur-Ron Light Bee X

ARUNDEL COLLECTION
1916 Indian 8-Valve
1926 Indian Hillclimber
1928 Indian Model 401
1940 Indian Chief with Sidecar

THE AUSTRALIAN MOTORLIFE MUSEUM – PAUL BUTLER COLLECTION
1906 Spencer

THE BARBER VINTAGE MOTORSPORTS MUSEUM, BIRMINGHAM, ALABAMA, USA
1924 Moto Guzzi Tipo Normale
1949 Imme R100
1995 Aprilia Moto 6.5

COLLECTION OF RUTH BELIN AND IVAN MUNRO
1992 Yamaha V-Max

THE PETER AND FRANCES BENDER COLLECTION
1935 Brough Superior 11-50
1951 Vincent Black Lightning
1973 Triumph Hurricane

COLLECTION OF ANDREW BOYES
1969 Kawasaki Mach III

BUNCH FAMILY COLLECTION, DON WHALEN, CURATOR
1898 Cleveland Tricycle
1908 Indian Single C'Dora
1921 Ner-a-Car

CAKE
2019 Cake Kalk OR

CALLEJA COLLECTION, MELBOURNE
1948 Moto Guzzi Super Alce 500
1958 Harley-Davidson Sportster XL
1973 Norton Commando
1990 Suzuki GSX1100 Katana
1991 BMW R80GS

CLYDE CROUCH COLLECTION
1912 Henderson Four
1919 ABC
1920 Indian Scout Special

COLLECTION OF M AND J DALEY
1967 Husqvarna 250

COLLECTION OF TREVOR DEAN
1924 BMW R32
1939 BMW R12

DÉPARTEMENT DES HAUTS-DE-SEINE / MUSÉE DU DOMAINE DÉPARTEMENTAL DE SCEAUX
1871 Perreaux Steam Velocipede

TERRY DOYLE OF KEW, MELBOURNE
1957 Aermacchi Chimera

COLLECTION OF COLIN EVERINGHAM
1938 Triumph Speed Twin

COLLECTION OF GORDON FORRESTER
1977 Harley-Davidson XLCR

BOBBY HAAS AND HAAS MOTO MUSEUM
1903 Minerva with Mills and Fulford Forecar
1926 Peugeot P104
1929 Opel Motoclub Neander
1930 Majestic
1931 Dresch Monobloc
1936 Koehler-Escoffier Motoball Special
c.1942 Socovel Electric
1954 Gnome et Rhône LC531
1955 Puch SGS
2016 Bandit 9 Eve Mk II
2016 Hazan Black Knight
2018 Rodsmith Corps Léger
2019 Fuller Moto 2029

HARLEY CITY COLLECTION
1914 Harley-Davidson 10F
1927 Harley-Davidson FHA
1928 Harley-Davidson JDH Special
1928 Harley-Davidson Model SA Peashooter
1933 Harley-Davidson DAH
1934 Crocker Speedway
1938 Crocker
1977 Harley-Davidson XR750

COLLECTION OF DAVID AND COLLEEN HOWE
1960 Honda C102 Super Cub

JOHNNY GEE'S ANTIQUE MOTORCYCLES
2018 Indian Scout

KIM KREBS AND GREG WATTERS AND JIM HIGGINS (BLACK ART RACING)
2016 Suzuki Hayabusa

LAND / CLEVELAND CYCLEWERKS
2020 Falcon BLK Founders Edition

LOWE FAMILY COLLECTION
1914 Whiting

COLLECTION OF JOHN MCNAIR
1972 Honda CB750

KENDAL MARONEY COLLECTION (KMC)
1943 Harley-Davidson FL

COLLECTION OF ROBERT MARRO
1949 MV Agusta 125 Tel Turismo
1972 MV Agusta 750S
1988 Ducati 851 'Kit'
1996 Ducati 916 SP
2002 Bimota V-Due
2005 MV Agusta F4 Ago

COLLECTION OF DENNIS MARTIN / OWNER – PAUL MARTIN
1956 Tilbrook Prototype

JOSEPH MILDREN/DEUS EX MACHINA, SYDNEY
2009 The Drover's Dog

JONATHAN MUNN / CLASSIC STYLE MOTORCYCLES
1958 Matchless 350 Factory Trials
1961 Triumph Bonneville
1966 Suzuki T20 250 Hustler
1994 Triumph Speed Triple

COLLECTION OF BOB MUSS
1929 Ariel Model F

TOBY PRICE COLLECTION
2016 KTM Rally 450 Dakar

PRIVATE COLLECTION
1929 Douglas DT5 Speedway

PRIVATE COLLECTION
c.1973 Harley-Davidson Knucklehead Chopper

PRIVATE COLLECTION
1969 BSA Rocket 3

PRIVATE COLLECTION
1974 Ducati 750SS

PRIVATE COLLECTION
1981 Laverda Jota
2003 Harley-Davidson VRSCA V-Rod

PRIVATE COLLECTION
1994 Britten V-1000

COLLECTION OF J AND T RANDEL
1971 Bultaco Sherpa T
1973 Honda Elsinore

MICHAEL REILLY COLLECTION, BRISBANE
1963 BSA Gold Star Catalina

COLLECTION OF JOHN RICHARDSON
1929 Norton CS1

SAVIC MOTORCYCLES
2020 Savic C-Series

SCAYSBROOK FAMILY COLLECTION
1969 Velocette Sportsman

SEGWAY-NINEBOT ICT PTY LTD
2006 Segway PT
2020 Ninebot One S2

COLLECTION OF MR AND MRS HANS SPRANGERS
1928 Scott Flying Squirrel

TARFORM MOTORCYCLES
2020 Tarform Luna Founders Edition

VESPA AUSTRALIA
2019 Vespa Elettrica

VESPA HOUSE AND FRANK TONON
1960 Vespa 150GS

TONY WEBB SPEEDWAY COLLECTION
c.1949–1950 Huck Fynn JAP Speedway

THE RJ WEBBER DESMO COLLECTION, GOLD COAST
1994 Ducati M900 Monster

ZOOZ BIKES
2019 Zooz Concept 01

And the private lenders who wish to remain anonymous.

SPONSORS

STRATEGIC PARTNER
Tourism and Events Queensland

TOURISM & MEDIA PARTNERS
Brisbane Marketing
JCDecaux
Seven Network
Southern Cross Austereo through Hit105 and Triple M

SUPPORTING PARTNERS
Archie Rose Distilling Co.
Bacchus Wine Merchant
Emporium Hotel South Bank
Newstead Brewing Co.

QUEENSLAND ART GALLERY
BOARD OF TRUSTEES
Professor Emeritus Ian O'Connor AC, Chair
Liz Pidgeon, Deputy Chair
The Hon. Justice Martin Daubney AM
Dr Bianca Beetson
Gina Fairfax
Catherine Sinclair
Paul Taylor

EXECUTIVE MANAGEMENT TEAM
Chris Saines CNZM, Director
Simon Elliott, Deputy Director, Collection and Exhibitions
Tarragh Cunningham, Assistant Director, Development and Commercial Services
Duane Lucas, Assistant Director, Operations and Governance
Simon Wright, Assistant Director, Learning and Public Engagement

EXHIBITION CURATORIAL TEAM
Charles M Falco, Curator
Ultan Guilfoyle, Curator
Michael O'Sullivan, Coordinating Curator
Hector Brignone, Curatorial Assistant
Cassie Packard, Curatorial Assistant

PROJECT TEAM
Simon Elliott, Deputy Director, Collection and Exhibitions
Kate Mathers, Exhibitions Manager
Sophie Dixon, Project Coordinator, Exhibitions Management
Tiffany Noyce, Senior Registrar, Exhibitions
Samantha Littley, Curator, Australian Art
Natalie McCarthy, Curatorial Projects Coordinator
Grace Fraser, Administration Officer

Rebekah Coffey, Senior Exhibition Designer
Krissy Cowls, Exhibition Designer
Jenna Hoskin, Senior Graphic Designer
and staff

Amanda Pagliarino, Head of Conservation and Registration
Amanda Buxton, Assistant Registrar
Katie Cornell, Assistant Registrar
Catherine Marklund, Assistant Registrar
Elizabeth Thompson, Conservator
and staff

Kylie Lonergan, Head of Business Development and Partnerships
Bronwyn Klepp, Head of Marketing
Amelia Gundelach, Media Manager
and staff

Izabella Chabrowska, Manager, Retail Store Operations
Tony Parker, Manager, Retail Sales
and staff

WEB AND MULTIMEDIA
Aidan Robertson, Senior Multimedia and Web Designer

CINEMA PROGRAM
Amanda Slack-Smith, Curatorial Manager, Australian Cinémathèque
Robert Hughes, Assistant Curator, Australian Cinémathèque

PUBLICATION
Judy Gunning, Information and Publishing Services Manager
Mark Gomes, Senior Editor, Print and Digital Media
Chloë Callistemon and Joe Ruckli, Assistant Photographers

DIRECTOR'S ACKNOWLEDGEMENTS

The Queensland Art Gallery | Gallery of Modern Art acknowledges the deep commitment of the Queensland Government, through additional special exhibition funding and the great support of Strategic Partner Tourism and Events Queensland. The Gallery thanks Tourism and Media partners Brisbane Marketing, Seven Network, JCDecaux, Southern Cross Austereo through Hit105 and Triple M; and Supporting Partners Archie Rose Distilling Co., Bacchus Wine Merchant, Emporium Hotel South Bank and Newstead Brewing Co.

Chris Saines CNZM, Director

ACKNOWLEDGEMENT OF COUNTRY

The Queensland Art Gallery | Gallery of Modern Art acknowledges the traditional custodians of the land upon which the Gallery stands in Brisbane. We pay respect to Aboriginal and Torres Strait Islander Elders past and present and, in the spirit of reconciliation, acknowledge the immense creative contribution Indigenous people make to the art and culture of this country.

STRATEGIC PARTNER

TOURISM & MEDIA PARTNERS

SUPPORTING PARTNERS

CHARLES M FALCO

is Professor Emeritus of Optical Sciences and Physics at the University of Arizona. Falco has published more than 250 scientific manuscripts and co-edited two monographs. He also has seven US patents, given over 400 invited talks at conferences, research institutions, and cultural organizations in thirty-two countries, and has been elected Fellow of four science and engineering professional societies. In addition to his scientific work, Falco has assembled one of the world's most extensive libraries of motorcycle books and has published *Motorcycling at the Turn of the Century* (1995) and *The Gold Star Buyer's Companion* (2015). Falco was co-curator of *The Art of the Motorcycle* at the Solomon R Guggenheim Museum, New York in 1998. In recognition of The Hockney–Falco Thesis, which was based on their discovery that artists of such repute as van Eyck, Bellini and Caravaggio used optical projections in creating portions of their paintings, Falco and world-renowned artist David Hockney have received the Ziegfield Lecture Award from the National Art Education Association, the Dwight Nicholson Medal from the American Physical Society and were invited by UNESCO to speak in the opening ceremonies of the United Nations International Year of Light.

ULTAN GUILFOYLE

is a film producer, director, curator and writer whose films have appeared on HBO, Bravo and PBS in the USA and the BBC, ITV and Channel 4 in the UK. At the BBC he produced music and arts programs including *The Whistle Test* and *Live Aid*. In 2001 he produced the film *1071 Fifth Avenue* for ITV's *The Southbank Show* with creative partner Bob Geldof. Working with the late director Sydney Pollack, Guilfoyle's film *Sketches of Frank Gehry* was an Official Selection of the Cannes Film Festival in 2006 and was released theatrically by Sony Pictures Classics. Guilfoyle has made films with architects Renzo Piano, Annabelle Selldorf and the Japanese Pritzker-prize winning architects, SANAA as well as the Yale School of Architecture and Yale Law School. Guilfoyle was the founding director of the Film Department at the Solomon R Guggenheim Museum, New York, where he later co-curated the landmark design exhibition *The Art of the Motorcycle*. He has contributed to books including *Spoon* (2002) and *Phaidon Design Classics* (2006) both by Phaidon Press and his writing has been published in international publications including the *New York Times*, the *Independent* and *Design Magazine*.

AUTHORS' ACKNOWLEDGEMENTS

BOARD OF ADVISORS

Peter Arundel (Australia)
George Barber (USA)
Kirsteen Britten (New Zealand)
Trevor Dean (Australia)
Antony Gullick (Australia)
Bobby Haas (USA)
Eléanore Jaulin (France)
Kendal Maroney (Australia)
Stacey Mayfield (USA)
John McNair (Australia)
Jean-Pierre Praderes (France)
Jeff Ray (USA)
David Reidie (Australia)
Jim Scaysbrook OAM (Australia)
Don Whalen (USA)
Lee Woehle (USA)
Jared Zaugg (USA)

We are also grateful to a number of people for many helpful discussions as we organized the exhibition and in the development of the book.

Patrick Arundel	Stacey Mayfield
Peter Arundel	Susan McLoughlin
George Barber	John McNair
Emma Barton	Mark Mederski
Marc Bondarenko	Jon Munn
Andrew Boyes	Cassie Packard
Hector Brignone	Shane Phelps
Kirsteen Britten	Jean-Pierre Praderes
Richard Bunch	Jeff Ray
Ricky Bunch	David Reidie
Brian Case	Michael Reina
Clyde Crouch	Michael Reilly
Trevor Dean	Bernard Salvat
Paul d'Orleans	Jim Scaysbrook
Mick Frew	Sue Scaysbrook
John Gee	Brian Slark
Anthony Gullick	Daniel Statnekov
Bobby Haas	Emilia Terragni
The Hayes Family	Dean Tonon
Trevor Hodgkinson	Carby Tuckwell
Chuck Honeycutt	Daryl Villanueva
Steve Huntzinger	Alyn Vincent
Eléanore Jaulin	Tony Webb
Dare Jennings	Lee Woehle
Buzz Kanter	Markus Wolf
Peter Le Gros	Don Whalen
Alan Lindsay	Chris Zahner
Kendal Maroney	Jared & Brooke Zaugg
Kate Mathers	Jeff & Philippa Zuill

Phaidon Press Limited
2 Cooperage Yard
London E15 2QR

Phaidon Press Inc.
65 Bleecker Street
New York, NY 10012

phaidon.com

In partnership with the Queensland
Art Gallery | Gallery of Modern Art
Stanley Place, South Bank, Brisbane
PO Box 3686, South Brisbane
Queensland 4101 Australia

qagoma.qld.gov.au

First published 2020
© 2020 Phaidon Press Limited
Texts © 2020 Queensland Art Gallery
Board of Trustees and the authors

ISBN 978 1 83866 163 2

A CIP catalogue record for this book
is available from the British Library and
the Library of Congress.

All rights reserved. No part of this publication
may be reproduced, stored in a retrieval
system or transmitted, in any form or by any
means, electronic, mechanical, photocopying,
recording or otherwise, without the written
permission of Phaidon Press Limited, the
Queensland Art Gallery Board of Trustees
and the authors.

Commissioning Editor: Emilia Terragni
Project Editor: Emma Barton
Production Controller: Jane Harman
Design: Jesse Reed and Juan Aranda, Order

Printed in China

The publisher would like to extend special
thanks to Clive Burroughs and to Vanessa
Bird, Robert Davies, João Mota and Anthony
Naughton for their contributions to the book.